The Formative Decades

TNB695 C10455

First ed. †25-

Roy Flukinger

THE FORMATIVE DECADES

Photography in Great Britain, 1839–1920

*Published in cooperation with
the Harry Ransom Humanities Research Center
and the Archer M. Huntington Art Gallery
by the University of Texas Press, Austin*

First edition, 1985

Requests for permission to reproduce
material from this work should be sent to:
 Permissions
 University of Texas Press
 Box 7819
 Austin, Texas 78713

International Standard Book Number
0-292-72450-0
Library of Congress Catalog Card Number
85-50831

All the images in this book are from the
Photography Collection, Harry Ransom
Humanities Research Center. Those on
pages 19–27, 29–35, 38, 40–49, 51, 54,
56–61, 64–74, 76, 78–85, 87–92, 94,
95, 97, 100–108, 110–115, 117–125,
127–130, 132–135, 138–142, and
145–149 are from the Gernsheim
Collection.

Contents

Acknowledgments vii

Foreword ix

Introduction 1

Britain's Formative Decades 5

The Photographs 17

Bibliography 157

Glossary 161

Index 163

For

Alison and Helmut Gernsheim
and
Nancy and Beaumont Newhall
who pioneered and persevered

Acknowledgments

The genesis of this book and its exhibition lies in a number of discussions which I had with Richard Brettell, then of the University of Texas at Austin art history faculty, and James B. Colson, of the School of Communication, in 1977 and 1978. Customarily rigorous and stimulating, as talks with both these educators often are, our conversations led me to the eventual design and execution of this project. It is my foremost hope that these works will be of some benefit to their students, past and present, and to future students of the discipline of photography and its history.

Two individuals deserve my deepest primary thanks: Decherd Turner, director of the Harry Ransom Humanities Research Center, and Eric McCready, director of the Archer M. Huntington Art Gallery, both here at the University of Texas at Austin. Without their initial and continual support and trust in this project we could never have succeeded.

Don Etherington, associate director of HRHRC and head of its Conservation Department, has been among our firmest supporters. Those in his division who deserve separate thanks are Siegfried Rempel, photographic conservator, and the team members who helped prepare the prints for exhibition: Mary Baughman, Cheryl Carrabba, Randall Couch, Kathy Mayall, Jackson McPeters, Sue Murphy, Bruce Suffield, and Patricia Tweedy.

Elsewhere in HRHRC: Cassandra James, former registrar, who nursed this project through many rough waters with equal measures of faith and planning; Devon Susholz, present registrar, who saw to all the details and paperwork so efficiently; Eric Beggs and Tony Troncale, photographers, who did such a thorough and professional job of copying all the works for this publication; and Patrick Keeley and Nancy Guiles, photographers, who handled all the curator's final addenda or changes.

To those members of the National Endowment for the Arts and the University of Texas administration who helped us obtain the necessary funding for these projects, my deepest gratitude. It made all the difference.

To the company at the University of Texas Press, my thanks for their support and understanding.

It has always been a particular problem when dealing with deceased artists to get past their writings and images and try to find out what made them tick. One of the best aids I have found in this dilemma is to spend time with contemporary photographers, listening to what they think and feel as well as looking at their work. Among the fine artists who have given of their minutes and hours during the past years I should like to thank particularly: Frank Armstrong, Ave Bonar, Carol Cohen, Barbara Crane, Rita DeWitt, Rick Dingus, Chris Enos, Richard Greffe, Fritz Henle, George Krause, Russell Lee, Mike Murphy, Bart Parker, Barbra Riley, Charles Roitz, Ellen Wallenstein, and Rick Williams.

Among those individuals who have supplied information, advice, and/or important assistance are M. Susan Barger, Janet Buerger, Amon Burton, Martha Charoudhi, Brian Coe, Colin Ford, Greg Free, Marianne Fulton, Kathleen Gauss, Margaret Harker, Ralph Harley, Mark Haworth-Booth, Heinz Henisch, Robert Hershkowitz, Robert S. Kahan, Nancy Keeler, Sidney Kilgore, Carlton Lake, Anne McCauley, Arthur Ollman, James Reilly, Grant Romer, Richard Rudisill, Gerd Sander, Marni Sandweiss, David Travis, Stephen White, and Bill Wright.

Two other groups deserve my deepest and most special thanks:

—The staff of the Huntington Art Gallery, whose support and energy have seen the exhibition and publication through to its final stages. I shall especially cite Jesse Otto, Becky Reese, and Judith Keller for their significant contributions; Forrest McGill, former associate director, who led this project through all its initial stages; and, especially, Andrea Norris, chief curator, whose concise planning and brilliant observations make any collaboration with her an enjoyable learning and creative experience.

—The staff of the Photography Collection at the Harry Ransom Humanities Research Center. In particular I cite May Ellen MacNamara, Barbara McCandless, and Penny Moran, who have given warmly of their time and energy in support of this project and the collection which has nurtured it. Also deserving special thanks are those members of our staff, present and past, who have contributed significantly to this operation: Barbara Hagen, Alicia Reban, Richard Pearce-Moses, Monte Dorman, Kevin Gutting, Michael Hewitt, and Scott Van Horn. A collection's effectiveness is the sum of its staff members' energies and I feel very fortunate to have the best staff in the nation.

Finally, my most affectionate thanks to my wife, Martha, and our new daughter, Erica. This one is for you, as they all have been and will be.

—Roy Flukinger, Curator,
Photography Collection, HRHRC

Foreword

The Formative Decades marks an important beginning between the Archer M. Huntington Art Gallery and the Harry Ransom Humanities Research Center: collaboration between two major sister institutions at the University of Texas at Austin resulting in a significant art historical exhibition. Given the diversity and strengths of art collections at the University of Texas, this exhibition and others like it which bring together a sharing of resources, both human and artistic, are long overdue. When, in 1982, discussions began regarding the possibility of showcasing for the Centennial of the University an exhibition from the Gernsheim Collection with an accompanying scholarly catalogue, a major step had begun, one which we hope will be the first of many yet to come. Broadly speaking, the Austin campus is blessed with superb collections, however disparate and far-flung in scope. Paintings, sculpture, works of art on paper including photography, the decorative arts, coins, ceramics, textiles—these name only the most obvious of a wide variety of artistic resources yet to be shown and thoroughly plumbed for exhibition, research, and subsequent publication.

On behalf of the Huntington Art Gallery, I pay personal tribute both to Decherd Turner, Director of the HRHRC, and to Roy Flukinger, Curator of Photography, for their cooperation and ongoing awareness that scholarship takes many forms and can be achieved in a variety of ways. Given the importance of the study of the history of art, and the singular and unique character of the Gernsheim Collection at the HRHRC, we at the Huntington are delighted to offer this exhibition to you, the viewer and scholar. Students of photography and social history, among others, will be those who most immediately benefit from this exhibition and it is our hope that this will mark the first of many cooperative ventures during the years ahead between these two collecting repositories here within the Forty Acres. Images have been selected for a very discerning reason and we urge that you give each careful and thorough scrutiny.

Finally, thanks are given also to those individuals at the University of Texas at Austin and at the National Endowment for the Arts who made the funding and realization of this project possible. On behalf of the Huntington Art Gallery we invite you to enjoy this visually discerning and scholarly exhibition.

—Eric McCready, Director,
Archer M. Huntington Art Gallery

You are not to have, in any object of use or ornament, what would be a contradiction in fact. You don't walk upon flowers in fact; man can not be allowed to walk upon flowers in carpets. . . . This is the new discovery. This is fact. This is taste.

—Charles Dickens, HARD TIMES (1854)

Oh, sweet surprise—oh, dear delight,
To find it undisputed quite,
All musty, fusty, rules despite,
That Art is wrong and Nature right!

—Sir William S. Gilbert and Sir Arthur Sullivan,
UTOPIA, LIMITED (1893)

It is an excellent thing to look at photographs in which, as Oscar Wilde must have observed, you get nothing but photography. That is, images in service to Seeing. Not in service to Sociology, The Class System, An Excess of Rationality, Cosmic Adumbrations, Self-Expression, Masculinity, Document. One constantly hears in England: "Art is not so important as people. Art is not so important as Life. Art is not so important as Nature. Art is Small Beer." Blimey. Is it as important as itself? By Bright Apollo and Nicéphore Niepce, let us declare that it is.

—Jonathan Williams, "The Camera Non-Obscura" (1980/1981)

Introduction

The University of Texas at Austin purchased the Gernsheim Collection in 1963, thus inaugurating the Photography Collection of the Humanities Research Center (now the Harry Ransom Humanities Research Center). In depositing the works in the H.R.C.—one of the major archives of important nineteenth- and twentieth-century books and manuscripts—the university placed one of the world's largest collections of photohistorical materials into its research and rare books library. Officially, the H.R.C. acquired the collection as a "supplement" to its British literary materials.

The more than two decades which have intervened between then and now have witnessed a number of significant changes. Throughout the world we have witnessed a tremendous fascination with and acceptance of photography as both an art form and a communicative force. The H.R.C., with a more complete interpretation of the humanities, has made photography one of the three major archival divisions within the center. Finally, within the photographic discipline itself has come a reevaluation of the medium, not only in terms of art, communication, or other areas of learning and expression, but also in terms of the process of photography itself. Photography is an ongoing succession of ideas, techniques, and values, and the collection, besides experiencing tremendous growth, has welcomed this period of change and the learning experience it has generated for all of us.

We have honored our commitment to the Photography Collection in a number of ways. We maintain one of the more accessible photographic resource centers in the world. Through active programs of conservation and cataloging we can assure the scholarly utilization of our materials for future generations. We have provided images and information for thousands of publications and exhibitions generated throughout the world.

Photography exists on many levels: as a major art form, as a visual communication process, as an influential force throughout the humanities, and as an expressive medium with its own continual succession of ideas, techniques, and values. The experiential significance of this multiple heredity flourishes with the public exhibition—not only by providing the best first-hand appreciation of the artists and their images but also by supporting directly many of the original generative intentions and creative ideals behind the very process of photography. To this end we must thank the administrators and staff of the Archer M. Huntington Art Gallery on the U.T. campus. They possess the people and the facilities, not to mention the will and the support, to accomplish this function in a most professional style.

In defining the parameters of this, our first exhibition from the Photography Collection in nearly two decades, we decided to forgo an eclectic mixture of imagery. We sought to create a show which would reflect both the potential scholarly content of our holdings and the range and variety of our photographic works. The richness of the collection extends far beyond the few hundred images constantly reproduced in the texts of Gernsheim and others. We desired to produce an exhibition which could expand viewers' visual experience as well as provide further questions for their consideration.

For our subject we settled upon Great Britain and the three distinctive periods of growth during photography's first eight decades (1839–1920). In part this is due to the richness of imagery from this period to be found in the collection as well as the fact that this appears to have been the primary reason for the University's original purchase of Gernsheim's holdings. Even more important than these reasons, however, there is the intricate and expansive story of early British photography itself—a story that requires our continuing examination and reappraisal.

It is the study of artists both known and unknown, of subjects both traditional and innovative, of print quality ranging from the exquisite to the experimental, and of formats from the classical to the most faddish. Throughout this period certain aesthetics succeeded while others faltered; some processes survived well while others never advanced beyond the darkroom. The evolution of a photographic vision during this time and its effect upon humankind are fascinating indeed.

For the first eight decades of its public life photography preserved and respected the concerns and standards of the middle-class Briton of the time. Content and style, while affected as always by the technical limitations of the various photographic and photomechanical processes, were shaped primarily by the tastes and interests of those of moderate income rather than those at either end of the social spectrum. With a large and interested public, photography in Great Britain developed as a native artistic form, controlled neither by a coterie of specialists at home nor by influences from abroad.

Photography has often been called the "democratic art," and, although this term has been applied effectively to other printing media, the phrase, in both connotation and spirit, is decidedly appropriate. Well before the end of the period covered by this study, the photograph, though drawing its support from the middle class, had made inroads at all levels of British society. By the early years of the twentieth century some form of photography was available to nearly all citizens, regardless of their economic state or interest in the established arts.

From the first, the photograph offered a unique opportunity for seeing the world afresh. The apparent "objectivity" of the camera eye, the ability to record three-dimensional nature on a two-dimensional surface, the quality of repeating reality not through the skill of the hand but purely through the chemical action of light—all these qualities brought world-wide attention and interest. The freedom the process provided was represented in part by the variety of subjects and presentational formats that evolved at this time. Even more, however, the medium could eventually explore all levels of human experience while at the same time developing its own creative styles.

The evolution of the art of British photography into the mid-twentieth century is marked by a variety of directions, subjects, processes, styles, photographers, and technological innovations. It is an art based not upon the work of a dozen geniuses or on a few unique masterpieces—although Britain certainly saw the rise of the former and the creation of several of the latter during these first eight decades.

If there is a true art of photography it is to be discovered on different levels. It is found in the community of photographers that grew or stagnated, changed or would not change, during this era. It is found in the works of commercial firms and assembly-line portraitists, as well as in the cogently designed and finely prepared prints of major accepted artists. Above all, it is found in the ambivalent approach to the photograph of British society itself—a society that demanded improvement and innovation in all areas while striving to maintain its cultural status quo in an era of change.

It seems most appropriate that our own recent decades of transition have helped us reflect upon a past period of evolution and growth. If the process is continuous, it is heartening to know that past and present may endure in their mutual enrichment of each other.

Britain's Formative Decades

The revolutionary aspect of photography in nineteenth-century Great Britain was that little remained revolutionary about it. Injected in 1839 into a culturally fluid, democratic society, it thrived as an art form shaped by society, economy, and current tastes rather than one transformed by a singular genius or dominated by one or two aesthetic viewpoints.

Unlike nearly all of its European neighbors, Great Britain did not suffer from the violent political and economic revolutions of the day. The Empire had its share of problems—foreign wars, expanding poverty among the lower class, periodic inflation and depression—but its democratic foundation remained firm. The British were able to thrive well into the twentieth century by placing their trust in an economic system that afforded benefits to larger numbers of manufacturers and consumers alike and in a society with a rigid, inherent class structure that still provided democratic rule through representative government.

In other cultures at other times such a system might have produced a passive homogeneity of societal evolution or at the very least a general lack of spirited inquiry. Such was not the case with the Victorians and the Edwardians. The age that produced giants like Charles Darwin, John Stuart Mill, Alfred, Lord Tennyson, and William Gladstone was assuredly capable of providing a fertile environment for the advancement of human knowledge and appreciation of a variety of fields, including photography.

Throughout this period photography remained very much a product of its times. It developed into a largely democratic art, attractive to different groups for differing reasons, but bound to no singular direction and held to no individual vision. Superb pieces of art emerged from the studios and darkrooms of photographers both at home and throughout the world, but the field was never dominated by an independent genius capable of channeling the process in a single direction. Many tried, and some, like Peter Henry Emerson and Henry Peach Robinson, had an important effect. In the final analysis, however, it was the process that triumphed over the individual and had the largest effect upon society as a whole. By the early decades of the twentieth century the British possessed the most photographically sophisticated society in the world. Although its lead was rapidly being relinquished to the Americans, Britain had every right to feel proud of its photographic heritage and the immense variety of art it had produced.

Looking back from the vantage point of 1921, John Morley, the elder humanist and essayist, was able to summarize the more than eight decades of his life as a British citizen thus:

Whatever we may say of Europe . . . in our country at least it was an epoch of hearts uplifted with hope, and brains active with sober and manly rea-

*son for the common good. Some ages are marked as sentimental, others
stand conspicuous as rational. The Victorian age was happier than most
in the flow of both these currents into a common stream of vigorous and
effective talent. New truths were welcomed in free minds, and free minds
make brave men.*[1]

Philosophers and Entrepreneurs: The 1840s and 1850s

The initial period of British photographic history was relatively brief. Largely
a time of vast experimentation and deliberate commercial initiatives, it is
bounded by photography's official public birthdate, 1839, and the early 1850s,
when the young medium first began to find some definite direction while
affecting the manner in which people began to see the world around them. It
was a period that saw severe limitations imposed upon the medium and its
practitioners, but in which a growing sense of focus and purpose was nur-
tured as well.

Technological restraints abounded, creating varying degrees of challenge
to the individual visions of all who used cameras. Rudimentary equipment,
scattered communications, and the variety of processes—some perfected,
some modified, some untried—tested the willpower of the most dedicated
practitioner. A few of the processes followed a proven course of technical
growth or cultural application—the daguerreotype, with its unique positive
image on a silver surface, or the calotype and salted paper print, the first suc-
cessful paper negative and positive printing medium—while the discipline
witnessed vast experimentation in both practice and philosophy.

Photography's first years also marked the early period of Queen Victoria's
reign, highlighted by the final phase of the British Industrial Revolution, the
continuing rise of the middle class, and a prevailing artistic temperament
heavily influenced by the machine. It was this temperament, best expressed
in the contemporaneous phrase "beauty wedding strength," that was re-
flected in the ornamentation and artifice of the manufactured products of
the day. Industry and arts were united in a single pattern, pervading daily life
and finding their greatest expression in world fairs such as the Great Exhibi-
tion of 1851.

Photography was largely segregated from the accepted fine arts during
these years. A medium with little public advocacy, poor definition, and prac-
titioners from a variety of backgrounds and interests, it was enveloped dur-
ing the first decade or so within a society that was not prepared to come to
terms with its aesthetic qualities. The photograph could serve as a scientific

1. John, Viscount Morley, *On Compromise*, p. 246.

or illustrative tool or an amateur means of personal expression, but the line separating it from the established fine arts was strong and, in the eyes of the general public, impassable. For this youthful period the medium was primarily experimental and utilitarian.

Two groups appeared at nearly opposite ends of the developing spectrum of photographic practitioners. One was preoccupied with natural philosophy; the other, as Lady Morley wryly observed, kept the sun "fully occupied every day in taking likenesses in Regent Street."[2] Though no single life can fully embody an idea or philosophy, each group is best typified by its major figure.

Robert Hunt (1807–1887) was a geologist who eventually rose to the position of Keeper of Mining Records at the Museum of Practical Geology in London. From 1839 through the mid-1860s he was also a passionate advocate for and practitioner of photography. He invented new photographic processes and techniques, wrote both learned and critical articles on the medium for several widely read journals (*The Art-Union* being among the largest), and was a major political force in the formation of the Photographic Club and the Photographic Society of London, the two earliest photographic organizations in Great Britain. An indefatigable author, he wrote two important books on photography and several more on aspects of science and knowledge; nearly all of them were very popular and had to be reprinted. His in-camera photographs and photogenic drawings, although usually produced in the course of photochemical research, nonetheless possess a strong sense of design, enhanced by effective tonality and a readable definition.

Hunt epitomizes the natural philosopher of the day. He had the inquiring mind of the scientist, ready both to pose the question and to suggest a solution. He was a tireless worker and a brilliant photochemist, relying upon both empirical results and dialogues with his peers to enable him to find a sounder theory. The minutes of various societies show that he was a spirited participant who listened to the ideas of others but was never hesitant to state his own observations or to share the results of his work.

Sensitive to the spirit of his age as well as to his own avocation, Hunt shared with others like John Stuart Mill both a scientific interest in the universe and a decidedly unscientific faith in humankind's rationality and inherent goodness. One recalls again the popularity of his books which, although concerned with traditionally non-popular topics like science and natural philosophy, found a widespread audience. Indeed, his first photographic book, *A Popular Treatise on the Art of Photography*, published in Glasgow in 1841, besides being the earliest major British handbook and history of the medium, is well written and directed less to the photographic

2. Quoted by Sir Algernon West, *Recollections, 1882–1886.*

community than to the lay person. While its aim was instruction and enlightenment, it was also a positive, humanistic statement about the medium and the people, past and future, working with it. One wonders if John Ruskin, the future proponent of humanism, could have stated the philosophy any better than Hunt does in his introduction:

All men, even the most unintellectual, are sensible to the influences of Beauty, whether presented to their view in the completeness of Nature's works, or in the approaches of human effort toward perfection. There is, with men in general, a soul-felt wish to approach the excellence they admire, but it is too frequently trammelled by the bonds of ignorance and sensuality. The desire being but seldom seconded by persevering industry, is unfortunately too often abortive—the approach to perfection being granted only as the reward of labor.[3]

A chief representative of the entrepreneurial group of photographers was Richard Beard (ca. 1801–1885). He was a coal merchant in London for years before he became involved with photography. A modestly successful businessman, he decided in 1840 to carry his speculations into the new daguerreotype process. Not being a photographer himself, he hired the necessary talent, provided the funds and time for testing the process, patented all his modifications, secured all necessary licenses for improvements, and opened the first public daguerreotype studio in England in March 1841. The enterprise was a strong financial success, and by the next year Beard had two more excellently placed businesses in London and was also selling licenses for provincial studios throughout the country. However, late in the 1840s Beard encountered difficulties in controlling his daguerreotype patents while the number and variety of daguerreotype enterprises grew. Lawsuits took up a great deal of his energy and time and, although he won final judgment in 1849, he was forced into bankruptcy as the decade closed. In ten years' time he had experienced financial success and failure in the new economic enterprise of photography.

In one sense it is easy to dismiss Beard as a man who was only in photography for the money. Although his name was printed on thousands of daguerreotype cases, he was not directly involved in the photographic creations they housed. Because of the sheer volume of portraits his studios turned out, we have a tendency to dismiss any artistic intentions of his staff and to treat their body of work as the repetitive product of some industrial mill of the day. Finally, his attempts to turn a profit on the licensing of daguerreotype studios and his subsequent use of provocateurs and lawsuits to maintain his control have cast him in a villainous role.

3. Robert Hunt, *A Popular Treatise on the Art of Photography*, p. iii.

In another sense, however, Beard's activities were as significant as Hunt's. If the economic and social products of the Industrial Revolution led to spiritual and philosophical discoveries, they also encouraged free enterprise. Regardless of the particular field of endeavor, inertia and stagnation were the mortal enemies of innovators in every discipline in Victorian Britain. Robert Hunt and his fellow philosophers could promote photography through their words and experiments, but it remained for entrepreneurs like Richard Beard to bring the images themselves to the general public.

Between the two men and others of their type, photography gained a firm foundation. In the following decades the contributions of Hunt and Beard would be disseminated through improved communications, education, and technology.

Offering both summation and challenge, Roger Fenton, the artist-turned-solicitor and one of the major young British photographers, addressed the question of photography at the end of this first period. In 1852, upon the occasion of the first photographic exhibition in Great Britain, he made the keynote speech to the members of the Society of Arts. The sense of accomplishment, the optimism for the future, the changes in visual perception—all concerns of the medium at this time—were celebrated in Fenton's analysis:

Though the excellence of the specimens now collected might allow photographers the indulgence of a little self-confidence, still everybody feels that as an art, it is yet in its infancy, and that the uses to which it may be applied will yet be multiplied twofold. What practical use has yet been made of it in the artist's studio? Those natural attitudes of the human form which come unbidden, and which cannot be assumed, is there any pencil so rapid that it can depict them before meaning has departed from the pose? Is there any eye so true, any memory so faithful, that can mark and retain those delicate shades of difference which succeed one another in the human form, when it sinks back from intelligent movement into torpid inertness?[4]

Themes and Variations: The 1850s–1880s

In 1861–1862 Her Majesty's Commissioners for the International Exhibition of 1862 found themselves in the midst of a controversy with the British photographic community. Taking as their model the highly successful Great Exhibition of the Works of Industry of All Nations held a decade earlier, the commissioners again set up four sections (each with numerous classes) for the arrangement of all articles. Section 4 was for "Fine Arts" and included all

4. "Fifth Ordinary Meeting, Wednesday, December 22nd, 1852," *Journal of the Society of Arts* 1, no. 5 (December 24, 1852): 52.

traditional artistic media. Class No. 14, "Photographic Apparatus and Photography," however, was not placed in Section 4 but rather in Section 2, "Machinery."

To the commissioners it seemed to be a logical decision. After all, had not the Great Exhibition of 1851 included photography in the broad category of "Philosophical Instruments" within a similar "Machinery" section? Were not photographs simply the products of the application of scientific or mechanical apparatus? Was not a product on par with the machinery of its manufacture?

To the British photographic community the answer was very clear—a firm distinction existed between the camera and the camera's image, and the time had now arrived to make that distinction clear to the British public. Throughout most of 1861 the commissioners found themselves the recipients of angry letters and the targets of sharp columns and editorials in the photographic journals. It must have come as a great surprise to them that the philosophers and entrepreneurs who had seemed so grateful to be included at all in the 1851 exhibition, had, in the course of a single decade, been transformed into an avid horde daring to mention photography in the same breath with the fine arts.

The photographic journals of 1861 became major forums for the discussion of the nature of photography, its purpose and values, and for much theorizing and debate about what the medium was, was not, or had the potential of becoming. There was no consensus—other than the initial opposition to the commissioners' classifications. Some felt that all photographs should be placed in the "Fine Arts" section. Others, like the photographer Alfred H. Wall, worried about "the infantine condition of the art" and wanted a select committee of photographers formed to choose the photographs for a "Fine Arts" section.[5] Sebastian Davis, a vice president of the South London Photographic Society, promoted a scheme whereby all images would be placed into one of two specialized categories, "Art Photography" and "General or Applied Photography," with all prints in the former group going into Section 4 and all in the latter into Section 2.[6] Even Lyon Playfair, the designer of the original classifications in the 1851 exhibition, decried the commissioners' "gross philosophical error" and called upon them to change their categorical placement for photographs.[7] The International Exhibition, even before opening its doors to the public, forced both photographers and their audience to examine the medium's soul.

5. "The Societies and the International Exhibition," *The Photographic News* 5, no. 147 (June 28, 1861): 304.

6. Ibid., pp. 304–305.

7. "The Photographic Society and the International Exhibition of 1862," *The Photographic News* 5, no. 147 (June 14, 1861): 281.

In the end the commissioners did not reclassify Class No. 14, although they did promise to allow a separate "apartment" for the display of photographs, a modified physical distinction between process and product. The photographers acquiesced, recognizing that they would get no better deal. The exhibition was held on schedule, and the British reviewers, irrespective of the photographs' placement in the "Machinery" section, gave high praise to the great variety of images produced by their compatriots, especially over their traditional rivals from France. By the time the exhibition closed its doors, over one million visitors had had the opportunity to examine the photographs.

The status of photographs in the International Exhibition of 1862 serves as a metaphor for the medium's position in Great Britain from the 1850s into the 1880s. There still remained the firm line of the previous period, drawn between the established fine arts and the subservient, functional art of the photograph. Seeking to have their imagery appreciated for itself, the photographers had been unable to achieve a clear differentiation in the public mind between the machine and the product. And, although many photographers of the period produced outstanding works of art, the established fine arts and the society that supported them would not consider the young medium worthy of admittance through their hallowed portals. Like a Dickens protagonist, photography was expected to know its place and not attempt to cross the barriers of class or taste. Sir Charles Landseer spoke for many in the community of established painters and water-colorists when he derided science for having at last produced a "*foe-to-graphic* art."[8]

Faced with such a conservative reaction in the contemporary British arts community, the photographers did not effect a dramatic revolutionary change. Instead, and in full accord with the democratic spirit of the times, photographers chose to strengthen their position with renewed technological and artistic innovations. Also, building upon the foundations laid in the 1840s, photographers increasingly influenced greater segments of society through experimentation and application of a variety of presentational forms, each with its own artistic and economic parameters. Being aware of the themes, they now added the variations.

Technological developments continued to improve the quality, sensitivity, and utility of the photographic image. The processes that produced unique images, like the daguerreotype and the ambrotype, passed out of use in the 1860s. In their place came glass-based negative processes, such as wet collodion in 1851 and the commercially practical dry plate in the 1870s, which were capable of providing multiple prints at lower costs. Plain salted paper was replaced by such popular printing mediums as albumen, collodio-

8. Quoted by William Powell Frith, *My Autobiography and Reminiscences*, Vol. 1, p. 212. Frith observed that Charles Landseer "made better puns than pictures."

chloride, and carbon papers. Cameras, though still often tied to the tripod, went through a range of modifications and improvements that made them more practical, portable, efficient, and affordable to the middle class.

Likewise, the photograph adapted to the demands of society. The audience for camera portraits "from life" increased as reproducible paper prints replaced the daguerreotype and its kin. Photographically illustrated books and folios achieved commercial success as well as popular and critical acclaim. A number of new formats for photographic presentation, including the carte-de-visite and the cabinet print with all its variations, were introduced during this period, usually with significant economic success. Commercial travel views, often produced in large quantities, were widely and profitably distributed. The stereograph, with its broad range of subject matter —studio portraits, landscapes, domestic still lifes, tableaux vivants, satirical pieces, news events, sentimental and instructional scenes, science, architecture, engineering, and more—reflected the wide spectrum of interests of the time and became the purest statement of contemporary Victorian morality and interests. The stereograph format enjoyed periods of unrivaled popular acclaim as well as the commercial success necessary to propel it into the twentieth century.

There was also a broadening of the subject areas of photographs in general. Portraiture underwent a transformation as emulsion sensitivity was increased and new presentational formats were popularized and went into competition with one another. Genre and "fine art" photography found champions like O. G. Rejlander and H. P. Robinson, the latter attempting to redefine the aesthetics of a Pictorial school of photography. Travel photography flourished as more members of the growing middle class returned from their Grand Tours with a desire to own "true-to-life" images of the sites they had visited. Documentary applications of the camera, whether recording the poor of London or the latest engineering and architectural wonders, were found throughout the British Isles. Furthermore, the landscape, whether seen factually or romantically, remained a favorite subject for most photographers.

It was during this period that Victorian artistic taste began to change. The middle class's indiscriminate love for artifice and contrivance over functional design was challenged and altered by groups like the Aesthetic Society and individuals such as David Ramsay Hay, the Scottish theoretician who tried to discover a single rule of beauty to cover all "aesthetic science," or Eneas Sweetland Dallas, who sought out the levels of artistic communication instead of trying to penetrate the mysteries of art's essence. In his major book, *The Gay Science*, Dallas attempted to end the fashion of divorcing art from life by placing his trust in the people to judge in matters of taste and style. Unfortunately, Dallas' generally democratic approach did not incorporate any system for monitoring public taste or for evaluating the critical response of this mass of society to various aesthetic movements. Although he

failed to establish a practical methodology, his confidence in humanity was strong and highly influential, especially when it was embraced by that most important of Victorian aestheticians, John Ruskin.

Ruskin was the most rigorous of Thomas Carlyle's disciples and, influenced by that essayist's vigorous break with the romanticism of the previous age, he sought to find those realities of human experience that added value and significance to art. Although Ruskin could never accept photography as anything more than a sincere effort to record surfaces, his dictum for artists to be true to nature—advocating an intense level of artistic generalization based upon interpreting nature and not, as was often mistakenly thought, an exact transcription from nature—was one with which many photographers might have felt comfortable. Certainly his endorsement of content over form or technique must have found sympathetic ears among the more experienced photographers of this period.

Toward the end of this central period, photography had become the "juggernaut amongst nineteenth-century print processes."[9] Even if it had not crossed the rigid boundaries of the accepted fine arts, it had been infused into all levels of British society. Enterprise and the variety and quality of work won the attention and admiration of increasing numbers of individuals. The stage was set for a final transformation in the growth and acceptance of the medium.

Blurring the Line: The 1880s–1910s

Between 1880 and the First World War, change began to overtake the British. Technological advancements in a variety of fields—transportation, communications, industry, and, yes, photography—all began to have their effect on society. Despite an increasingly unsettled international scene and recurrent socialist and pseudo-socialist movements, the British were not susceptible to revolution on any front. The class structure remained the basic foundation of the Empire and, though it was often tested and stretched during these forty years, it held firm and remained the measure for all social and economic questions that might be raised. Not even the passing of the beloved Queen Victoria in 1901 seriously altered her realm. Change continued—in fact it accelerated—but it was evolutionary, not revolutionary. As T. H. White noted, "Now it had become a velocity."[10]

These decades also witnessed an increasing schism between art and society. The Aesthetic Movement, concerned as much with appreciating beauty as with creating it, rejected the previous commitment of Victorian

9. Richard T. Godfrey, *Printmaking in Britain*, pp. 10–11.
10. Terence Hanbury White, *Farewell Victoria*, p. 177.

art to conventional morality. Led by Oscar Wilde, the Aesthetes ignored the bonds of communication and inspiration that Ruskin and others had sought to forge during this period. Instead they sought to maintain the artifice and the pose, to idealize the artist instead of the artist's vision. In the end this cult of artificiality would be carried into twentieth-century Britain, first by the Decadent Movement, with its highly stylized personalities and its affected world-weariness, and finally by the philosophical attachment of the Edwardians to their own self-interests over those of society. Despite the occasional brave attempts to review the romance of reality—notably in the writings of William Ernest Henley, whose *Book of Verses* and other poems reflected an animated, optimistic view of society, or even in the guileless imperialism of such figures as Rudyard Kipling—the "velocity" in other aspects of British society began also to engulf the arts. The dispirited air of self-consciousness proved far more attractive in the new century than the prophetless theories of moral obligation and artistic commitment.

As in the earlier periods, photography was no more immune to these changes in taste than any other creative medium. Despite the ongoing conflict in arts and letters, the medium, due to its technological innovations as well as to its own particular visual properties, began making exciting and significant inroads into the fine arts. The long-established line was finally blurred.

The 1880s witnessed the first major battle in photography's artistic struggle. One protagonist was Henry Peach Robinson, a professional photographer and author of nearly a dozen books on photographic art theory. Robinson saw the photographer's primary function as one of controlling and shaping the image to conform with the pleasing sentiments and picturesque arrangements popular in other artistic mediums of the day. He subordinated the camera's ability for depicting the real world to the artist's higher quest for truth, thereby drawing a critical distinction between what was recorded and what could be depicted in the final print. The achievement of this artistic "truth" was often attained through retouching, masking, hand manipulation, multiple printings, and other techniques in which Robinson himself excelled. From the late 1850s until his death in 1901 he was a major force in photographic art in nineteenth-century Britain.

In opposition stood Peter Henry Emerson, a Cuban-born physician who became an energetic amateur photographer in the 1880s. Although active in the camera clubs of the decade he did not possess the standing or experience that nearly three decades had given Robinson in the British photographic community. Nonetheless, the community was shaken from its lethargy in 1889 with the publication of Emerson's *Naturalistic Photography*. Advocating a style of photography essentially free of contrivance and manipulation,

the book flew headlong into the face of Robinson's more studied, painterly theories. It led to "a long and inky war"[11] in the photographic press and, despite Emerson's rejection of his own theories two years later, the war would continue throughout the decades to come. It has not really been resolved even today.

However, regardless of how we look back on the battle—Pictorialism versus Naturalism, manipulation versus pure photography, sharpness versus blurring—it would appear that neither side won a victory. The main benefit from the struggle was the recognition that photography in general and photographic art in particular were suitable topics for serious analysis and theoretical discussion. Whereas the two previous periods were marked primarily by technical experimentation or proselytization based upon pragmatism or empirical observations, now photography began to be the subject of discussion and argument from many divergent points of view.

Technological innovations also affected the quantity of images produced and the quality of individual vision. The gelatin film negative competed with the dry plate, and by the turn of the century the albumen print had been displaced by prints on the newer silver bromide papers. Professional photographers from all schools began experimentation with and the exhibition of prints in such non-silver processes as the palladiotype or the platinotype. Photomechanical methods of reproduction ranged from photoengraving processes to such ink-on-paper techniques as the photogravure.

Subsequent changes in commercial formats and presentational media, often accompanied by these later technical innovations, also began to have an impact upon photography and society during these decades. Cartes-de-visite and cabinet prints were replaced by other popular formats, notably lantern slides and postcards, both becoming successful for topographical albumen printing firms like those of G. W. Wilson or Francis Frith and Co. With the rise of the hand camera and commercial processing of prints, the family album underwent major changes, including smaller "amateur" snapshots in place of scenes or portraits by professionals. Photographically illustrated books turned away from albumen prints in favor of finer processes like gravure or commercially affordable photoduplication by means of the halftone. Indeed, it was the triumph of the halftone at the turn of the century that gave impetus to the rise of the photographically illustrated press and began to affect the psychology of perception in the general populace.

11. Peter Henry Emerson, "Naturalistic Photography," *The Photographic Journal*, n.s. 17, no. 6 (March 28, 1893): 156.

However, the strongest impact on photographic vision during these decades came with the development of gelatin roll film. With the Eastman Company's introduction of the process in 1888 and its subsequent marriage to appropriate print-processing and camera-manufacturing industries, photography began to spread throughout the British class structure. With easily portable cameras and a commercial processing establishment to handle all technical requirements, photography became a less complicated enterprise for the average person ". . . more concerned with making pictures than making emulsions."[12]

This popularization—simplistically branded "amateur" photography—led to a great deal of debate among the "professionals" who felt that either their businesses or their artistic standards would be made to suffer. In the end, however, the "professional" came to recognize that the "amateur" was not really a threat. The "amateur" population remained generally concerned with the relative immediacy of photography and with its documenting capabilities. Their motivations and expected results, although often marked by a high degree of style and creativity, usually differed greatly from those of the "professionals."

In this final conflict in early British photography, as with all previous dichotomies—philosophers and entrepreneurs, Art and Nature, Robinsonians and Emersonians—the matter was resolved by both the flexibility of the medium and the spirit of the time to accept and nurture change. Throughout most of these eight decades, constantly evolving dialectics taxed photographers and their ideas. Their photographs, the products of these ideas and times, became the mirrors of the age. It was an era not of singular milestones or masterpieces but rather of ceaseless questions, answers, and redefined vision. In the end change had become the only true constant in their world.

12. R. Child Bayley, "'The A.P.' and Other Memories," *The Amateur Photographer &* *Cinemaphotographer* 78 (June 20, 1934): 551.

The Photographs

Robert Hunt (1807–1887).
Leaves. ca. 1842.
Experimental process print. 13.7 × 18.1 cm.

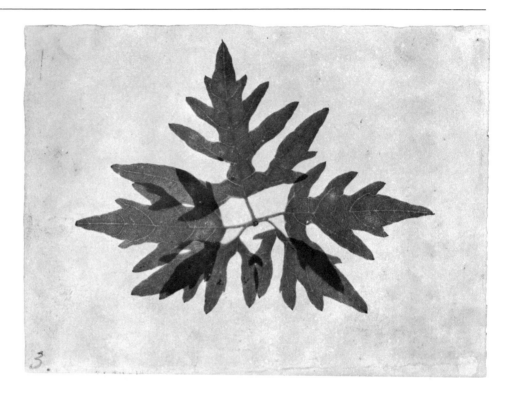

Like William Henry Fox Talbot before him,
Robert Hunt employed natural and artifi-
cial forms in contact printing for many of
his early photographic experiments. The
clean lines or distinctive forms of such ob-
jects as leaves, plants, feathers, and lace
were easily identifiable and less compli-
cated to "read" or measure than a compli-
cated, difficult-to-control, in-camera nega-
tive. Thus, a number of distinctive flat
objects came to be impressed between the
glass and sensitized papers in early printing
frames.

Still, many of Hunt's early experiments
betoken a creative eye. The prints he pro-
duced from these forms, besides possessing
attractive colors and hues, were often ar-
ranged with more than a little sense of
balance and scale. Resulting shapes were
permitted to overlap or to defy the conven-
tional proportions of the frame. Many of
Hunt's final pieces, though primarily in-
tended to achieve certain scientific goals,
also reveal a strong sense of symmetry or
harmony which exceeds the rudimentary
intentions of the work itself.

Anna Atkins (1797–1871).
Lycopodium flabellatum. ca. 1844.
Cyanotype. 28.2 × 20.8 cm.

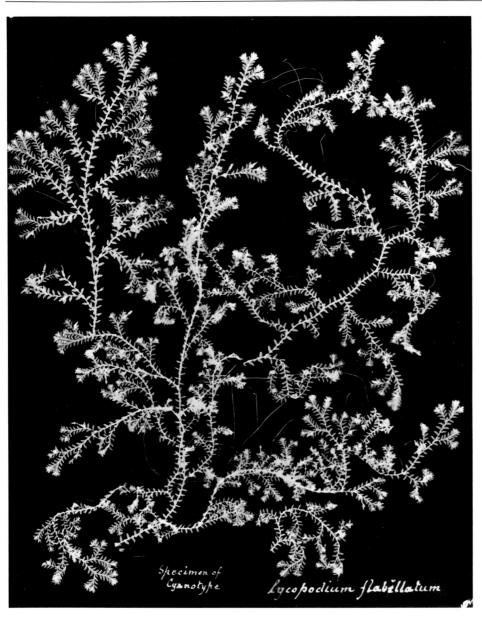

Specimen of
Cyanotype
Lycopodium flabellatum

Photogenic drawings became the earliest canvases for the sun artists, primarily through the technique of contact printing. Without the intercession of the camera, objects became subjects only through their direct contact with the sensitized paper itself, usually within the compressed boundaries of a printing frame.

Such contact printings, as icons of scientific inquiry, freeze their subjects in space rather than time, reducing their natural forms to such basic elements as line, shape, and texture. For the scientist they provided an altered but accurate means of record-keeping, an outline of reality. The natural philosopher was provided with a different perspective upon the world.

However, as no tool of science is ever unaffected by the talented hand or the spirited eye, the photogenic drawing was capable also of providing a medium of artistic expression. While dozens of Anna Atkins' cyanotypes of native plants are little more than research notes, others like this composition reflect a more poetic sensibility. Like the aerial blueprint charting an interchange of railway lines, this unique print possesses a clarity and precision of design worthy of a draftsman or engineer. The arrangement is clean with little overlap, a structure defined by both artist and object, becoming a piece of natural lacework floating momentarily on a calm, blue pool. While we may debate Atkins' metaphorical intent, we cannot deny her eye for rhythmic beauty.

William Henry Fox Talbot (1800–1877).
Photogenic drawing of an Engraving. ca. 1842.
Salted paper print, from a calotype. 23.0 × 18.8 cm.

To William Henry Fox Talbot's inquisitive mind there were no avenues of exploration, no areas of society and human experience that would not be affected by the advent of photography. An innovative and practical individual, he left behind a body of work which—as a *catalogue raisonné* of his work will one day show—reflects the broad range of interests of the educated English gentry of his day. His magnum opus, *The Pencil of Nature* (1844–1846), besides being the first major photographically illustrated book, is a remarkable attempt to define the parameters and suggest the possibilities of the new medium.

Among the practical applications suggested in his book, Talbot points out the copying of works of art for the benefit of scholars and students of the visual arts. Although he recognized the basic fact that nothing could replace viewing the original, he also saw the logical benefits of photographic copying. Works previously inaccessible to educators and interested individuals could now be seen in accurate and relatively inexpensive photographic reproduction.

Although artists would remain suspicious of the camera's ability to copy their images and the photographers themselves would find little creative challenge in copying two-dimensional works, there was always a steady interest and market for photographic copies of art works. Print quality and manners of presentation would vary dramatically, but when the images were carefully produced, as is this early copy by Talbot of an engraving, they could suggest something of the power and intricacy of the original artist's talents.

William Henry Fox Talbot (1800–1877).
The Chess Players. ca. 1844.
Salted paper print, from a calotype. 19.5 × 14.3 cm.

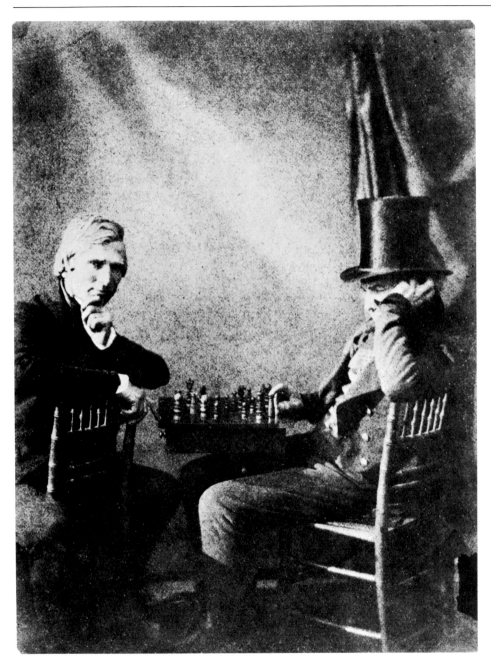

There are few images in Talbot's oeuvre that speak as eloquently as this one of his natural understanding of light and its power in photography. The closest that early photography ever came to a marriage of science and art was in the vision of the medium's founding patriarch.

The depiction of a chess game became one of the frequent iconographic devices in early photographs. It gave the subjects a common activity to be engaged in while holding still through the long duration (up to several minutes) of the exposure. Countless images from the nineteenth century represented games of chess, but few would match this one in complexity and none surpass its power.

The print is a superb technical achievement, rich in tones and subtle in lines and textures. Moreover, it embodies several qualities of photographic vision that were just becoming evident to artists at this time. The lower half of the image is a complex fugue of shapes and lines, forms and surfaces. The camera records its fascination with detail—coat buttons, chess pieces, pants creases, chair ornamentation—as revealed by both the angle and the intensity of the light. Above the board, in the upper half of the photo, light and the edge of a gathered curtain paint bold swashes against an otherwise dimensionless backdrop. Finally, there are two heads and figures, framing each side of the composition, both arresting our eyes from leaving the print and forcing us back into the intricacies of the arrangement.

"The Chess Players" is a triumph of light, an early testament to the aesthetic power of the photographic practitioners. In 1861 Antoine Claudet, the London photographer and scientist and, like his friend Talbot, "one of nature's gentlemen" (and, incidentally, the hatless chess player in this image) would recall this creative challenge:

> . . . but as I find from my own experience, which is as old as photography itself, that nothing is more difficult than to produce photographs deserving to be looked at, that it requires thought, taste, judgment, and refinement to use with success the apparatus and the process, I consider there is as much art in the result as in any of the so-called fine arts. ("On the Classification of the International Exhibition of 1862 as regards Photography," *The Photographic Journal* 7, no. 112 [August 15, 1861]: 241)

Sir William Crookes (1832–1919)
and **John Spiller** (1833–1921).
Still Life. ca. 1853.
Salted paper print, from a calotype. 8.8 × 6.8 cm.

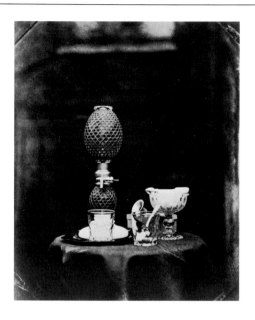

Sir William Crookes and John Spiller in many ways typify the practitioners of photographic science during the earliest decades. As expert chemists and amateur photographers, they turned their attention to the existing technical processes of the day. Their experiments ranged from modifications of negative emulsions to alterations in the process of print toning. And, as one would expect, their research and publications affected a variety of photographic techniques, including means of exposure and methods of printing.

It was in the course of their studies of exposure control and printing that this still life was produced. The arrangement was undoubtedly made to provide a variety of light-reflective surfaces so that subsequent prints (of which several exist) could show the differences in effect for the various generated hues. In the process, nonetheless, they also created a pleasing arrangement that possesses a balance of shapes and textures that was successfully complemented by their print quality. It is through such marriages of propitious vision and refined technique that photography first excelled as an art of imagination and delineation.

Warren de la Rue (1815–1889).
The Moon. ca. 1859.
Stereograph: albumen prints. 8.5 × 17.4 cm.

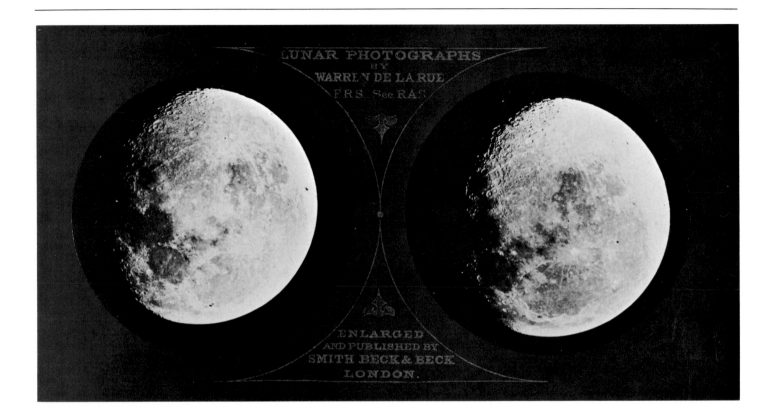

It was among the sciences that the "new art" of photography received its initial enthusiastic reception. Indeed, many of the earliest practitioners were scientists or "natural philosophers" who sensed, even if they did not fully understand, the enormous potential which careful applications of the new medium would have in their respective fields.

Astronomers were among the earliest scientists attracted to photography; indeed, two of them—François Arago in France and Sir John Herschel in Britain—made significant contributions to the medium in 1839, the year of its public announcement. The attraction between the two disciplines was natural, since they shared a physical interest in the reflectance or absorption of light upon surfaces. In fact, photography did more than provide a much more accurate recording mechanism for celestial bodies. Allied with the then very young sciences of photometry and spectroscopy, it led to the eventual redefinition and expansion of astronomy itself.

Among this earliest generation of astronomer-photographers was Warren de la Rue, of the Kew Observatory. An apparently tireless worker, de la Rue overcame many technical problems, ranging from calibration and achromatism to focusing and exposure, in order to perfect the results of his experiments. The resultant imagery, especially of the lunar surface, was marveled at for its scale and richness of detail.

This stereograph is a rather remarkable by-product of his research. Each image of the stereo pair consists of an exposure of the full moon in its entirety. Produced at different geographical locations and at different times of the year, the two images give the illusion of depth when "read" through the stereo viewer. In addition, with the then rising popularity of stereography, the image takes on a dual function in terms of the role it plays in both scientific application and popular culture.

Unidentified photographer.
Study with Chair and Bird. ca. 1845.
Stereograph: daguerreotype. 8.4 × 17.2 cm.

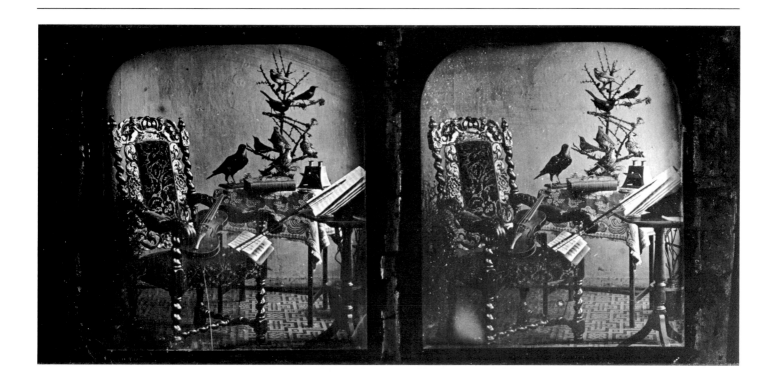

The principle of stereoptical viewing having been known long before the invention of photography, it is not surprising to find it applied early in the history of the new medium. Since stereographic viewing of an image could enhance the depth perception (and hence the reality) of its subjects, the application of the technique to the daguerreotype was at once rapid and very popular.

Still lifes, such as this study, became the most popular and easily affordable of these new productions. They took advantage of both the qualities and the limitations of the daguerreotype process—such as excellent image quality and long exposure times. Also, since living models were not employed, the technicians could take the time to produce many such unique plates of each subject. Thus, still lifes like these may have been among the first mass-produced images made from a unique photographic process.

Studio of Richard Beard (active 1841–1850).
Portrait of a Gentleman. ca. 1842.
Daguerreotype. 8.4 × 7.4 cm.

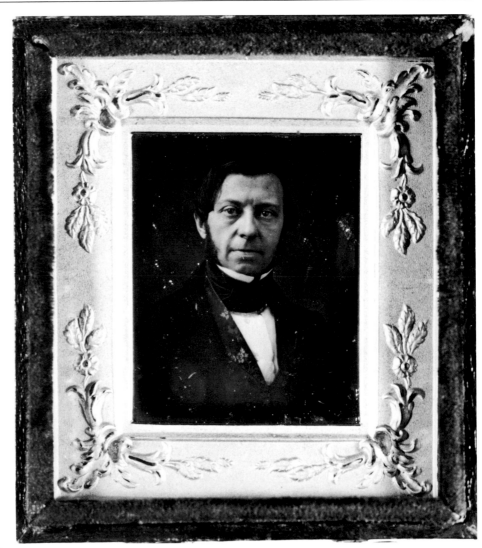

The daguerreotype was a direct positive image on a silvered copper plate, exposed in camera, processed, and then mounted under a cover glass and frame. The resulting photograph was unique, offering a finely detailed image on a very reflective surface.

It was in the field of portraiture that the daguerreotype found its first and foremost application. Beginning with those of Richard Beard and Antoine Claudet in 1841, commercial daguerreotype studios appeared throughout Britain and the world. For well over the next decade the daguerreotype became the most successful photographic medium, influencing the vision of the British people and setting new standards for portraiture.

The vast number of daguerreotypes produced during this time were the products of commercial studios that produced portraits at record rates to meet the large public demand. Very few photographers could devote the necessary time and energy to collaborate with their subjects to create a sensitive and penetrating portrait. Eyes and expressions, rather than mirroring the soul, were often fixed on the camera operator or else stared off in the distance, as Lewis Carroll satirized:

With a look of pensive meaning,
As of ducks that die in tempests.
("Hiawatha's Photographing," in *Rhyme?
and Reason?* p. 68)

Still, even the manager of the most successful portrait factories could produce interesting and evocative daguerreotypes. Beard's portrait of a gentleman is perhaps most significant in that it lacks the stiffness of most conventional daguerreotype portraits. The subjects, usually made to sit still for many seconds with head held firm in a head rest, often display their discomfort for the camera. This gentleman, however, seems more relaxed in comparison, with his eyes and composed expression focused on his unseen viewers rather than glaring at the intimidating camera. The image, though untypical, perhaps best expresses the ideals for which the daguerreotypists aimed.

Jean François Antoine Claudet (1797–1867).
Portrait of a Naval Officer. ca. 1847.
Daguerreotype; hand-colored. 13.8 × 11.2 cm.

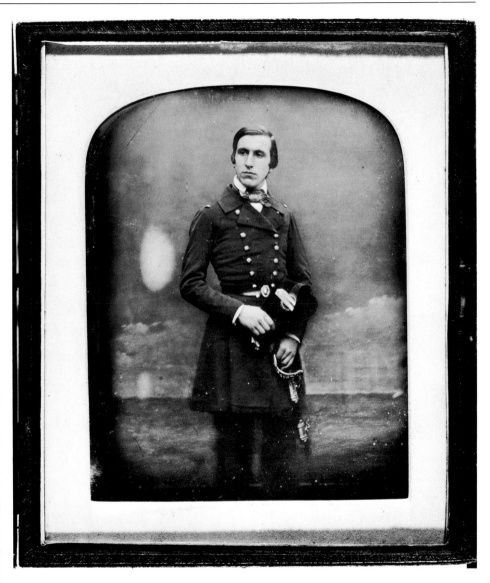

Despite the preponderance of daguerreotype studios throughout the 1840s, Antoine Claudet would remain Richard Beard's chief competitor. Perhaps this was largely due to the fact that theirs were the first two commercial daguerreotype establishments in London and that Beard had attempted to have Claudet's newly established studio closed when it first opened in 1841. In any event they remained the premier daguerreotypists in the city until Beard's bankruptcy at the end of the decade. Afterward, Claudet continued to maintain his studios, improving both the quality and the variety of his images while maintaining strong ties within the growing photographic community.

Claudet was one of the first photographers to attempt to bridge the early gulf between entrepreneurship and science. His business ventures bore significant fruit and his name continued in the forefront of commercial photographic portraiture throughout most of these earlier decades. His interest and enthusiasm, however, did not stop here. He maintained an active friendship with many in the photographic trade as well as with natural philosophers such as Talbot. He continually experimented with new techniques and processes within the medium and, if one can judge from his published writings, was not averse to sharing his findings and opinions in a true scientific spirit.

One feels that he also was more in tune than Beard was with his potential customers. His daguerreotype of the young naval officer, while lacking the bold directness of Beard's portrait, tends to be more idealized. Although both sitters probably suffered through the head braces and long exposure times so traditional to daguerreotype portraiture, Claudet's officer, in both pose and expression, appears more relaxed and personable. The hand coloring of the image further enhances its decorative, intimate values. Claudet appears to have been in touch with the dominant sentiments of the Victorian age.

Peter Wickens Fry (d. 1860).
Two Children in Doorway. ca. 1851.
Salted paper print, from a calotype. 13.6 × 11.0 cm.

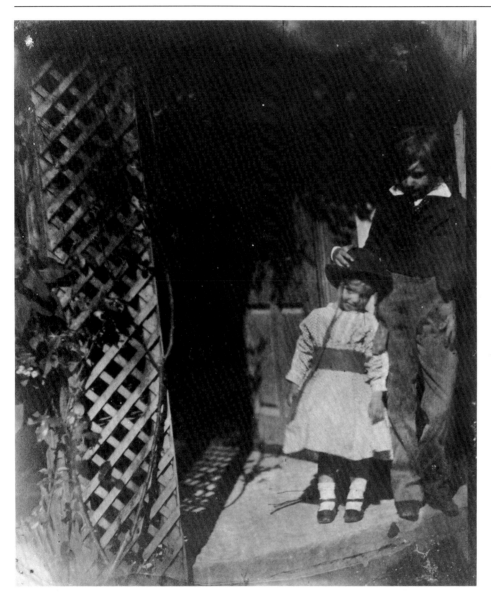

As an organizer and experimenter, Peter Wickens Fry made a number of significant contributions to the development of photography in Great Britain. He was one of the medium's earliest and strongest advocates, and the results of his labors are represented by the major societies, clubs, and exhibitions he helped to organize and shape in the 1840s and 1850s.

As a photographer, however, he was not among the medium's early masters. His prints, though scarce, are marked by a great variety of technique. They are generally small, and their subject matter ranges from familiar architecture to almost snapshot-like records of his family and friends. The extant body of his work is marked by subjects recorded with a variety of exposures, in nontraditional poses and framing. One feels that his experimentation was limited not by the chemistry of photography, but rather by the visual properties available to the camera technician of the day. As in this picture of his two children, his compositions possess a certain naïve quality that betrays the hand of the amateur rather than the eye of the professional.

Fry maintained his passionate, avocational attachment to photography throughout his final decades. Still, the existing body of his work did not possess that true characteristic of a work of art—what T. S. Eliot would later describe as a life of its own detached from its maker: that preeminence would come to some of Fry's associates like Roger Fenton or P. H. Delamotte. Fry remains, however, that rarest of creatures, the pure amateur, lacking the refined skills and vision of the professional but unyielding in his passionate commitment to the possibilities of the medium.

Unidentified photographer.
Mother with Deceased Child. ca. 1856.
Ambrotype; with hand-coloring. 10.8 × 8.2 cm.

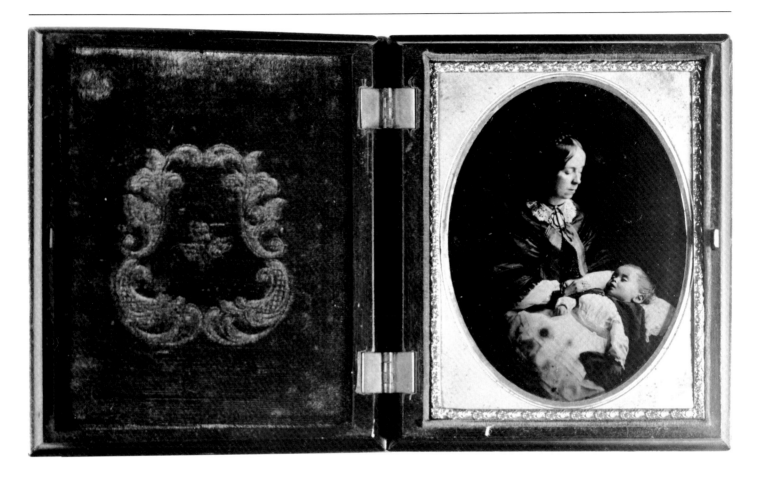

With the camera's affinity for attempting to depict the real, objective world, photography had the capacity to become the most immediate and accurate image-generating system in the world. And, with its ability to freeze moments out of time and human experience, it seemed to be an ideal tool for nurturing personal memories as well as generating original thought or enlightenment.

Perhaps the clearest expression of this personal interest can be found in death imagery. Use of the camera to depict for a final time the countenance of a deceased individual began in the earliest daguerreotype years and has existed in one form or another up to the present. It remains one last, tangible manner of holding on to a departed loved one, perhaps not as personal as keeping a lock of hair (another common practice) but certainly more representational or "true to life." For whatever reason or com-

bination of reasons, death portraiture was a major part of the trade during the early decades of photography's economic life. To offer loved ones a final photograph of the departed—or, in the case of young children, perhaps their only camera portrait—was considered a most natural practice.

In the hands of an accomplished portraitist it could also result in a moving photograph. The ambrotypist who recorded this image of a mother and her child's body employed a chiaroscuro-like effect of lighting and pose which, coupled with superb technique, gives added strength to this portrait of personal loss. A moment in time of personal grief long past is given a universal timelessness and power.

David Octavius Hill (1802–1870)
and **Robert Adamson** (1821–1848).
Group of Six Men. ca. 1844.
Salted paper print, from a calotype. 23.3 × 30.5 cm.

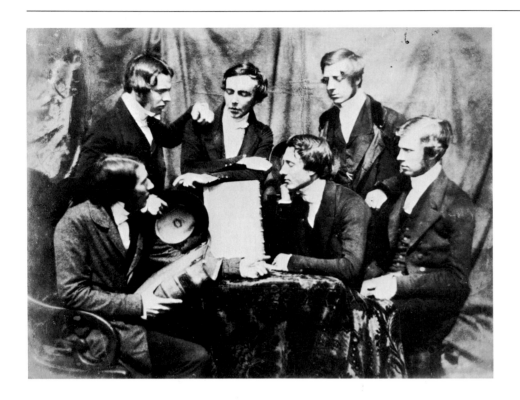

The collaboration of D. O. Hill, the landscape painter, and Robert Adamson, the chemist, produced only some 1,500 known works and was of a relatively brief duration, from 1843 until Adamson's death half a decade later. Despite these limitations, this energetic artist-scientist team produced with remarkable consistency some of the finest photographs of these early decades. Their prints span a remarkable range—from formal portraits to scenes of Newhaven fisherfolk to views of Edinburgh—while retaining an outstanding degree of presence which adds to their fidelity.

The portraits of Hill and Adamson, despite their furnishings or other hints of domestic intimacy, were produced outdoors in broad, direct sunshine. In addition, the calotype process by which the negatives were produced required long exposures of several seconds and, therefore, the firm pose and positioning of all subjects before the lens. Portraits of great moment as well as compositions of intimate gesture or expression thus would share the same generative processes of design and technique.

The anomaly of these photographs was not lost on their creators. It is doubly gratifying, therefore, that the portraits of Hill and Adamson, despite their restrictive genesis, possess a power and dignity which transcends their immediate origins. Despite the arabesques of heads, arms, and torsos which such large group shots engendered, the photographers still managed—with the turn of a head, the slant of a body, the placement of a hand—to add a degree of naturalness to the final portrait.

Unlike the daguerreotypists of their time, Hill and Adamson had to satisfy their own demands, not just those of the sitters. Since Hill was using the photograph both to illustrate his ideas and to serve as models for his portrait painting, the images were meant to serve both intentional documentary and aesthetic functions. They thereby represent one of the first blendings of the early duality of photography.

Maull and Polyblank.
George Cruickshank. ca. 1857.
Albumen print. 19.8 × 14.7 cm.

Within the spectrum of early photographic portraiture, the firm of Maull and Polyblank fits neatly into the period between the heyday of the daguerreotype and the rising proliferation of the carte-de-visite format. The firm's standardized portraits—produced from glass negatives and printed in uniform size—depicted many notable individuals in the fields of art, science, politics, and education, and were made available for purchase on a per print basis.

In standardizing its techniques and business practices, the firm seems to have also established a routine to its very style of portraiture. In nearly all cases the subjects are photographed approximately three-quarters of full figure, and they may usually be found to conform to one of a half-dozen traditional poses. Wherever possible, associated objects (such as plants for botanists or stones for geologists) are included in the image. The resulting portraits are marked by a degree of passivity on the part of their subjects, with a spark of animation or liveliness showing through only rarely. These painterly, studied poses were traditional for the medium of brushes and oil, which photography was replacing, but they did not work effectively before the camera's more rapid gaze. From their images we know what the subjects looked like; from the captions we know who they were; but from the photographs themselves we can catch only the spirit of the age, not that of the individuals.

**Lady Jane Frederica Harriot Mary Grimston Alexander,
Countess of Caledon** (1825–1888).
Hon. Charles Alexander. 1856.
Albumen print. 14.8 × 11.3 cm.

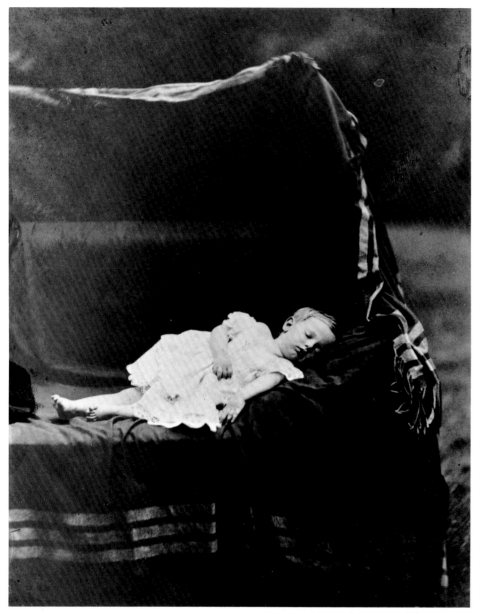

Commercial daguerreotype portraiture set certain standards of pose and style which were generally accepted throughout the professional community. The serious studio portrait of the early years featured a rather limited number of standardized poses, usually dependent upon the talents of the individual operators, the attitudes of the sitters, and, of course, the technical limitations of the medium, which required long exposures and tightly restricted movement for a relatively long duration.

However, with the inception of the negative-positive processes, chiefly among the amateur practitioners, the rules governing standardization of pose and demeanor underwent gradual changes. Rather than simply mirroring life, the photographs of subjects began to take on a life of their own. Although few commercial studios could work within the framework of such compromises, the British amateurs allowed experimentation and innovation to guide their trials.

Within the small body of extant prints by Lady Jane Alexander, there are numerous instances of this attitude at work. Working at home with the customary messy chemicals and complex apparatus of the day, her prints reflect an inconsistent technique. Likewise, the majority of her sitters appear awkward or ill at ease within her framework and settings. However, it is also apparent, as in this photograph, that she possessed a great fondness for the family and friends who appeared before her lens. The works contain an intimacy and innocence that is at once naïve and touching.

Robert Adamson (1821–1848).
Tree in Barnyard. ca. 1843.
Salted paper print, from a calotype. 13.1 × 17.1 cm.

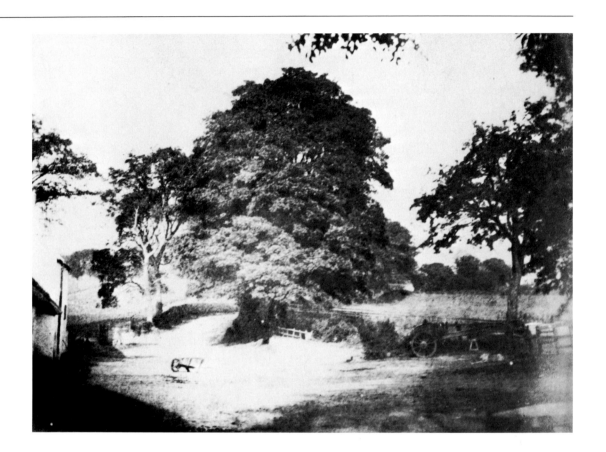

Robert Adamson's rural scenes and land-scapes are among the boldest of his images. Certainly they exceed the traditional pic-turesque elements found in much of his collaborative work with D. O. Hill.

This is evident in even so prosaic a scene as this view of a barnyard. The tree which dominates the work is placed within a hori-zontal rather than a vertical frame. Its pre-dominance is therefore further enhanced by the swatches of dark and light that sup-port it from the ground and the sky. The large, bright foreground space which domi-nates the lower portion of the image not only provides a superb balance for the en-tire piece but also draws the viewer into the scene. Adamson remains among the earliest to recognize this directness of the photographic image in its application to traditional scenes.

George S. Cundell.
Houses of Parliament. ca. 1845.
Salted paper print, from a calotype. 6.2 × 15.7 cm.

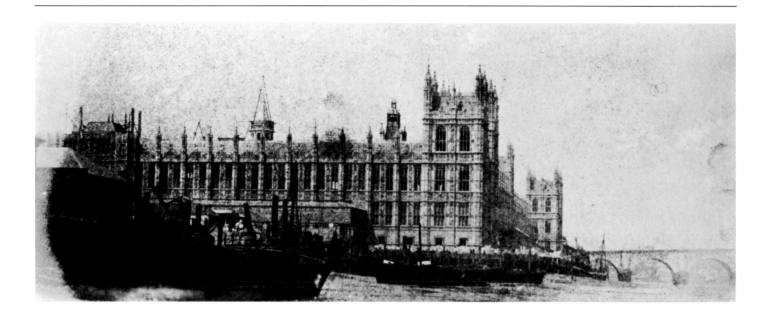

Subtle variations in tones and shading, long in use by painters and engravers, were first employed in British photography by the amateur calotypists of the 1840s. Utilizing paper negatives capable of multiple reproduction and broad tonal ranges, the calotypists interpreted their subjects with greater range and force than was possible with contemporaneous processes like the daguerreotype or cyanotype. They became the first group of photographers to explore photography's non-objective qualities in terms of such prevalent artistic concepts as effect and form.

Thus, George Cundell's image of the Houses of Parliament goes far beyond the medium's documentary potential. It is a re-interpretation of familiar shapes and forms, an edifice defined in tones and shades rather than by line or precise definition. Cundell provides the buildings with a tangible, substantive atmosphere, thereby giving the entire scene a far greater presence than a sharp, direct exposure would have been capable of doing.

Thomas Keith (1827–1885).
Edinburgh: Skyline and Rooftops. ca. 1856.
Salted paper print, from a calotype. 24.0 × 27.1 cm.

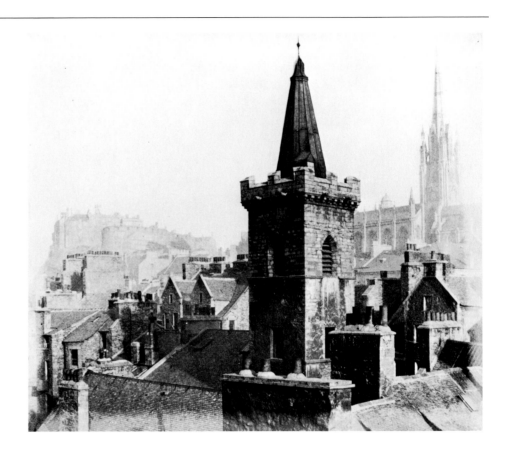

An Edinburgh physician and friend of D. O. Hill, Thomas Keith was introduced to photography by Hill shortly after Robert Adamson's death in 1848. Keith's involvement with the medium was intense but brief, lasting little more than half a decade during the 1850s and ranging not much farther afield than the city proper and surrounding neighborhoods of Edinburgh.

Yet, despite these limitations of time and distance, Keith pursued his avocation with a surprising intensity and variety. His subject matter ranged from cityscapes to rural scenes, from visual documentation to figural studies in landscape. His technique is deliberate and thorough, denoting his passionate regard for all levels of the photographic process. Finally, his vision was the most mature and innovative of his time. As his photograph of the skyline and rooftops of the city clearly demonstrates, he sought out bold angles, planes of light and shadow, and nontraditional points of view to re-

define the appearance of his traditional environment. Whether elevating his camera or juxtaposing intricate shapes and details, he produced images that remain complex and vibrant.

The substance and quality of Keith's imagery call into question the validity of such terms as *amateur* and *professional*. Despite the brevity of time during which he pursued his hobby and the limited number of prints in his existing oeuvre (a little more than 200), Keith displayed a remarkable depth of feeling and a range of vision which extended far beyond that of many contemporaries who followed the photographic profession for their entire lives.

Roger Fenton (1819–1869).
Haddon Hall. ca. 1856.
Albumen print. 23.5 × 35.7 cm.

By its very physical nature architectural photography is a system of compromise. The photographer and the apparatus are at the constant mercy of an edifice or detail that rarely undergoes significant change, while always under the influence of light which undergoes constant change. In comparison with the studio or portrait photographer, the architectural photographer has less control of the subject matter or the lighting conditions, and must, therefore, have even greater expertise and sensitivity in the remaining areas of control—point of view, framing, exposure controls, print quality, and emotive response.

Roger Fenton solves the problem in a traditional manner by placing the entire building within the larger context of its surrounding environment. He relies upon the dramatic contrast of the textures and façades of the thirteenth-century hall to stand forth from the background of trees and sky and the foreground of lawn. The angle at which the house is photographed and the dark tree which overlaps the façade further serve to lock the building comfortably into its countryside setting. The total effect is one of complete balance, rather like a puzzle in which all pieces are firmly in place and totally accounted for.

By contrast, B. B. Turner's photograph of Rievaulx Abbey makes its own rules. Turner eschews the traditional approach of placing the walls and arches of the ruined abbey prosaically against an open sky—a tradition stretching back to the previous century among sketchers and watercolorists. Instead, the sky all but vanishes from the composition, and the formerly simplified horizon line is replaced by a modified rolling terrain. Arches, passageways, and façades are all compacted against one another to form an overlapping and interlocked pattern. The tight framing of the piece further enhances the rhythmical complexities within the composition. In opposition to the formalist presentation that Fenton has made, Turner permits himself an inwardly directed exercise in light and line that is jointly shaped by documentation and interpretation.

Benjamin Bracknell Turner (1815–1894).
Rievaulx Abbey. ca. 1850.
Salted paper print, from a calotype. 28.5 × 37.1 cm.

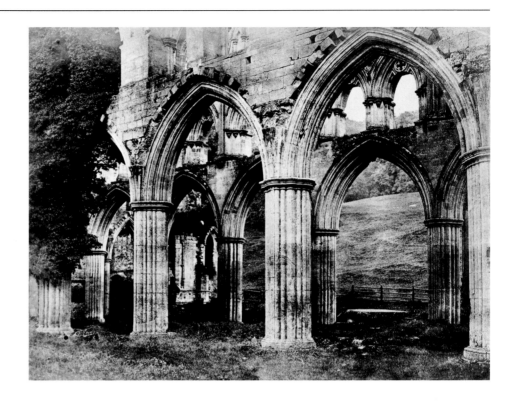

William Russell Sedgfield (1826–1902).
The Precinct Gate, Norwich. 1854. Published in Sedgfield, *Photographic Delineations of the Scenery, Architecture, and Antiquities of Great Britain and Ireland.*
Albumen print. 20.5 × 25.4 cm.

The range of topographical photography in nineteenth- and early twentieth-century Britain was tremendous. In part this was derived from the fascination which painters and printmakers of previous centuries felt for certain visually stimulating or historically significant locales. Also, it was undoubtedly partly due to the continual fascination which the island empire felt toward its own past and present, especially in preference to those of other European nations. Finally, topographical photography proved to be a generally lucrative enterprise for camera artists in the period of nationalistic fervor which reached its zenith during Queen Victoria's reign.

At one end of this spectrum of topographical artists were individuals like William Russell Sedgfield, an important photographer whose career ran throughout the daguerreotype and albumen periods of British photohistory. Sedgfield's "Precinct Gate, Norwich" is from a series of photographic portfolios which he produced in the mid-1850s, an entrepreneurial attempt to market limited, subscription portfolios of prints depicting well-known locales or edifices. As such, his photograph maintains a clearly direct approach to its subject matter, produced from the same traditional viewpoint adopted by previous artists. Sedgfield has chosen to rely upon the print's size and quality, as well as the camera's attention for detail, to give the photograph additional power.

By contrast, and at the other end of the range, we find Francis Bedford's view of Barnstaple. Bedford was one of the most successful and prolific photographers from the albumen era, heading a firm that produced tens of thousands of prints annually. In opposition to selective marketing schemes like Sedgfield's, Bedford aimed for the larger group of consumers among the middle class. His imagery ranged from documentation of famous sites or buildings to landscapes which relied solely upon accompanying captions to signify their location. Many, like Barnstaple, were commonplace locales, with no particularly significant edifice but with many interesting topographical elements. Bedford composed his works carefully, seeking out the angles, accents, textures, tones, and lines which made each setting unique and exciting to the eye. The resulting superbly printed images became brief, bright sonnets, orchestrated around the beauty inherent, but often overlooked, within each scene.

Francis Bedford (1816–1894).
Barnstaple: The Bridge and River Tow. ca. 1857.
Platinum print. 12.6 × 19.9 cm.

Bedford, 938. Barnstaple, The Bridge and River Taw.

William England (d. 1896).
Interior view of the Building of the International Exhibition of 1862 in South Kensington. 1861.
Albumen print. 29.7 × 24.2 cm.

Following a decade after the Great Exhibition of 1851 set the standards and vitalized the concept of a world's fair, the International Exhibition of 1862 was intended to exceed its predecessor in all ways. In actuality it began with two major drawbacks: first, the death of its chief supporter and benefactor, Prince Albert, in 1861; and, second, the inescapable fact that it could never have the national and international impact of the original exhibition or the Crystal Palace which had housed it. Still, the 1862 show was successful and did serve the continuing mandate to introduce the newest in the arts and industry into the British society.

There were those, however, who felt that the machine age would hasten in another Dark Age, in which the artistic spirit would be crushed. Despite the success of the fairs and the continuing growth of the middle class, many individuals continued to feel ill at ease with machines making such inroads into daily life.

William England's photograph of the exhibition building under construction at South Kensington captures this air of ambivalence. On one hand its skeletal structure appears crowned with a diffuse and penetrating light, a benediction reminiscent of that earlier luminous edifice, the Crystal Palace. At the opposite extreme others could ask if England had not already shown them the hell of the modern age—if they were not already within the belly of the whale. Whatever the feelings we bring to the photograph, we cannot deny the strength which England gave to his image. If these were truly the gothic cathedrals of the new age, then how appropriate that they were recorded and revealed by that newest of the mechanical arts, the camera.

Ross and Thompson?

Woodland Scene. ca. 1858.
Albumen print. 21.4 × 21.8 cm.

In trying to read the subject, symbolism, and aesthetic pattern of a photograph, it is always important to remember that each image is first and foremost an experience to be shared between the artist and the viewer. Thus a critical or historical dissection may enhance our appreciation or understanding of the work but not the experience itself.

There is little we can add of a factual nature to our analysis of this woodland scene attributed to the commercial firm of Ross and Thompson. Its combinations of line, form, shadow, and texture all seem to balance and indeed complement one another. Without sky or distinctive horizon line, it becomes a rich, relaxed tapestry of shapes and tones—a woodland locked in time and space for each viewer.

John Shaw Smith (1811–1873).
Turkish Burying Ground, near Constantinople. November 1851.
Gelatin silver print, from a calotype. 16.3 × 21.4 cm.

Certainly the spirit of the Grand Tour did much to strengthen the impact and influence of photography during its early decades. Talbot himself acknowledged that a major impetus for his experimentations in photography was the fact that he was unsatisfied with the camera obscura and camera lucida drawings he executed during his early tours of Europe. The very human desire to retain visual images of a personal event as momentous as a vacation or tour —whether for record-keeping purposes or purely as a mnemonic mechanism—lent itself quite naturally to photography as it had to printmaking mediums of preceding decades.

The traveler's commitment and dedication to photography had to be great indeed. Negative-making processes of these early years required not only complicated chemicals and equipment but also a spirit prepared to meet and overcome the sociological and technical challenges of working with the relatively new medium in different lands and climates, all of which could have an adverse effect upon the production of images.

John Shaw Smith, an Irish landowner, was an exemplary early tourist and photographer. He and his wife made an eighteen-month tour of Europe, the Mediterranean, and the Middle East between 1850 and 1852. Carrying his camera and apparatus with him, he produced hundreds of calotype negatives of sights great and small throughout the trip. An indefatigable photographer, he turned his attention to everything from the ruins on the Acropolis to street scenes in Cairo.

His images are refreshing and unique, perhaps because he had no preconceived notions of how to depict the architectural and archaeological monuments he saw. He approached his subjects and scenes with a fresh eye, less concerned with static, classical recording than infatuated with the complexity and flexibility of the camera. His photograph of the Turkish burying ground is at once dramatic, intricate, and lyrical. A front foreground corner with two detailed stelae gives definition to the entire piece while adding depth to the dominant planes of the image. A complex arrangement of vertical shapes defies the general horizontal patterns of earth, shadow, and tree lines. Finally, Smith has elected to include the pointed treetops against an opaque sky, thus providing a strong (and perhaps symbolic) upward thrust to both scene and subject. It is a moment in time and space that contains a graphic eloquence far beyond the moment.

Robert MacPherson (1811–1872).
Façade, Via de Sugherari. ca. 1856.
Albumen print. 40.4 × 28.2 cm.

No photographer of the nineteenth century impressed his unique vision upon Rome more than did the Scotsman Robert Mac-Pherson. Throughout the 1850s and 1860s he produced countless mammoth plate photographs of the Eternal City that found their way into the collections of many institutions, scholars, architects, and tourists. As a dedicated commercial photographer and fine technician, he did not eschew the traditional temple-against-the-sky imagery so popular with foreign travelers as visual documentation. Yet there is a subtler, more complex aspect to MacPherson's images, born of a creative drive to interpret as well as record the existing world. None surpassed him in his ability to make buildings and sites part of a complex visual expression instead of mere transcriptions of mortar and stone.

On one level the photograph taken at 30–31 Via de Sugherari is merely a record of the architectural and structural change which a Roman façade has undergone in past centuries. However, like his close American counterpart Carleton E. Watkins, MacPherson could see well beyond the mechanical transcription of the real world. He finds lines and shapes and textures that abut, approach, or counterbalance one another. He employs light and shade dramatically to give added dimension to the façade's intricate surface. Finally, he has chosen to give us no sky, no horizon line from which we can take our bearings as we explore the complexities of the print. Like an aerial photograph from a future century, MacPherson's view transforms the real world into a new structure, forcing us to reexamine our process of seeing.

Francis Frith (1822–1898).
The Great Pyramid, and the Great Sphinx. 1858.
Published in Frith, *Egypt, Sinai, and Jerusalem.*
Albumen print. 38.0 × 48.5 cm.

Until coming into direct contact with one of Francis Frith's mammoth prints, one tends to forget their sheer presence and dramatic impact. Contact printed from glass plate negatives, the photographs provided an immediacy unlike any previous imagery of the landscapes and artifacts of the Middle East. Adopting a print size and a technical proficiency which complemented that of the ancient artisans and architects whose works were his subjects, Frith recorded many of the major sites and edifices of the foreign lands beyond the Empire's boundaries. In addition, through his print sales and published folios of photographs and personal narratives, he did more than supply a newer and larger interpretation of these foreign lands. He also provided his viewers with the opportunity to further understand the experience both of these outward vestiges of foreign cultures and of the nature and spirit of the peoples which produced them.

At the opposite end of this creative spectrum stands Frith's former assistant, Frank M. Good. In the years following Frith's Middle Eastern expeditions, Good staked out the same geographical territory for his own commercial enterprise. Specializing in smaller format work and stereoviews, Good's photographs featured the same high technical standards and general subjects as those of his former employer. However, the difference in the two artists' visions is readily apparent. Whereas Frith sought out the monumental and attempted to provide it with an almost classical presentation, Good's prints either placed such sites into their everyday milieu or else focused on intimate details and subtle compositions. His interpretation of the cedars of Lebanon is a quiet, harmonious coalescence of light and form, as evocative in its understatement as Frith's near-symphonic presentations are in their magnitude.

Frank Mason Good.
Cedars of Lebanon. ca. 1859.
Albumen print. 20.2 × 15.2 cm.

William Lake Price (1810–1896).
The Soldier's Toast. ca. 1856.
Published in *Photographic Art Treasures*.
Photogravure. 22.5 × 19.5 cm.

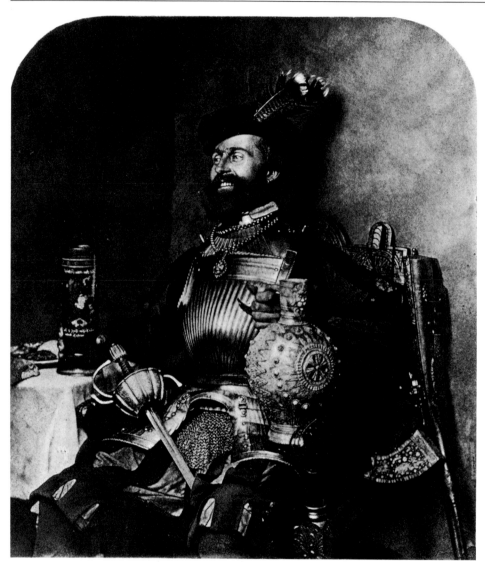

Although he authored a major text on early photographic aesthetics, *A Manual of Photographic Manipulation* (1858), and was an influential member of many photographic societies and informal groups of the 1850s, Lake Price never became an innovative photographer in his own right. A watercolorist whose photographic career spanned less than a decade, he became noted for his elaborately constructed compositions depicting literary subjects or historical events. His images reflect the moral sensibilities and classical approaches seen in many popular Victorian paintings of the age.

"The Soldier's Toast" is just such a production, an attempt to capture in costume, gesture, and light the moment in Shakespeare's *Othello* when Iago gets Cassio drunk in order to ruin the lieutenant in his commander's eyes. The caption—the opening line of an English drinking song sung by Iago—is included to make us fully aware that Price has designed an illustrative piece, attempting to lend graphic intensity to the words of the play.

However, if it is meant to be illustrative it cannot help being interpretive as well. Price has created a theater piece—a record of a tableau vivant, if you will—that sustains a life of its own. Although we recognize the lack of spontaneity in the central figure—the awkward position of the hand, the forced smile (necessitated by a long camera exposure)—we can still appreciate the complexity of Price's construction. The lighting, like Rembrandt's, provides both drama and texture to the figure and his environment. The assortment of mixed surfaces, alternately reflecting and absorbing the light, invite our decipherment.

Price was among the earliest photographers to apply the medium to this fictive genre. Through the effects of light, his images found the life that his models and processes sometimes lacked.

Roger Fenton (1819–1869).
General Bosquet and His Staff. 1855.
Salted paper print, from collodion negative. 17.2 × 16.3 cm.

The Crimean War photographs of Roger Fenton—comprising over 360 views in all—are still the most significant body of photographic war reportage from the first two decades of the medium's history. They represent a significant advancement in the growth of photography, not only because of the logistical and operational problems that Fenton had to overcome in order to function in the Crimea for four months, but also because of the variety of images he produced in the course of his project. Although the technology of the wet collodion negative did not provide him with the necessary chemistry or equipment to produce instantaneous reportage, he did provide portraits, scenes, and landscapes capable of adding greater depth to our understanding of war.

Yet there is also an element of unreality to the photographs. No doubt because current war photography and television provide us with more immediate imagery, Fenton's prints seem devoid of the heat of battle. Scarred landscapes, destroyed buildings, and haunted expressions do come through in certain images, but many are studio set-ups done against a backdrop of war. Fenton's pioneering work was outstanding in its time, and we must not permit our cumulative visual experiences with similar subject matter to interfere with our appreciation of these photographs.

As for the subject of this particular image, Fenton described General Bosquet as a "good take" and compared him in stance and figure to Napoleon. Perhaps this describes the general's staged, dramatic stance —a model for his forthcoming statue?—in the midst of his four aides-de-camp. The superficial theatricality is easily overlooked, however, when the graphic elements of the work are analyzed. Besides his symmetrical placement among his four aides, Bosquet also holds his position halfway between a receding, mottled earth and a severely light sky. The general becomes the fulcrum for the entire work's motion and tension.

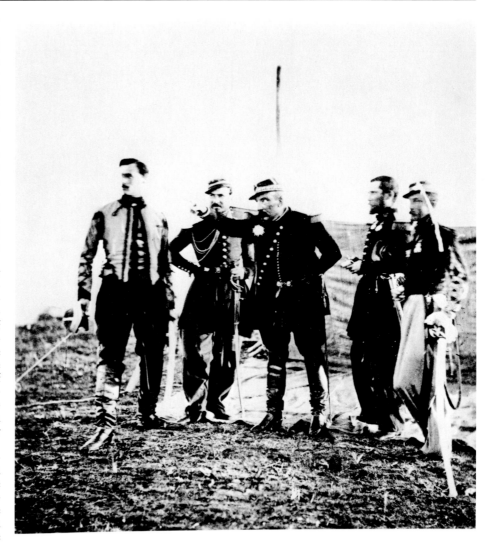

Roger Fenton (1819–1869).
Captain Lord Balgonie, Grenadier Guards. ca. 1855.
Salted paper print, from collodion negative. 17.6 × 13.7 cm.

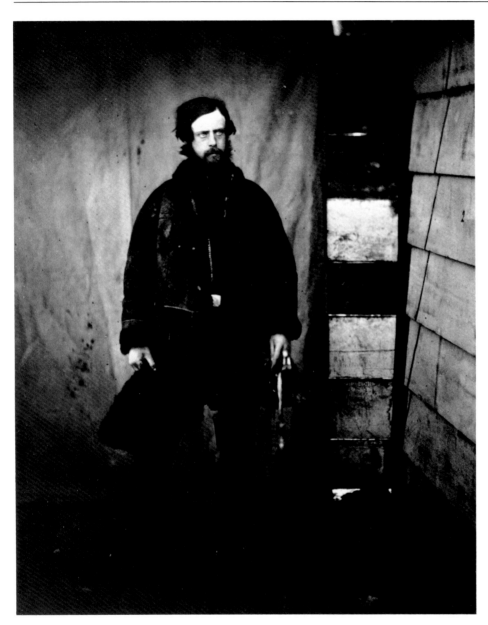

Considering the poor physical conditions and limitations upon the photographic process (ranging from exposure time to processing and storage conditions), it is remarkable that Roger Fenton returned from the Crimean War with so many significant and powerful images. Of the photographers and artists who reached the scene of battle, Fenton alone emerged with images that reflected something more than the topography and artifacts of war. He came closest to depicting in imagery the wasted heart that lay at the center of this grim military adventure.

For Fenton the war was first and foremost an economic enterprise. He came to the Crimea for only a few months, returned to England, showed the images to the Queen and Prince Albert, obtained an exhibition, and proceeded to distribute portfolios of photographs until the war concluded and the public lost interest. In the process, however, his photographs began to remove much of the romanticism which had previously evolved around the "art" of warfare. While depicting the commanders, the soldiers, and the scenes of battle, Fenton's camera could not avoid recording some of the destruction, fear, grime, and emotional exhaustion of this undertaking.

Alexander Leslie-Melville, styled Lord Balgonie and heir apparent to the earldoms of Leven and Melville, was, at the age of twenty-four, a hero of the war when he stood before Fenton's camera. A captain of the First Foot of the Grenadier Guards, he had fought bravely at the Battle of Inkerman, had had his horse shot out from under him, and had even received the knighthood of the Legion of Honor of France. He stands before us, like so many of Fenton's subjects, on the soil of the Crimea surrounded by the weathered or worn trappings of the battlefield camp. He wears no parade dress, and his body's attitude is not that of a military officer. Above all his face lacks the usual indomitable expression which the Victorians might have expected of their military heroes; rather it is an expression that puzzles, disturbs, and invites different interpretations. One wonders if it remained with the young lord until his death two years later.

James Robertson.
Sebastapol, from the Malakoff. 1855.
Albumen print. 24.2 × 29.8 cm.

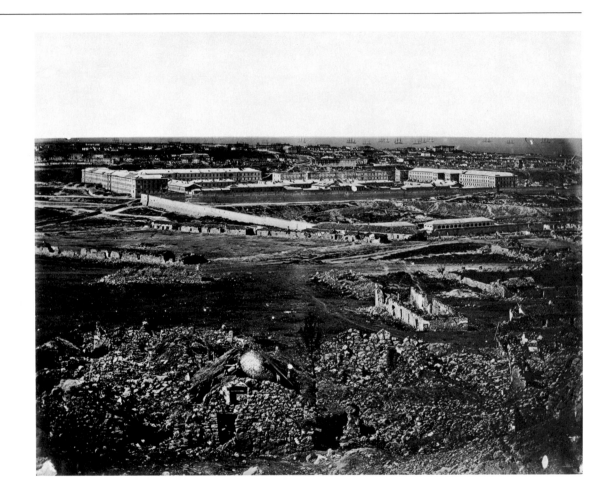

James Robertson, like Roger Fenton, brought his camera to bear upon Britain's conflict in the Crimea. In almost proportionate opposition to Fenton, however, Robertson aimed to view much more of the landscape and terrain of war and less of the individuals engaged in the proceedings. Thus, when the human figure appears in Robertson's photographs it is merely as an element in the overall view of the camp or battlefield, humanity becoming only one part of a tremendous process called war.

As Fenton chose to reflect the battles in the faces and figures of men, Robertson found his reflections in the land extending from foreground to horizon line. His tapestries of earth—such as this view of Sebastopol with its ruins, city buildings, and ships at sea—present a needed geographical panorama to add weight to the economic and human losses reflected in the records of this war.

Present photojournalistic practices encourage a near-far method of documentation, focusing strongly upon both the setting and the details of the story. In the end the balance established in the Crimean photographs of Robertson and Fenton seems derived from these very principles. Although, as we now know, the Crimean War was not the first war covered by the camera, perhaps it still remains the earliest professionally photodocumented one.

Unidentified photographer.
Wounded Soldier. ca. 1870.
Albumen print. 14.0 × 10.2 cm.

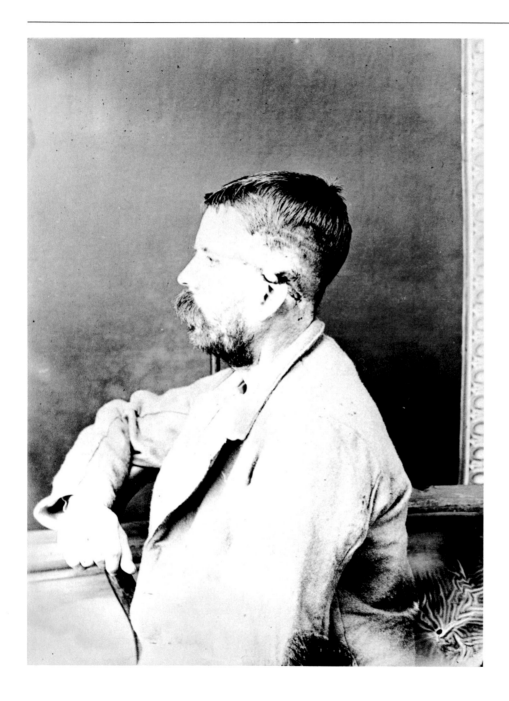

Unidentified photographer.
Guns Captured at Cabul. ca. 1879.
Albumen print. 18.3 × 23.4 cm.

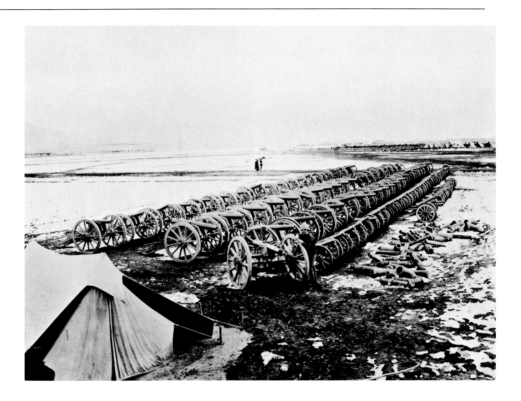

The camera ultimately began to record more than the events and faces of war. In the end it started to capture the ambiguity of war itself.

The unnamed soldier gives us his profile, recorded in a standard pose reminiscent of the work of commercial portrait films of the day. It is only when we look less quickly that we see the ugly gash of the head wound, depicted with the lens' same direct matter-of-factness as the rest of the portrait's features. It is an incongruity that shouts for some degree of relief or explanation, but, in this instance, only the portrait in all its detail is our matter of record.

At variance with the concept of truth is the image of the guns captured at Cabul [Kabul] during the Second Afghan War. The guns blanket the field, carefully arranged and touched with a light covering of snow, like odd-shaped stacks prepared for a forthcoming harvest. Yet we know that the battle for Cabul was hard and costly, that the guns were paid for in human lives, that the snow will melt and increase the frustrations of living with mud in addition to the cold weather. The scene is almost bucolic in its tone while still dispassionate to its subject matter.

We can only guess at the names and intentions of these photographers, at least until more detailed information comes forward to support our theses. For the present they remain with us, obscure riddles in the complex pattern of human experience.

51

Samuel Bourne (1834–1912).
Part of the W. S. Club, Simla. ca. 1865.
Albumen print. 23.7 × 29.7 cm.

Throughout his three photographic expeditions to India in the 1860s, Samuel Bourne constantly maintained an almost effortless, positive directness to his vision. His India is the India of Pax Britannia, an era in which the British sought to maintain their empire in the East with a modicum of interaction with the native people but with a large military presence. However, whereas other bodies of nineteenth-century British images appear to represent this attitude through their selectivity and cultural bias, Bourne's oeuvre reflects a broader sensibility. Although he approached his subjects with a Westerner's eyes, he maintained an awareness and responsiveness to the Indian traditions and beauties that surrounded them. He sought to direct his efforts toward coming to terms with the country as it was, rather than attempting to either politicize or romanticize its situation.

His image of the W. S. Club in Simla typifies this position. There is no attempt to explain or defend this whites-only, imperialist social club, typical of many that flourished throughout the country at this time. Neither, however, is the edifice given prominence such as many of its patrons might have expected. Instead, the building becomes part of a total composition of natural and artificial forms and lines, locked in place by a blanket of snow—rather like "snow globes" which maintain a single scene within their own water-filled universes. Bourne's visions remained locked in the amber worlds of the albumen prints, timeless glimpses of a world which would be subject to the many changes of time.

J. Lawton.
Standing Buddha, North Road, near Dambool. ca. 1875.
Albumen print. 28.0 × 20.6 cm.

There is a light, gentle quality to this image that permits it to transcend the ordinary, straightforward travel photograph typical of the commercial views sold by J. Lawton and others. The soldier, leaning closely at the base of the Buddha, with his hat neatly placed at his own feet, does not presume a superiority to this artifact of a foreign people. Instead, standing almost the way a tourist of either century might place himself, he assumes a position neither of conquest nor of indifference. The image betrays a quality of humanity and respect not usually associated with the popular notion of East meeting West in the heyday of the British Empire.

James Anderson (Isaac Atkinson) (1813–1877).
Base of Trajan's Column. ca. 1858.
Albumen print. 36.1 × 28.6 cm.

As a young man, the British watercolorist Isaac Atkinson moved to Rome in the late 1830s. He gradually found his livelihood in photography, choosing, like his contemporaneous competitor, Robert MacPherson, to specialize in large-format views of Italian landscapes, architecture, and copies of classical paintings. His enterprise, founded under his pseudonym of James Anderson, proved to be highly successful, both in terms of local commissions and with the ever-expanding tourist trade in Rome.

Like his rival, Anderson chose large, wet-plate collodion negatives and correspondingly large albumen prints as the medium by which he hoped to capture some of the grandeur and scale of Roman architecture. Unlike MacPherson, who employed such innovative techniques as dramatic lighting and the use of oblique angles, Anderson tended to utilize a more straightforward approach to his subjects. Still, Anderson's direct documentary attitude probably matched that of the tourists more closely, and this shared visual experience between creator and purchaser is perhaps one of the chief reasons that his firm stayed in business for many decades into the twentieth century.

In addition, much of his work possesses an unexpected power underlying its basic straightforwardness. On one level his photograph of the base of Trajan's Column attempts to record the details of one quadrant of the support plinth of this classical edifice. However, because of the print's precise tonality as well as the image's controlled framing and depth of field, the photograph contains a subjective presence equivalent to the physical experience of the base itself. Like Carleton Watkin's image of a mammoth California redwood from the 1870s, Anderson's photograph is a testament to the majesty of the total object. Beyond the image's frame can be found additional remains of the Roman Empire; within the frame we can experience its continuing presence and influence within the contemporary world.

Charles Clifford (ca. 1819–1863).
Puente del Diablo, Cataluña. ca. 1858.
Albumen print. 29.6 × 43.6 cm.

For most of his brief professional life, Charles Clifford enjoyed a unique position—that of royal photographer to the court of Spain. He recorded the landscape and architecture of all areas of the Spanish nation as well as the scenes and events surrounding the many official travels of Queen Isabella throughout the country. Although the royal appointment undoubtedly kept him busy, it also provided him with a relatively stable economic base from which to develop and improve the quality of his vision.

The results are remarkable. Among his British contemporaries, only Frith, Mac-Pherson, and Fenton can approach his brilliance in topographical photography. Clifford's mammoth prints, produced from both paper and glass negatives, are rendered with superb technique and exquisite clarity. His studies are never rigidly formal—framing is often slightly askew, and the presence of people, whether by inclusion or inference, is usually maintained—but they do possess a grandeur and richness of interpretation beyond their original documentary intent. Thus, the footbridge becomes a monumental arch, the plaza turns into an architectural mosaic, or the simplest tree is transformed into a celebration of light.

Indeed, Clifford did more than record and reshape his views of Spain. Ultimately he glorified the land which appeared before his lens, searching for a certain majestic character in even the most common vista or façade. To what degree his royal commission shaped this attitude is a matter for greater debate and analysis, but there is no denying that before his untimely death he served the interests of his medium, his queen, and his adopted country in an outstanding manner.

Philip Henry Delamotte (1820–1889).
Preparation of Exhibit Case for Aquatic Specimens;
Building of the Crystal Palace at Sydenham. 1853.
Published in Delamotte, *Photographic Views of the Progress of the Crystal Palace*.
Salted paper print, from collodion negative. 23.0 × 28.7 c.m.

A commission also provided the impetus behind some of the major work of P. H. Delamotte. In this case, however, the photographer was supported not by a country but rather by a group of private investors, the Directors of the Crystal Palace Company. In what is certainly one of the earliest long-term private endowments to a photographer, the directors charged Delamotte with recording the re-erection of the Crystal Palace at Sydenham. The resulting work, a two-volume portfolio containing 160 prints, was published in a small edition in 1855.

There is no greater symbol of the social, cultural, economic, and aesthetic factors which were at work in mid-Victorian Britain than the Crystal Palace. Built originally to house the Great Exhibition of 1851—the first world's fair—the Palace was also a major architectural and aesthetic innovation.

It was a resounding financial and social success and came to symbolize the national development and international preeminence of the British Empire. The Directors, seeking to maintain the edifice and its major function as a showplace, acquired the building from the government, supervised its disassembly and move from Hyde Park to Sydenham, and oversaw its eventual reconstruction between August 1852 and June 1854.

Throughout this period Delamotte had continual access to all phases of the reconstruction. He documented everything from the design and contents of the building itself to the daily lives of the workers at the site. His photographs range in style from unadorned documentation of events and incidents to highly personal interpretations of the physical elements of the Palace's design. Some of the prints even invite more

radical speculation or interpretation. For example, his photograph of workers preparing one of the massive natural history cases can provide us with much practical information about the men and their work. However, with its distorted depth and dark tones, its frame-within-a-frame design, and its overlapping lines and forms, it seems to also take on a surrealistic nature beyond its caption's original intent. Surely Delamotte, a professional engraver before he took up photography, was no naïve interpreter of the effects of light and line. His works are too rich in effect and nuance for us to see them only as documents. Their elegance and variety are tremendous, and the final portfolio remains a strong testament to the artist, to the Directors who entrusted the scope of their project to him, and to the socioeconomic system which could engender it.

Negretti and Zambra (active ca. 1850–ca. 1932).
Crystal Palace, Sydenham. ca. 1855.
Stereograph: collodion on glass. 8.2 × 17.0 cm.

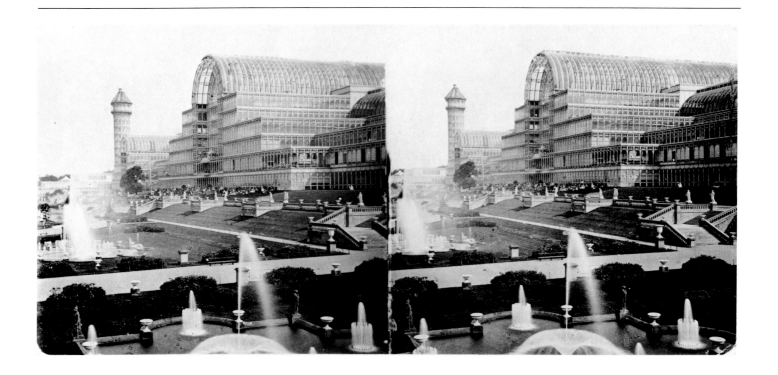

The first major impetus for the stereograph came with Queen Victoria's purchase of the apparatus after having seen examples in the 1851 Great Exhibition in Hyde Park. Sir Joseph Paxton's building for the exhibition, called the Crystal Palace, became the focus for the newest applications and achievements in science and the arts, so it was only natural for the cameras of many photographers to focus also upon this great endeavor of civilization.

When the Crystal Palace was removed from Hyde Park and re-erected in Sydenham in 1853 as a private commercial enterprise, the optical firm of Negretti and Zambra received the rights to photograph and produce sets of stereos of the new building, its interior displays, and its grounds. Thus the association of the palace with stereography continued.

Among the most successful and dramatic of Negretti and Zambra's views are those produced on glass for viewing by transmitted light. Certainly the translucent quality of the imagery added increased impact to the viewing of the photograph. In addition, it served to emphasize the majestic play of light which was so important to the building's overall design and impact. In process and presentation the image is able to transmit to the viewer a larger sense of the majesty and character of its subject.

Stereography, in its intermittent periods of popularity, would follow the Crystal Palace throughout its existence. Some of the final photographs taken during the building's destruction by fire in 1936 were made with the stereographic camera.

D. W. Hill.
Burnham Beeches. ca. 1865.
Stereograph: albumen prints (Oxymel process). 8.4 × 17.4 cm.

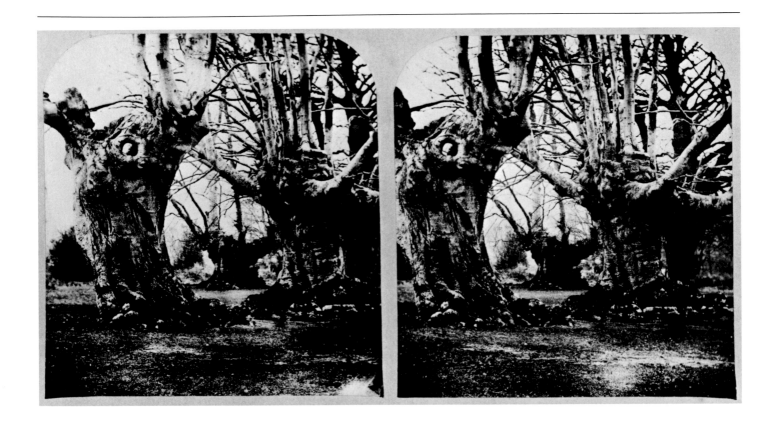

Located in Buckinghamshire near Maidenhead, the Burnham Beeches, those "aged sires" of British flora, were the preeminent trees in an ancient forest which had attracted writers and artists for generations. They offered solitude and inspiration to many, including Thomas Gray, who wrote to Horace Walpole in 1737, "Both vale and hill are covered with most venerable beeches, and other reverend vegetables, that, like other ancient people, are always dreaming out their old stories to the winds . . ." (*Letters of Thomas Gray*, ed. Henry Milner Rideout, p. 5). Their fantastic shapes were due to an old pruning system called pollarding (supposedly dating back to Cromwell's time), and the resulting skeletal branches and rough surfaces were to provide exciting visual elements for many a photographer.

The stereograph added additional elements to these exercises of lens and light. With stereo separation, the spatial relationships between these craggy giants could be further enhanced, thereby increasing the pictorial possibilities. In addition the stereograph also provided enhancement of surface textures and details which had been recorded with a more general flatness by the traditional monocular cameras. The stereos of the beeches are interesting, therefore, both as intricate images in their own right and as evidence of valuable instruction in the application of stereography.

Alfred Silvester.
Silvester's Household Brigade. ca. 1860.
Stereograph: albumen prints with hand-coloring. 8.4 × 17.3 cm.

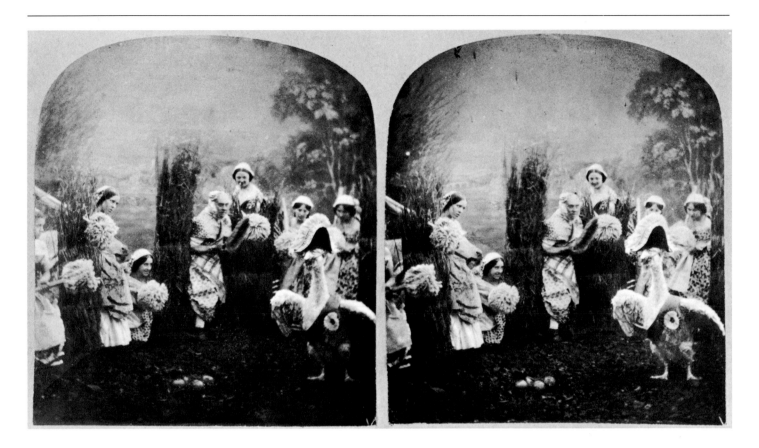

The popularity of the stereograph is practically immeasurable. We know that in its heyday of the 1850s and 1860s hundreds of thousands of these views were produced and sold annually. In an age in which the vast majority of the population of Britain did not own a camera or possess the knowledge to produce a photograph, the stereograph, along with the carte-de-visite, became the most prevalent photographic format throughout the society. Those who could not afford all the expense and time to master the photographic process did usually have enough to invest in views and portraits for the family to experience.

The photographer's relationship to the public, therefore, became a strongly economic one, with firms forced to compete through all levels of fad and fashion for the same limited funds. Innovation and experimentation were as much in vogue as the reproduction of standard, commercially successful scenes or portraits. With such an intensely symbiotic relationship it is hardly surprising to note how much of a mirror the stereographers of these decades held up to their society. Views ranged from the religious and highly moral to the satirical and pornographic, with all manner of variations in between. Likewise, personal artistic vision and technical processing standards also experienced large variations.

"Silvester's Household Brigade" is one of the innumerable commercial genre studies from this period, produced in studio and without a great deal of personal style. Its humor has a rather quaint and stodgy air—the family members using brooms to fend off a goose with Emperor Louis-Napoleon's features. Technically, the image quality, printing, and hand-coloring are rather amateurish, as if the entire piece was the work of an assembly-line operation—which in fact it was, since Silvester's stereographs were quite successful sellers for a number of years. Thus, although they may possess little artistic merit, they do represent one of the major ways in which the photograph reached its mass audience.

Unidentified photographer.

Boudoir Scene. ca. 1858.
Tissue stereograph: albumen prints, with hand-colored backing. 7.9 × 17.0 cm.

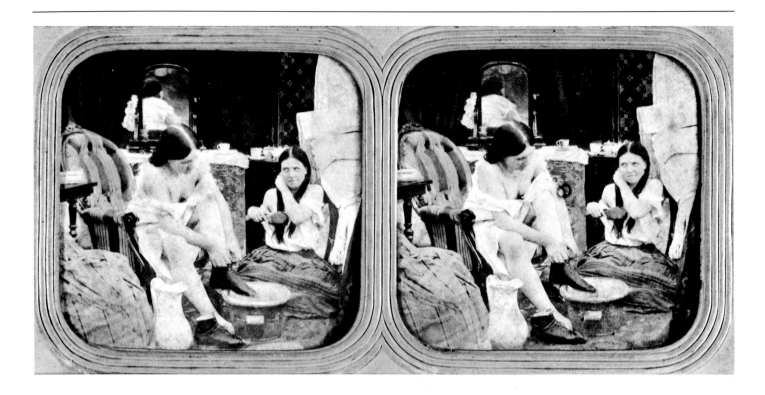

With all individuals possessing to some degree a prurient element in their nature, it comes as no surprise that salaciousness created its own economy and made its own inroads into British society at this time. Nor is it any less surprising that the photographic medium, with its easily reproducible qualities, strong graphic impact, and inherent attention for detail, was employed almost from its beginnings in this clandestine enterprise.

Because of these qualities, photography added new dimensions to most levels of the pornographic trade. The quantity of negatives that could be made in one "sitting" and subsequent prints that could be produced from each negative undoubtedly led to a significant increase in provocative and sexually explicit imagery. Subject matter varied from staged depictions of sexual liaisons to copies of images in other visual mediums to lightly stimulating topics such as ladies in their toilette or somewhat snickering depictions of such private events as the wedding night. Because of its serial nature of production, photography undoubtedly provided sets or series which possessed narrative or thematic structures or featured certain popular individuals.

It is interesting to speculate upon the degree of impact that photography had on this under-the-counter economy. Furthermore, what effect did it have upon the legitimate side of the business? In all likelihood several marginally successful studio photographers may have been able to get ahead in their competitive trade by dealing in lascivious imagery with certain select clientele. For obvious reasons, however, this work is almost entirely anonymous, and the creators of even so mildly titillating an image as this tissue stereograph of a peek into the boudoir remain unknown to us regardless of their mastery of pose and composition.

Oscar Gustave Rejlander (1813–1875).
A Nude Study. ca. 1860.
Albumen print. 20.5 × 15.5 cm.

The nude has been a classical theme in all the visual arts. It must come as no surprise, therefore, that, despite the rather lofty moral tone we tend to impose upon Victorian England, the nude prospered in early photography as well.

Of those who chose to interpret or reinterpret the nude in nineteenth-century photography, none occupies a more important place than O. G. Rejlander. The photographer maintained contacts with a number of artists and illustrators and made a significant part of his livelihood selling "artists' studies." These studies, usually of a figurative or thematic nature, may appear dated or naïve to our modern eyes, but their basis in the other popular art forms of that period adds validity both to their intent and to Rejlander's execution.

Rejlander's nude maintains a forceful presence due in part to photography's capacity for realistic rendition but even more so to the dramatic combination of light, texture, and form within the frame itself. The economy with which object and space are united serve as ample proof of Rejlander's mastery of his art.

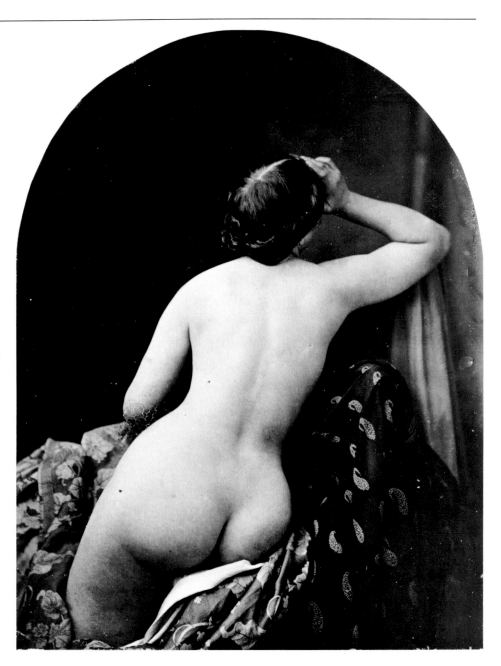

61

Francis Currey.
Dead Birds. ca. 1860.
Albumen print. 15.4 × 20.5 cm.

Robert Burrows.
Still Life. ca. 1862.
Albumen print. 11.5 × 15.8 cm.

The still life remains one of the most basic exercises for amateurs and professional artists alike. The rendering of immutable objects in a controlled space and light has long been one of the fundamental tests of an artist's skill and technique. It was not surprising, therefore, that a number of early photographers chose this genre for the expression of their particular talents.

Francis Currey's depiction of dead fowl is based upon a most traditional academic approach. *Nature morte* possessed an artistic heritage dating back nearly two centuries, and Currey's photograph is a closely literal extension of its principles into this relatively new medium. With its precise framing, spare composition, sharp focus, fine tones, and firm attention to detail and texture, the photograph lacks only the element of color to be fully comparable to paintings in this genre.

In contrast, Robert Burrows' still life does not possess the studied, classical look of the Currey piece. The Burrows photograph lacks much of the precisely controlled studio refinement found in the other work. The objects in Burrows' composition are inanimate rather than dead, items placed in a vertical arrangement but framed and depicted within a horizontal landscape. Whereas Currey's fowl are given an almost heroic placement—as if trophies of some great hunt—the commonplace gardener's implements utilized by Burrows almost seem to have been left in place rather than positioned for refined treatment by an artist. Burrows seeks to discover and interpret the world around him, rather than trying to ennoble it. As such, his print is less affiliated to traditional artistic principles but, conversely, more strongly allied to the rising popular fascination with the objectivist, democratic nature of the photograph.

Roger Fenton (1819–1869).
Roman Bust of Lucius Verus, British Museum. ca. 1857.
Albumen print. 36.9 × 23.8 cm.

The use of photography to document examples of art in other media was one of its earliest applications. Indeed, both Talbot (with his numerous depictions of the bust of Patroclus) and Daguerre turned their cameras to such tasks. The use of photography in creating objective records of art works, while it undoubtedly placed photography in a subordinate role to the other fine arts, nonetheless served to increase the popularity and utilization of the medium.

Working within a five-year period but within vastly different stylistic spheres, Roger Fenton documented classical marbles from the British Museum's collection while Charles Thurston Thompson recorded fifty objects included in the publication for an exhibition at the South Kensington Museum. Fenton's prints are large and bold, as befits the monumentality of his subjects. In addition, they are delineated by direct sunlight which contrasts sharply with the patches of shadow contained within the frame, strongly suggestive of the accepted strength and power afforded classical pieces. In contrast, Thompson's composition, with its generously diffuse lighting and its harmoniously component background fabric, is a far more intimate work. Like the best still lifes, it invites our study of the lines and forms of its subject—in this case the artistry that went into a fifteenth-century silver piece. In its subdued manner Thompson's work is as much in harmony with its subject as is Fenton's, and both speak precisely to the maturity and variety found within the photographic medium.

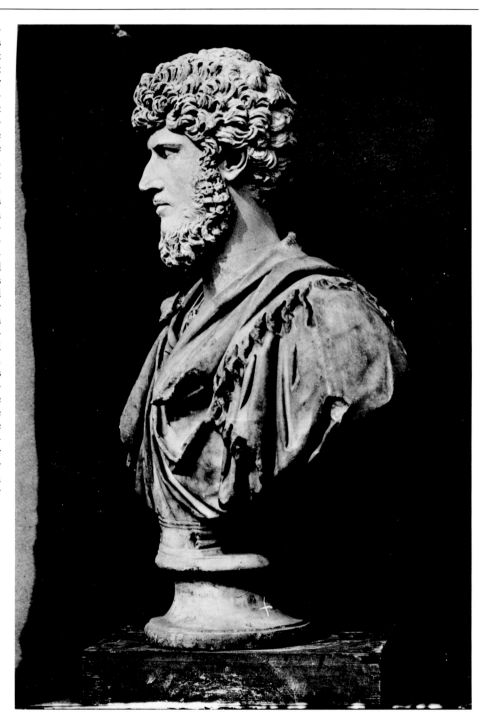

Charles Thurston Thompson.
Silver Gilt Salt Cellar, Old English Work. Date 1493. 1862.
Published in J. C. Robinson, *The Art Wealth of England*.
Albumen print. 20.0 × 11.0 cm.

Unidentified photographer.
Bukiyanas. Rajpoots, Now Mussulmans. Googaira. Mooltan. ca. 1870.
Published in John Forbes Watson and John William Kaye, eds., *The People of India*, vol. 5.
Albumen print. 17.8 × 12.8 cm.

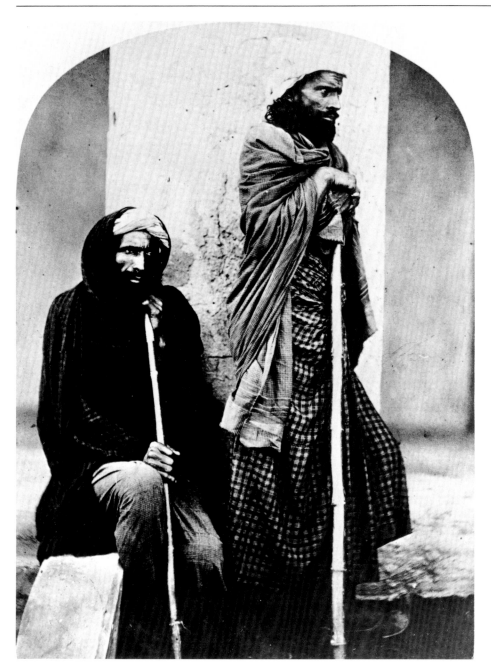

One of the offshoots of Lord Canning's Governor Generalship of India was the production of an eight-volume work, *The People of India*, edited by John Forbes Watson and John William Kaye, in 1868–1875. The editors traced the impetus for this work to the fascination which the British in India felt for photography and to "the desire to turn it to account in the illustration of the topography, architecture, and ethnology of that country."

The publication, with Canning's endorsement and the sponsorship of the Home Secretary and the British government, chose to focus upon the various tribes and racial groups which made up the people of this most populous of the British protectorates. The volumes consisted of descriptions of each group followed by a mounted photographic portrait of a member or members of each particular caste or sect. Fourteen amateur and military photographers, together with one professional firm, Shepherd and Robertson, amassed the images over a period of nearly a decade. Unfortunately, individual photographers were not credited to separate works. *The People of India* remains, almost single-mindedly, a work of popular ethnology served by the photographic medium.

Still, the volumes have come to typify the strong effect that photography began to have on the growing interest in other peoples. Certainly the British of this period were often rabidly ethnocentric—the Empire was still expanding in the latter half of the nineteenth century—but they also possessed a high level of curiosity about the world around them. An evolving discipline, such as cultural anthropology, while making its early formative steps utilized whatever tools were at its command. That photography—with its attention to detail and seeming objectivity—could play such an active role in this field was a significant inducement to the continued growth of the medium; that it could do so with a sense of style and emotive power—as in the portrait of the Bukiyanas—was an additional testament to the skills of its practitioners.

Richard Leach Maddox (1816–1902).
Stauroneis acuta. ca. 1860.
Albumen print. 7.6 × 7.3 cm.

Save to a select few, the worlds seen through the microscope were as unknown as those viewed through the telescope. Until the photograph had been adapted to these instruments, neither the reality nor the validity of their observed worlds could be shared with the average person. Photography made such realms more accessible and a little less arcane.

Richard Leach Maddox and other similar scientists did more than isolate and record such unseen vistas. They also worked to perfect the problems of magnification, light intensity, and sensitivity which made the recordings possible in the first place. In the process they provided the world with new qualities of visual experience. Photomicrographs introduced new forms and lines from the natural order, capable of both scientific enlightenment and popular fascination. With their ambiguous scale, alien shapes, and technical names, they represented a fascinating disorder beyond the usual nature of human experience.

Stauroneis acuta.

PHOTO. DR. MADDOX.
Published by JAMES HOW, Successor to G. KNIGHT & SONS,
2, Foster Lane, London.

[r. t. over.

Victor Albert Prout.

Kew Bridge. ca. 1860.
Published in *The Thames from London to Oxford in Forty Photographs*.
Albumen print. 11.3 × 28.5 cm.

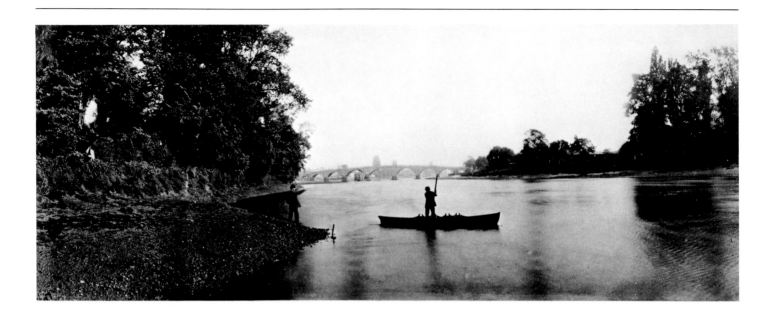

The panoramic format has proven intensely attractive to photographers since the early days of the daguerreotype process. The possibility of elongating the image—generally in a horizontal presentation and usually along the horizon line—has long been a seductive variant to our traditional frame orientations.

Victor Albert Prout chose to explore the run of the Thames over its most popular distance, from Oxford to London, to investigate the relationship of the river to the land and the people who inhabited it. Although this was not an original idea, the decision to apply the panoramic camera to the project was, and the results are often very stimulating.

In part this was due to the nature of the panoramic camera—a scanning mechanism which exposed progressive sections of the film plane along a 120°–180° arc over a number of seconds (subject, of course, to relevant exposure conditions). As a result, each image became a function not only of the artist's personal conception but also of the vagaries of space and time throughout the course of the exposure. The wind in the trees, the boats on the river, the texture of the water, the positions of the people—all became variables to challenge the final composition of the artist. Prout met the challenge of this ruthless horizon, utilizing all the visual elements and their unpredictable conditions to add a delicate, dramatic feel to the world of the river.

Unidentified photographer.
Road Repairers near London Bridge Station. ca. 1860.
Ambrotype. 20.3 × 25.3 cm.

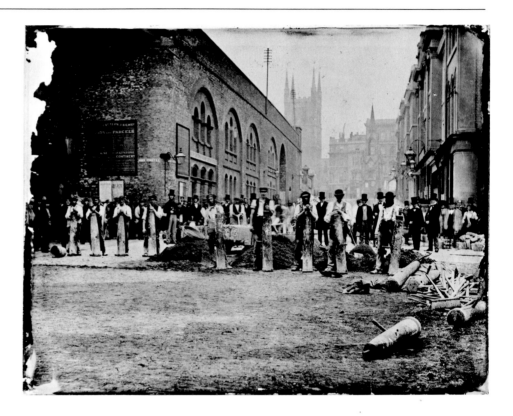

The city became the primary stage upon which life evolved and was played out during these decades. As such it began to attract more and more photographers for many different reasons.

With the growth of the photographic medium, the events of daily life began to acquire added significance. Any subject matter which seemed to exceed the norm of the tenor of everyday existence gained interest in the eye of the photographer. Likewise, urban dwellers became more visually attuned to the city around them and particularly to the expressive and documentary powers of the photograph within that world.

The motivating factor behind this whole-plate ambrotype may have originated with the photographer or with a specific client. No real clue exists apart from whatever we choose to read or interpret from the image itself. What does underlie either possible motivation is the growing awareness that, as cities grew, so did the complexities and nuances of life within them. The photographer has isolated a moment out of London's vast panorama of daily activity; the experience is perpetuated for our possible edification, to give us the chance to encounter that moment again. We cannot share the original photographer's or viewer's experience—those have been altered by time and the process of living, not to mention the uniqueness of their individual personalities—but we have the opportunity to learn or feel more through this evidence of their commitment.

James Mudd.
The Inundation at Sheffield. 1864.
Albumen print. 25.7 × 37.4 cm.

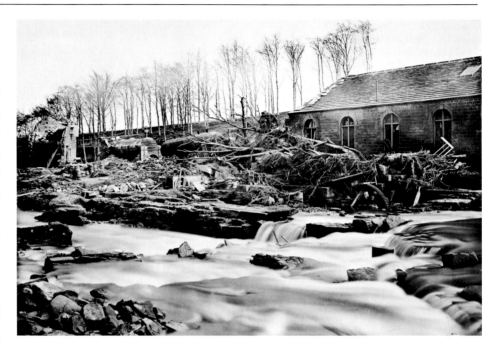

From Fenton's views in the Crimea to the near end of the nineteenth century, there is a marked passivity to the early photo-journalistic image. Newsworthy events and natural disasters were usually documented after the fact and then usually in the only commercially viable format for such images, the stereograph. There are many reasons for the paucity of good news photography: the absence of any major photographically illustrated picture press until the rise of the halftone in the 1890s; the lack of any sort of practical national market for such images; technical problems such as film sensitivity and camera portability which restricted the photographer's flexibility and a general philosophical attitude which held that hardships and disasters were meant to be endured and overcome rather than reviewed or dwelt upon.

Therefore, in terms of their photohistorical significance, James Mudd's mammoth prints of the aftermath of the Sheffield flood of 1864 are generally anomalous to the standard photographic practices of the day. Utilizing a large-format camera and subsequent contact print sizes, he gave epic proportions, once reserved for landscapes and architecture, to scenes of the inundation's destruction. Subjects previously associated only with the stereo camera's reportorial approach were given an added presence, as well as an additional historic impact which is perhaps, in retrospect, far out of proportion to their actual importance.

Mudd's strikingly composed and well-printed photographs record the scenes and details with an immediacy and impact that still communicate to modern day viewers. In addition, Mudd's interpretations possess a strange, unsettling beauty. It is as if he had witnessed and interpreted a new order imposed by nature upon vaguely familiar scenes from daily life. Regardless of Mudd's final intentions for the sale or distribution of his works, we must be grateful for his initiative in promoting a different nuance to established patterns of photographic vision.

Unidentified photographer.
East Hill. Colchester. ca. 1860.
Albumen print. 14.3 cm. diameter.

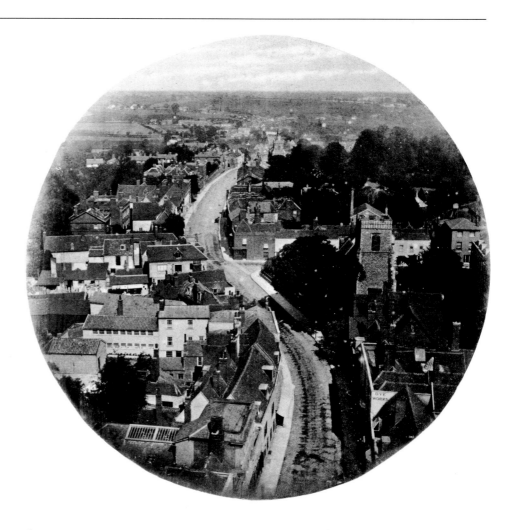

The question of vantage point has always concerned the photographer. Among the many difficulties Francis Frith encountered in his travels was his eternal quest for the correct "photographic fulcrum" for each scene: that ideal position at which the camera could be placed to match the photographer's vision. With every degree of change in camera placement, scale, perspective, relationships, and values are also subject to changes. Thus, the mere positioning of the camera is capable of revealing much about the photographer and his or her vision.

By raising the level of the camera to an aerial perspective, the unidentified photographer of this view of Colchester altered the previously existing conceptions of an audience which had been shaped by more traditional topographic views. The land and the buildings are viewed in a previously inaccessible manner, and the viewers' preconceptions of and relationships with the town will naturally be altered. As the camera continued its movement skyward, nuances in style and technique further enhanced the entire visual process.

Archibald Burns.
"Bit" in Bull's Close, Cowgate. 1868.
Published in Burns, *Picturesque "Bits" of Old Edinburgh.*
Albumen print. 10.3 × 8.4 cm.

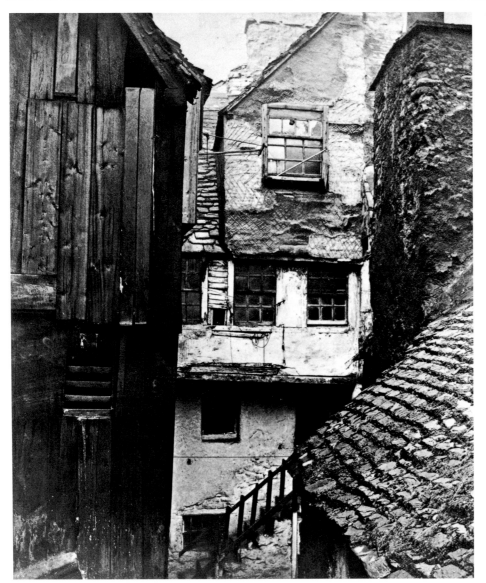

The growth of the middle class and the increasing urbanization of British society throughout these decades led to proportionate increases in the number and variety of images of the city produced by photographers. The majority of these were topographical renderings, composed by commercial artists like G. W. Wilson or James Valentine and designed to depict buildings and street scenes under the most optimal conditions of representation. The city could be reduced to a series of fine edifices and significant sites, less concerned with artistic or documentary expression than with preserving idealized views with maximum marketability.

The growing British cities were more than this, however. As centers of increased levels of economic and social activity, they began to reflect the spirit of change that was affecting the Empire. They formed the backdrop and subject matter for photographers with richer stories to tell and greater details to reveal.

For Archibald Burns the city of Edinburgh was a rich visual and cultural experience, as his book of picturesque "bits" would show. The photographic "bits" depicted in his fifteen prints ranged from rather mundane records of memorials to complex visual studies. His bit in Bull's Close has an almost modern, abstractionist flavor. Although designed originally to show old architectural details, its complex array of forms, lines, and textures produces its own statement independent of his original subject matter.

Thomas Annan (1829–1887).
Close No. 18, Saltmarket. ca. 1873.
Published in Annan, *Photographs of Old Closes, Streets, &c.*
Carbon print. 28.2 × 23.0 cm.

A more straightforward documentary intent is provided by Thomas Annan in the work he did for a different Scottish city, Glasgow, during the 1860s and 1870s. Annan, working for the City Improvement Trust, recorded the streets and back alleys of those sections of Old Glasgow which were due to be torn down for civic improvements. In contrast with Burns' rather delicate "bits," Annan's large carbon prints with their somber dark tones and rather severe lines possess a tangible feel of silence and oppression. Like the quiet that precedes the storm, his vistas of Glasgow's compact buildings and narrow passageways stand awaiting the inevitable leveling that is to come.

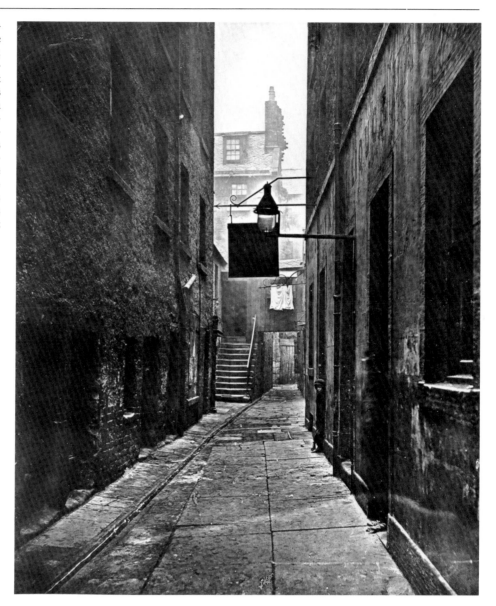

Henry (d. 1893) **and T. J. Dixon.**
Churchyard of St. Lawrence Pountney. 1879.
Published in *Society for Photographic Relics of Old London*.
Carbon print. 21.9 × 17.8 cm.

Henry and T. J. Dixon, father and son, were one of two teams of photographers hired by Arthur Marks' Society for Photographic Relics of Old London. Working during the 1870s and 1880s, they sought to preserve in photographs those edifices and historic sites which Marks felt would soon be gone or altered by the daily changes throughout the city. Despite the rather strong documentary aspect to this project, the Dixons were able to add a marked degree of personal expression to the works they produced over the years for this undertaking. Their "Churchyard of St. Lawrence Pountney" is just such a piece: less a factual recording of graves and grounds and more an expression of the beauty and style to be found in even the humblest sections of the city. It is a statement of strength and faith in the past generations which will outlast all changes and improvements of more modern times.

Francis Frith (1822–1898).
Ripon Minster; Chapter House. ca. 1870.
Albumen print. 18.8 × 28.8 cm.

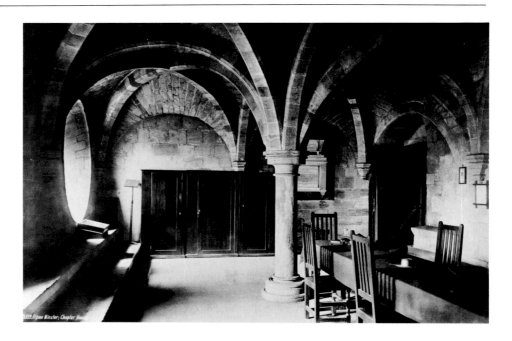

The religious revival of the nineteenth century also served to strengthen an interest in the medieval period of British history. Among the populace this meant a growing interest in reappraising and re-evaluating everything from archaeology to Gothic architecture. Among painters and sculptors it marked a Romantic movement which sought to suspend time and place with a carefully considered creation of mood. And it was also this search for mood, this feel for the sublime, which began to infuse itself gradually into the works of amateur and professional photographers alike.

Like other commercial artists, Francis Frith was certainly aware of what sort of subjects and moods influenced his prospective buyers. Throughout his travels, therefore, he sought out the medieval buildings and ruins of British history and attempted to capture them in subtle, timeless moods. Because of the recording objectivity of the camera lens, he was not always successful—the present had too many ways of infusing itself into any record of the past—but his efforts were often equal to those of most artists and engravers of the day.

Frith applied this attitude to many of his domestic views, including this interior of a chapter house. Interiors were always a challenge to photographers of this period, especially since little existed at this time in the way of practical artificial light sources. Frith relied upon his long expertise with both the wet collodion negative and the albumen printing process to record the room using only the available light sources. The result is a harmonious composition of lines and tones, aglow with a lively light that few were capable of capturing.

London Stereoscopic and Photographic Co, Ltd. (active ca. 1850–ca. 1921).
St. Mary-Le-Bow, Cheapside. ca. 1867.
Albumen print. 20.8 × 13.3 cm.

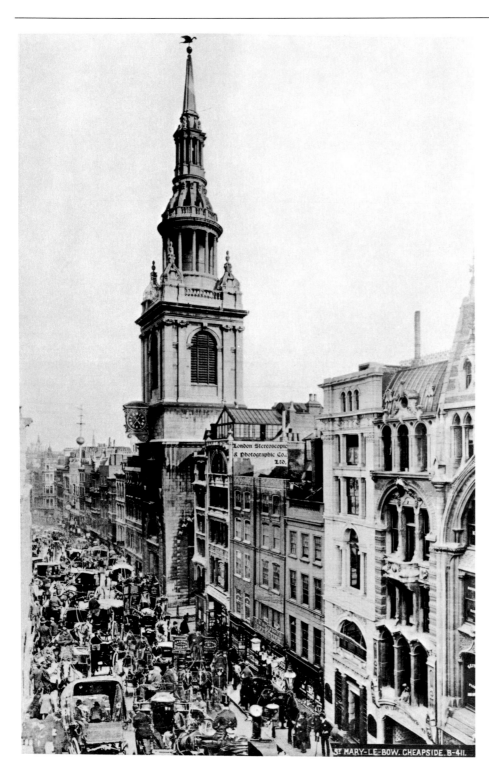

With its sense of immediacy and its false sense of objectivity, the photograph has always been an effective tool for advertising and promotion. Since the early days of the daguerreotype, camera-generated images have been used to illustrate products and promote services for a variety of businesses and enterprising individuals. However, as salesmanship began to exceed the direct, illustrative power of the medium, it was not unusual to find increased levels of creativity being brought to bear upon the photograph.

In order to promote their Cheapside studio, the London Stereoscopic and Photographic Company produced an image of the commercial block in St. Mary-Le-Bow which housed businesses. Stylistically it is, at first glance, indistinguishable from countless other London street scenes put out by the company or by such rivals as G. W. Wilson or James Valentine. Closer inspection reveals, however, that the image contains a good deal of manipulation. To begin with, the company name has been set in type, photographed, and stripped in to the original glass plate negative, to make it appear that the building housing the firm carries a large sign on its rooftop studios. In addition, the street itself, probably a blur of motion and "ghosts" in the original exposure, has been altered substantially. A collage of period street figures, taken from a variety of other photographs, was added to the source print, rephotographed, and then reprinted in this final version.

As a result, St. Mary-Le-Bow becomes a commercial artery awash in daily traffic, a hub of major activity over which rise the offices, studios, and gallery of the London Stereoscopic and Photographic Company. The reality of the photographic image has been enhanced and extended in order to further serve its creator's economic as well as creative demands.

E. Coke.
Ernest Doyle. 1856.
Albumen print. 10.1 × 13.1 cm.

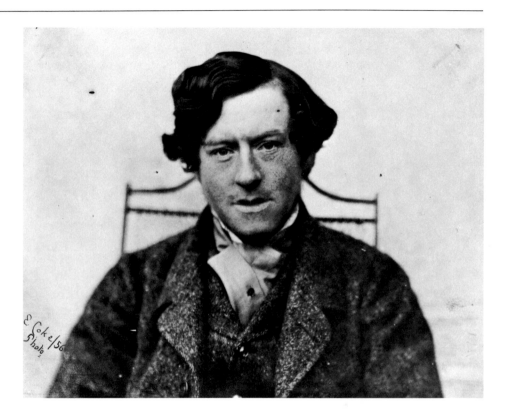

In our age of instant image generation and videographic revolution, it is easy to lose sight of the complexities which amateurs faced in producing photographs during the medium's early years. The negative-production processes of the wet plate era were complex and messy, the exposures far from instantaneous, and the resulting prints less than naturalistic in their final impact upon the viewer. Thus, when a photograph is capable of breaking the rules and rising with the artist's vision above the technical limitations of the medium's chemistry, we should pause and consider its questions.

There is no information about E. Coke or his subject, Ernest Doyle, accompanying this photograph. There is nothing in existing photographic literature that gives us any firm insight into Coke or his work. Within the photograph itself there are very few details about Doyle which can shed much light upon the man and his life. On the surface the image remains a rather abrupt direct portrait snatched out of time.

That it is more than this is due to photography's subtlety and power. Perhaps it is the photograph's frame (cropped in a ratio nearly proportionate to modern 35mm formats), which produces a symmetry and balance for the subject's face. Certainly the spartan light background and the ascending lines of the chair's back also force us to focus upon Doyle's countenance. Undoubtedly, the limited depth of field also influences our sense of proportion. But most significantly, it is the near instantaneous quality of expression which arrests our eye; Doyle is depicted candidly and directly in effortless relationship with Coke and with future generations of viewers.

Charles Lutwidge Dodgson (Lewis Carroll) (1832–1898).
Chess Game. ca. 1858.
Albumen print. 13.7 × 16.7 cm.

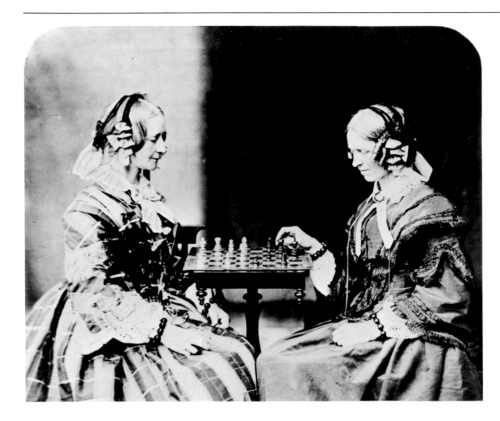

Products of love, intelligence, and wit, the photographs of Lewis Carroll continue to tantalize and move us—in the same way many of his writings still do. Although the retiring clergyman/teacher did not consider himself to be any more than an amateur practitioner, his camera imagery remains unique: charged with a strong personal style, yet imbued with a degree of sensitivity that approaches a near universal humanity.

His image of two aunts playing chess revives that studied subject so dear to Talbot and dozens of other amateurs from the early decades of this period. On the one hand it is a simple record of two figures in a familiar, intimate relationship—handled with more faithfulness than most, perhaps, but still direct in its initial approach. A closer viewing, however, reveals great depth and complexity to the work. The aunts, for example, despite their rather symmetrical placement, are far more than mirror images. They provide a contrast of dark and light, a juxtaposition which is carried out, in alternating patterns, through all the graphic elements, from the backgrounds to the chess pieces themselves.

Perhaps Carroll's greatest talent lay in his ability to combine his subjects in such effective visual forms. On a primary, intuitive level no photographer seems to have understood so well both the directness and the complexity which the medium was capable of combining.

Unidentified photographer.

One-eyed Gentleman. ca. 1860.
Ambrotype; with hand-coloring. 11.0 × 8.2 cm.

The ambrotype, like its predecessor, the daguerreotype, is a unique image, produced in camera and typically presented in a case with cover glass and metallic frame. Also like the daguerreotype, its primary application, due to its technical complexity, was in studio portraiture.

In reality an underexposed wet collodion negative, the ambrotype was produced by applying a black coating to the non-emulsion side of the glass negative. The resulting "positive" image could then be placed in a protective enclosure and sold to the sitter.

The daguerreotype with its highly reflective, mirror-like surface, did not invite the eye to closer inspection; rather, as more than one contemporary critic noted, the portraits of one's friends glared back at one. The ambrotype on the other hand did invite inspection. The width of glass between the emulsion and the backing gave the image an added depth that under the correct lights provided a subtle relief effect to the work. This, combined with the process's rich tonality and affinity for detail, made the ambrotype an important successor in cased photography.

The artist who made this particular ambrotype handled the technical and aesthetic problems quite professionally. In view of the apparent objectivity of the lens and the process's ability to record details accurately, it was a difficult test to handle the sitter's disfigurement in one eye. It is significant that the portraitist did not opt for a simple profile but, instead, chose to pose the subject in the more traditional three-quarter seated position. The disfigurement is masked by the superb lighting, the lighter-toned hat and suit, the dark backdrop, the hand-coloring, and even the vase and small table, which provide a further magnet for the viewer's attention. Perhaps this simple commercial portrait represents the ideal powers of the camera lens: to objectify and idealize simultaneously.

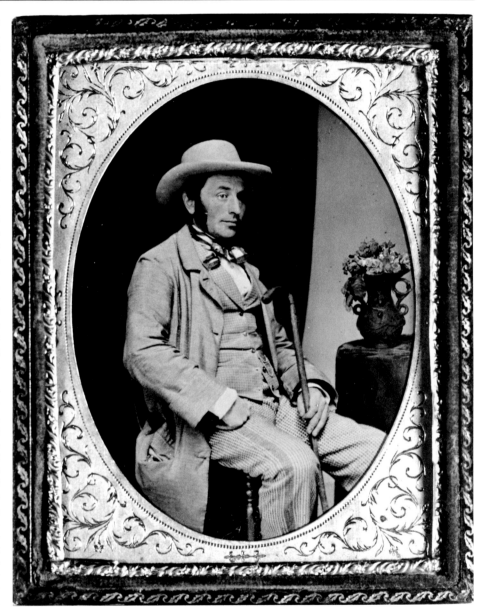

New trends in photography seemed to capture the public's fancy at almost regular intervals during these early decades. The initial enthusiasm of the daguerreotype portrait of the early 1840s and the massive popularity of the stereograph in the early 1850s were followed by the fad of the carte-de-visite in the 1860s. These small portraits, of a standardized size and often of a traditional style of studio portraiture, proved to be immensely popular with the general public and led to annual sales of hundreds of thousands of the cartes. They also generated a not inconsequential support industry of associated materials ranging from the traditional carte albums to a variety of support objects such as frames, cards, portfolios, ladies' fans, etc.

The genesis of the carte-de-visite remains a matter of some debate—perhaps, in a larger sense, its derivation goes back to the British and European fascination of previous centuries with silhouettes and hand-painted miniatures. There is, however, little disagreement concerning J. J. E. Mayall's major role as an early practitioner and popularizer of the format. An American-born daguerreotypist who remained in commercial portrait photography throughout his career, Mayall obtained a series of sittings with members of the Royal Family in July 1860. The resulting carte-de-visite portraits, available both individually and in a very successful "Royal Album," were a popular, critical, and financial success for the photographer and his studio. Mayall read his public well and continued to use advertising and the printed media to promote his operation throughout the era of the carte's successor, the cabinet print. He also profited from various technical innovations and competitive salesmanship. He was one of the most successful photographers of his day.

Mayall also pioneered the style for many of the hundreds of carte photographers to follow; his formalized poses were copied by many of his competitors. As a result there is little to distinguish his work from that of the vast majority of carte makers of the day. His photographs of Queen Victoria and her family are worthy of additional notice, not so much for their style as for their in-

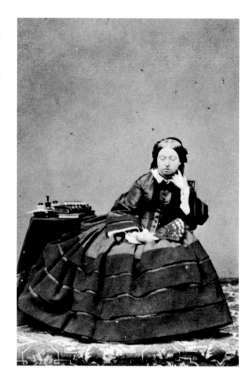

timacy. The Queen, her children, even the somewhat somber Prince Consort—all adopted a proper but less ritualized stance for Mayall's camera.

Perhaps this was why Mayall's royal portraits were so well received by the British public. The Queen could retain her position, authority, and popularity while being recorded pensively seated in the lower half of a frame; British royalty could retain both its dignity and its humanity in front of the camera's eye. Mayall's simple cartes seem to embody much of the democratization that was occurring throughout both the world and the photographic medium at this time.

Camille Silvy (b. 1835).
Multiple Portraits of John Leech. ca. 1860.
Albumen print. 14.4 × 22.2 cm.

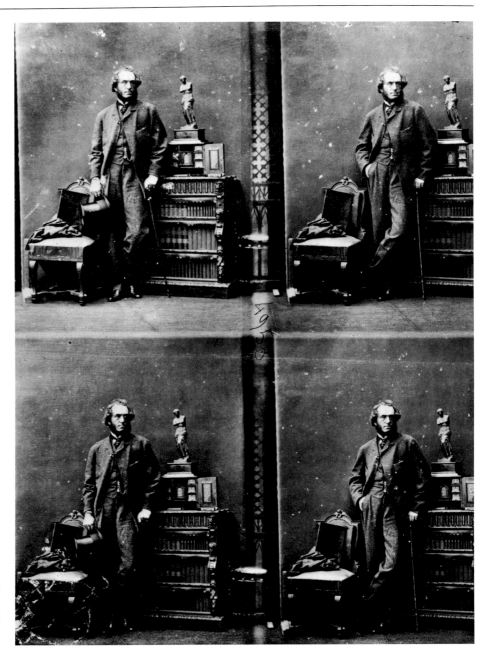

Camille Silvy, a French aristocrat and diplomat, chose to begin a professional photographic career in London in 1859. He became a portraitist who specialized in the carte-de-visite format, and by the early 1860s his studio had become one of the most successful in all of Britain. He attracted the elite of the English aristocracy with his excellent facilities, graceful compositions, and finely processed prints. Yet, though he made his mark both in British photography and in the social structure of the time, he made no major attempt to change either his formats or his business practices when the carte-de-visite lost its popularity. After little more than a decade he quit his business, eventually leaving England to renew his studio work in Paris.

There is an aristocratic style about Silvy's photography which puts him well above most carte-de-visite photographers of this time. A sense of place, a refined studio atmosphere, seems to pervade all his work: comfortable backdrops and screens, tasteful props, even a well-kept carpet. Furthermore, the subjects themselves become an active part of the overall composition, seeming to fit into the scene that Silvy has constructed. It is as if the photographer, in collaboration with his sitters, was able to recreate their world in the imaginary theater of his studio. Silvy, from first pose to final technically superb print, was a master of this magic.

This print of multiple exposures, made for the sitting of the caricaturist John Leech, is not a finished print. Rather it is a contact sheet, a study print made of four exposures on a single glass plate, as produced by the multiple lens carte-de-visite camera. While not the final work, however, it does reveal much about the technical, chemical, and aesthetic problems Silvy had to overcome in completing his composition; a knowledge of the complexities of the score can add to one's appreciation of the performance.

George Fear.
Itinerant Preacher. ca. 1870.
Carte-de-visite: albumen print. 5.7 × 9.1 cm.

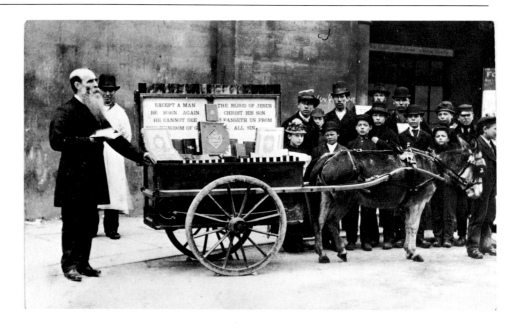

As the camera was capable of graphic depiction, so it was also capable of selective interpretation. And in no area of photography is this more readily apparent than in social documentation.

Domestic and social problems have always been a part of the complex fabric of British society. In the nineteenth century, however, the social landscape of the Briton underwent a subtle but powerful change. Attitudes began to shift away from a dispassionate, intellectual approach toward a far deeper understanding and discussion of social and economic ills. Romanticism, if not totally supplanted, was at least infused throughout with Realism, the abstract was replaced by the specific, and people began to focus upon the causes and the potential cures rather than just upon the end products of those ills. The manifestations of the process were many: from the popularity of Dickens' novels to the massive governmental reform acts of the later decades; from numerous social welfare programs to an idealization of the rustic life by the 1900s.

Photography, too, went through cycles of change during this time. By the 1870s the manifestations of this change were apparent through a wide range of images.

At first the photograph sought to isolate "street types," posing them with their trappings in a neutral setting which could range from the studio to an isolated street corner. As in the case of George Fear's carte-de-visite of an itinerant preacher, the pose was often stiff and clinical, making the subject an object for study and discussion. Even the choice of format, the carte, suggests that Fear produced his image less out of any specific social concern than with an idea of making a sale.

John Thomson (1837–1921).
Dealer in Fancy-Ware. 1876.
Published in John Thomson and Adolphe Smith, *Street Life in London*.
Woodburytype. 11.4 × 8.9 cm.

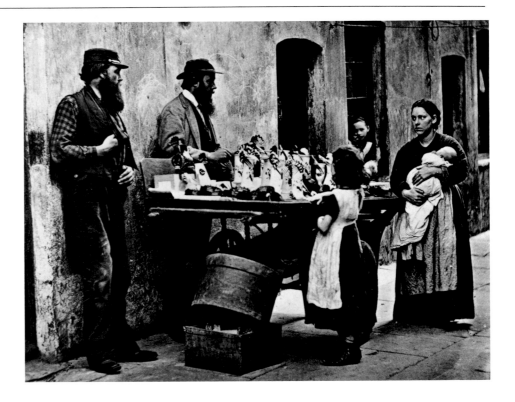

Probably some of the strongest socially oriented work of all this period was found in the series of photographs John Thomson did among the lower classes of London in 1876. Thomson captured his subjects in situ, arranged in a naturalistic manner and looking as if they were depicted instantaneously from everyday life. By keeping the people in their day-to-day context and by having them relate to each other and to their environment, he brought Realism into the documentary photograph. That he further elected to preserve his images in book form, together with supportive text, is an even stronger indication of his serious commitment to his subjects and his art. He chose to investigate, report, and illustrate, thereby aiming at a deeper understanding of his camera's subjects and the conditions that affect them. One need only study his subjects' faces or look at the way they hold themselves and interact with their surroundings to achieve some sense of the degree of his compassion.

James Valentine (1815–1880).
Peat Cutting, Hoy. ca. 1878.
Albumen print. 13.4 × 20.3 cm.

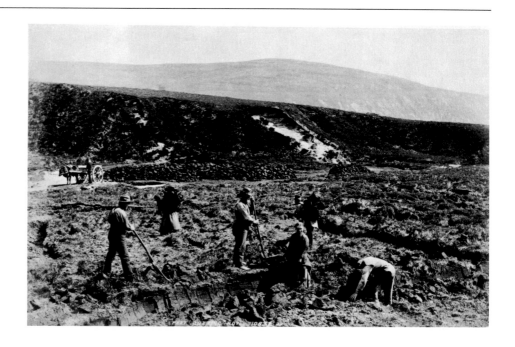

James Valentine's study of peat cutters predates the rise of Naturalism, the pre-eminent visionary movement that was championed in the following decade by Peter Henry Emerson. With its strong lines, sharp textures, and use of figures in the lower portions of the picture plane, his photograph is highly reminiscent of the landscape paintings of Constable and other Romantics. On the other hand, although it does relegate its human figures to being components within the landscape, it also focuses upon these individuals engaged in their own specific activity. With Emerson this dichotomy would become much more refined; with Valentine it remains rather single-minded in its attitude and production. In one sense Valentine, a commercial photographer, harkens back to Fear's implied isolation. In another, Valentine's attitude to humanity and nature is almost Millet-like, at least in its sensibility if not its execution.

Charles Lutwidge Dodgson (Lewis Carroll) (1832–1898).
Xie Kitchin, Reclining with Parasol. ca. 1873.
Albumen print. 12.8 × 15.6 cm.

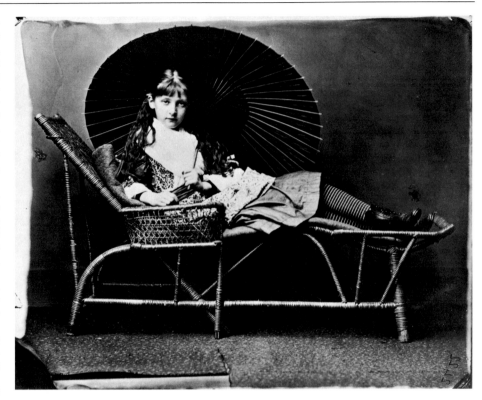

With respect to Lewis Carroll's photographs, many seem unable or unwilling to look beyond their psycho-sexual inferences. Writers and analysts of our post-Freudian age seem determined to dissect his portraits of young girls for every type of nuance reflecting aberrant psychological behavior—both in the artist himself and in the age during which he flourished. Indeed, in both his images and his writings Carroll revealed much of his repressed soul in addition to his intelligence, sensitivity, and grace.

We cannot deny the existence of such subliminal levels; then as now they were all too obvious. Indeed, Carroll himself was too well aware of his own feelings and of the mores of the day—he wrote often of the "Mrs. Grundys" and their influence upon social behavior. He remained, nonetheless, honest and open with his young friends and their parents, carefully scheduling his portrait sessions with them and sharing his works with the children and their families. All his imagery, ranging from the portraits of celebrated people to the few nude portraits of children, was treated with the same direct honesty and practical concern.

As with his writings, the photographs of Lewis Carroll are not the product of a naïve, amateur practitioner. Largely self-taught but passionately devoted to the medium for two and a half decades, he combined practical skills with an intuitive eye. The majority of his existing prints show his incredible talent—a talent which made him one of the foremost portraitists of the age.

Finally, it is important to note that his portraits possess a level of emotional purity beyond most others from the Victorian Age. Except for the issuance of a few of his portraits of famous individuals by major card companies, Carroll's portraits were by and large intended only for himself and his subjects or their families. As such they reflect both the sincerity of his intent and the honesty of his vision. The portrait of Alexandra "Xie" Kitchin, one of his favorite subjects, demonstrates an innovative sense of balance and design that is doubly complemented by the artist's care for his subject and his true understanding of the potentialities of the photograph. Few photographers of any age have possessed such purity of heart and eye.

W. Currey.

William Gladstone, Resting from Chopping Wood. Hawarden. 1877.
Cabinet card: carbon print. 14.0 × 9.4 cm.

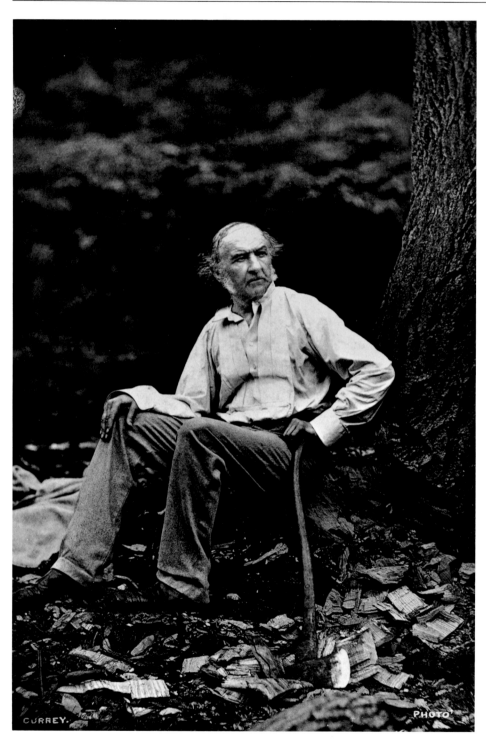

Currey's portrait of William Ewart Gladstone is unconventional in both its style and its application. Certainly, it goes directly against the traditional approach to commercial portraiture of famous people—an approach cemented by decades of formal studio arrangements and near-standardized styles of posing. The majority of individuals who became the subjects of such commercial cards were photographed for a definite reason—they were in the public eye and, with the possible exception of some stage personalities (whose temperaments have always tended to allow for a degree of abnormal behavior), provided a marketable image of themselves, conservative in their life styles and in harmony with the accepted norms of society.

Thus, the portrait of a shirtsleeved, informal Prime Minister, resting after the labors of wood-chopping, seems less a portrait than a document of a public figure. We also know, however, that Gladstone was an astute politician, often conscious of his public image. The Currey photograph, therefore, may have implications beyond its seeming documentary intent. Gladstone may have contrived and must have approved of the mass production of the photograph. The image of this most senior of government officials not averse to daily labor undoubtedly struck a chord with the values of industry and good works so prevalent among the majority of his constituents. It seems that the Prime Minister was among the earliest of the camera's subjects to calculate and utilize the immediate, persuasive power of the photographic medium.

Julia Margaret Cameron (1815–1879).
May Prinsep. ca. 1870.
Albumen print. 34.9 × 27.4 cm.

There is something almost universally appealing about the works of Julia Margaret Cameron, a pervasive, living force which makes them overcome all the technical and aesthetic imperfections that they are heir to. Cameron, very much a member of the upper middle class in Britain, took up photography at the age of forty-eight and pursued it for little more than a decade and a half. Possessed of both an indomitable spirit and a unique photographic vision, she also permitted herself to be influenced by certain painters, especially David Wilkie Wynfield and her friend G. F. Watts.

Thus, the subject matter of her photographs ranged from startling portraits treated almost as close-ups to genre scenes imitating Pre-Raphaelite paintings and drawings or illustrating scenes from great literature. Such variety in a brief career span has presented problems to many photographers, but Cameron appeared to embrace all her subjects with equal intensity of purpose and clarity of vision.

The near full-length portrait of May Prinsep is a clear example of this passionate talent. There are a variety of reasons why the print should not work: the cropping of the figure, an awkward pose, an uncomfortable placement of the hand and arm, a non-planar background, even incorrect processing of the original plate. Instead, however, these parts contribute to a strong but subtle wholeness typical of Cameron's images. For example, the dominating shapes and textures of the dress and the intruding backdrop add a comfortable motion to the entire work. The lines of the body and hands, though following no classic placement, all conspire to work with the tones of the print to bring our eyes back again and again to the serene face and its uncompromising stare. In witnessing how grace and fluidity overcome such potential stylistic hazards, it becomes possible for us to experience Cameron's heartfelt fascination with photography.

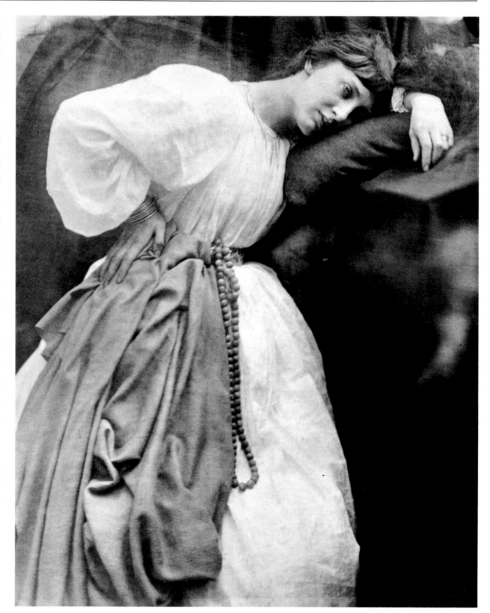

Julia Margaret Cameron (1815–1879).
Summer Days. ca. 1865.
Albumen print. 35.2 × 27.7 cm.

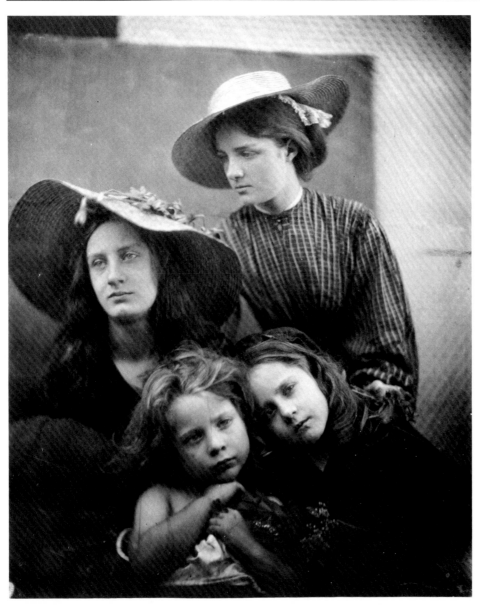

Unlike the commercial portrait studio of the day, which was used to reflect a comfortably nebulous environment for its wide variety of clientele, Cameron's "glass house" was a new canvas upon which each image could be composed afresh. It became at times an inky void from which noble heads like Carlyle's or Tennyson's could emerge from a beam of light. In other instances it was an indistinct whirl of cloth and draperies, often echoing forms or lending substance to the figures. Finally, it also served as a small stage upon which could be arranged props and backdrops to add a small nod to reality in several of her literary or thematic productions.

By its very title "Summer Days" seems to want to will away its studio environment. This pastoral grouping of three girls and a boy with similar calm expressions seems to beg for an outdoor setting, such as Lyddell Sawyer would have found or H. P. Robinson might have manufactured in his own studio. One wonders if, by way of some aesthetic compromise, Cameron originally planned to crop the top and right side of the print, thereby isolating her pensive subjects in the neutral, amorphous background.

For whatever reason, she chose not to do it, and the resulting final photograph is a masterfully complex image. The three rectilinear zones of the background, with their different tones and textures, form a striking contrast to the organic massing of her sitters. The four subjects' faces—at once serene and perhaps a little bored by the long exposure time—all lean to the left of perpendicular, setting up a very subtle tension with the light background. Heads, hats, clothing, arms—all defy the rigid right angles which seek to frame the group in the traditional conformity of the commercial studio.

Oscar Gustave Rejlander (1813–1875).
Head: An Artist's Study. ca. 1861.
Albumen print. 21.5 × 16.2 cm.

The associations between O. G. Rejlander's photographs and classical painting are scrupulously derivative and often direct in the most straightforward manner. This is not a surprising revelation, especially when we consider the fact that the photographer studied fine art in Rome and worked as a painter in England for nearly a decade before he opened a photographic portrait studio. Despite the diversity of subject matter which evolved throughout his twenty years as a professional photographer, the roots of the trained painter are honest and secure throughout his works.

Thus, this artist's study of a model's head, while suggesting both assurance and serenity through the camera's eye, is strongly reminiscent of both the classical bust and one of Corot's Italian studies. The immediacy of Rejlander's lens did not provide him with such effective and strong work every time—a number of his works are too reminiscent of costumed models posed inanimately in hushed studios—but, as his best works often proved, these dichotomous disciplines were capable of maintaining a presence all their own.

Rejlander's studies and genre pieces served to influence scores of photographers from H. P. Robinson onward. His works, although bound to the classical traditions of the past and the allied Victorian sentiments of the day, often possess a liveliness of gesture and expression which are his own unique signature. It has always seemed significant and appropriate that Charles Darwin selected Rejlander to illustrate his seminal book *The Expression of the Emotions in Man and Animals*—that the scientist could recognize in the work of this artist that singular quality of life experience which intrigued them both so very much.

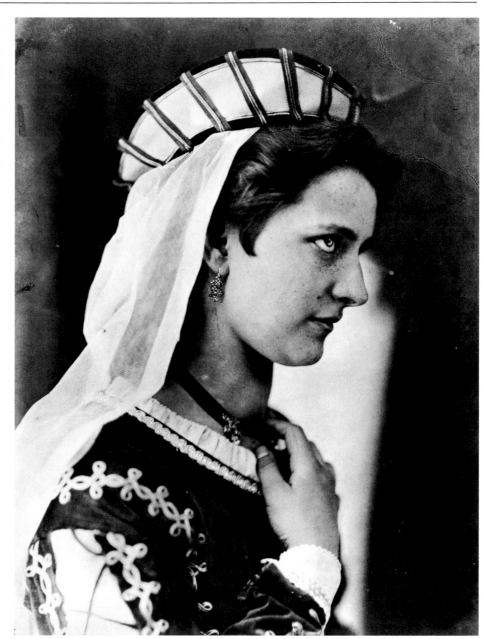

Henry Peach Robinson (1830–1901).
When Day's Work Is Done. ca. 1876.
Platinotype. 54.4 × 74.8 cm.

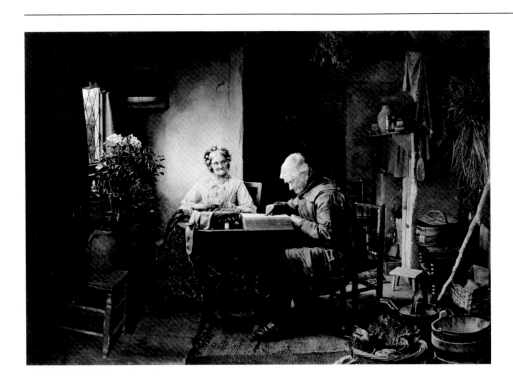

The standard bearer for British fine art photography in the latter half of the nineteenth century was Henry Peach Robinson. His composite photographs—derivative of both Rejlander's classical allusions and the paintings of any number of members of the Royal Academy—were simple in their genesis and deceptively complex in their execution. As Andrew Pringle pointed out in his essay on Robinson in *Sun Artists*: "... he has at least endeavored to do something more than portray facts; he has always displayed intention and left something for imagination—he has, in short, aimed at art."

"When Day's Work Is Done" is one of his most important and best known compositions, a fusion of technical expertise and serious ideals which was a hallmark for many of his masterworks. It reflects Robinson's basic tenet that the commonplace not

only provided the richest subject matter but also provided the greatest challenge to the photographer's basic skills. A work of theme and sentiment rather than documentation, the final photograph is a composite print made up of different photographs of models and studio arrangements, all combined, retouched, and reprinted to provide both the possible illusion of a single exposure and the practical evolution of a single idea. If Robinson's allegorical stance is unfettered by equivalent complexities, it is less a function of the artist than it is a consideration of the audiences and professional peers he sought to reach.

To view Robinson's work today is to see it with eyes and hearts and minds transformed by nearly a century's worth of newer technical innovations, attitudes, and human experience. In permitting ourselves to be blinded by the theatricality of his

compositions or the overt prosaicness of their themes, we forget that no photographer came closer to achieving both the artistic scale and the aesthetic attitudes of the many painters and printmakers of this time. George Bernard Shaw once observed that Oscar Wilde's play *An Ideal Husband* had "the property of making his critics dull" because while everyone could fault some point or idea, no one could compose what Wilde had put together. Likewise, Robinson remains the thorough photographer, an individual capable of raising the everyday to universal proportions through the near magical combination of his technical virtuosity, his considered philosophy, and, most certainly, the sheer persistence of his will.

Lady Charlotte Milles (1835–1927).
Collage. ca. 1868.
Albumen prints; with ink and watercolor. 22.9 × 21.2 cm.

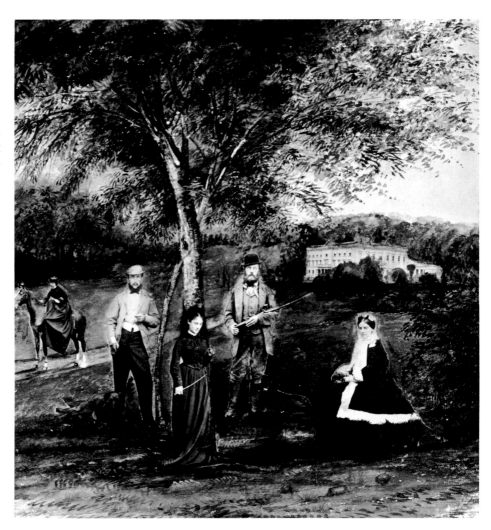

The earliest combinations of the photographic image with other media appear to have been done for either private or commercial reasons rather than to explore the aesthetic relationships between various technical processes. Throughout most of these early decades photography struggled for its own sense of identity among the fine arts, and few of its practitioners had either the economic or the professional inclination to diffuse the properties of the still young medium. Experimentation, innovation, and discussion followed the parameters of photographic chemistry and technique, with hand-applied arts being employed almost exclusively to such commercially advantageous procedures as retouching or hand-coloring. Thus we must look among the amateurs of the Victorian era to find the advocates of mixed media with photography.

Among this number is Lady Charlotte Milles, wife of the Earl of Sondes. When she married and moved into the family estate, Lees Court, in 1859, she became an active member of the landed gentry in the Kent countryside. During the first decade or so of her new life she also began working on composite prints. Beginning with the traditional graphic arts media customary for refined women of the upper class—the pencil and water colors—Lady Milles began incorporating photographs into her work. The photographs were either amateur prints or dismounted carte-de-visite portraits (undoubtedly acquired from family members and friends) which were adhered to the board before final hand work was done.

Nearly two dozen of the composite pieces by Lady Milles are known to exist. They display a distinctly primitive technique in terms of their brush work and use of color, although it is also readily apparent that her eye was remarkably sensitive to such characteristics as balance and perspective. The small albumen portraits are placed with economy and care, although many of them look incongruous floating in seas of water colors. In spite of their aesthetic shortcomings, the plates reveal much about another time and place and the people and events which the artist held most dear. Like much outstanding naïve art, they possess a natural emotivity which compensates for much of their ingenuousness.

Gilbert Venables.
Basildon Ferry. ca. 1862.
Albumen print. 10.1 × 13.1 cm.

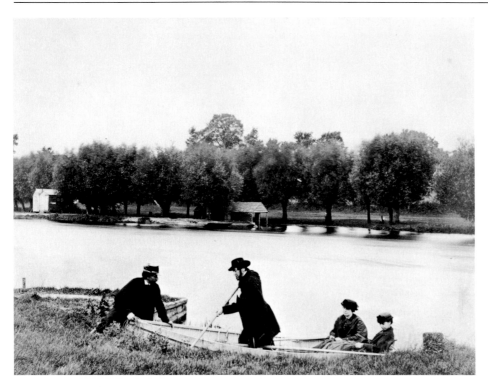

As there were degrees to the level of professionalism among photographers, so too does there seem to have been a wide variety of imagery produced within the broad spectrum of work labeled "amateur photography." As vague as the term "amateur" may be, it has generally been applied to those image-makers who did not rely upon photography as their predominant or exclusive means of support. Although the influx of photographers into the amateur field had not yet reached the high levels of the following decades, the 1860s witnessed the establishment of accepted processes and the growth of a practical economic base for a photographic industry among nonprofessionals.

On its seemingly least complicated level, amateur photography developed a "snapshot aesthetic"—an approach evolved from the experience of immediacy provided by the faster lens, greater film sensitivity, and relatively instantaneous nature of the exposure. As John A. Kouwenhoven has so ably pointed out in *Half a Truth Is Better than None*, snapshots "best exemplify the basic distinction between painting and photography," since the former implies a large degree of selectivity, cost, and labor, while snapshots are easier, less expensive, and much more plentiful. The Gilbert Venables photograph—part of a series he produced on a tour of the Thames countryside with family and friends—typifies this nuance of amateur photography. Its subject matter is basically personal and intimate, it possesses a sense of immediacy, and its informal structure and design imply a totally nontraditional approach to image-making. The print possesses a highly personalized, mnemonic function aside from any overt aesthetic purpose.

Robert Tucker Pain.
Labourers at Rest. ca. 1865.
Albumen print. 15.3 × 20.5 cm.

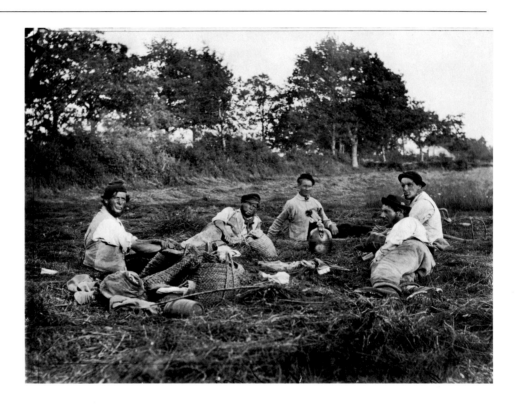

In contrast, Robert Tucker Pain's image of laborers relaxing is an obvious composition, an arrangement made in conscious imitation of the Romantic pastoral painters of the period. It comes as little surprise to learn that Pain was a minor landscape painter active in London in the 1860s and 1870s. His image typifies that of many amateurs of the day who tried to employ the camera in pale imitation of the subjects and schools prevalent in other fine arts of the period. The resulting work, while it may have satisfied the aesthetic curiosity of some amateurs or provided good study prints for artists like Pain, did not stretch the bounds of a photographic aesthetic; at best they left us with pleasing renditions of the everyday and the picturesque.

Alfred Pumphrey.
The Swallow Falls, Bettws-y-Coed, 357. ca. 1866.
Collotype. 11.8 × 16.9 cm.

The Swallow Falls, Bettws-y-Coed 35

At the other end of this spectrum stood the passionate amateurs, the photographers who knew the qualities and limitations of their materials, their apparatus, and their own vision. Within these parameters a devoted amateur might learn the photographic art: exposure, framing, tonality, texture, contrast, harmony, the balance of line and light. It is readily apparent in the eye of such an individual as Alfred Pumphrey, his "Swallow Falls" extending far beyond any straight documentation of topography and becoming a fanciful juxtaposition of the rhythms of nature. It comes as little surprise to learn that Pumphrey, possessed with such an intensity of vision as to celebrate pure form in his perceptions of the everyday, became a full-time professional photographer a few years later.

The amateur eye remained and flourished throughout all these stages of development within the field. From its earliest time the pull of the photographic image was too strong, too rich for large numbers of Britons to ignore. As William Pumphrey observed on an earlier expedition to Bettws-y-Coed: "This concentration of subject has made Bettws a very favourite resort for artists, indeed it may fairly be said to be infested by them: you cannot walk half a mile in any direction without coming on someone sketching under a white umbrella, or a tent, & if the day is fine you are almost sure to meet with some photographers: between the two, the place is overrun" ("Rambles in North Wales in the Summer of 1862").

Joseph Wilson Swan (1828–1914).
Holystreet. Mill. Devon. 1865.
Carbon print. 20.7 × 23.6 cm.

J. W. Swan's image of a rustic mill is an excellent combination of subtle tones and evanescent light. It is a superb pictorial achievement, made equally effective by its composition of visual elements and by the luxurious values inherent within the carbon print process.

By 1865 Swan had perfected his non-silver, carbon transfer process. The photograph of the Holystreet mill is among the earliest successful prints which he produced with his new technique. More than just a picturesque image therefore, it serves to make us aware again of the continuing experimentation and redefinition within photographic processes which provided photographers with wider ranges of nuance and value for enhancing and interpreting their vision.

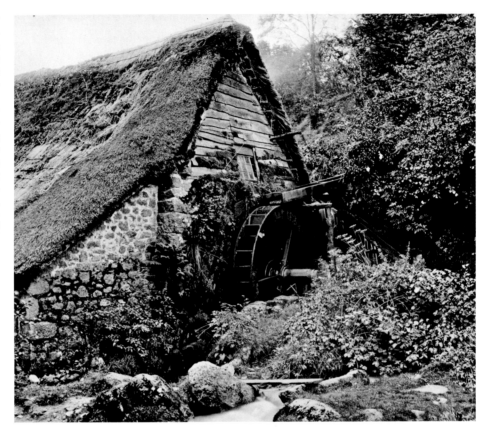

William Carrick (1827–1878).
Russian Peasants in Wheat Field, Simbirsk. ca. 1871.
Albumen print. 13.8 × 9.7 cm.

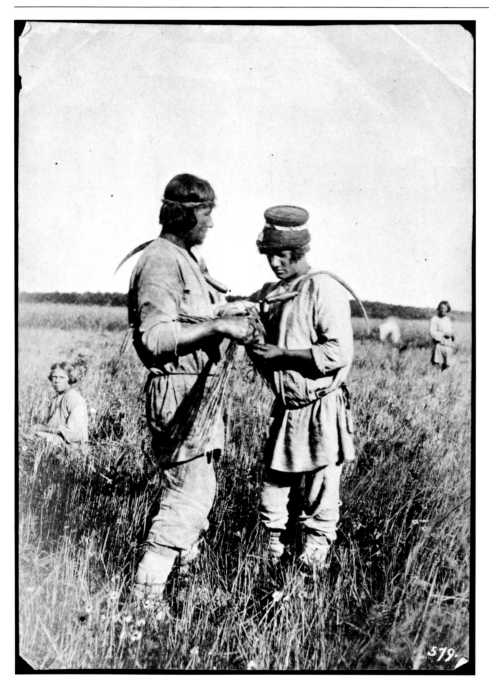

William Carrick, with the assistance of a fellow Scotsman, John Macgregor, established a photographic business and portrait studio in St. Petersburg in 1859. For nearly two decades he struggled to make his operation a success, despite the economic, technical, and cultural problems he faced in trying to maintain his enterprise in a foreign society like Russia's. His livelihood was maintained chiefly through commercial portraiture and photographic copying.

Carrick, like many another British commercial photographer whether at home or abroad, struggled to make his business successful. Yet one may imagine that he also possessed one other characteristic shared with many of his contemporaries in the field: a strong creative urge to produce a significant body of art using the new medium. He first accomplished this with a series of studio and in situ portraits of Russian street types which, although reminiscent of similar British subjects by Richard Beard or (later) John Thomson, possessed an effortless and humane grace in both pose and execution.

However, the epitome of Carrick's visual power rests in his "Simbirsk Series." These portraits of Russian peasants in their native villages and landscapes were a natural evolution from his studio portraits of the street people in St. Petersburg. However, unlike the earlier work, the portraits made in rural Simbirsk contain an intrinsic power which transcends their time.

In part this is due to their continuing strength as visual documents, capable of revealing new information and insight into a time and culture relatively unknown to us. Chiefly, however, the work is significant for its own integral style which blends subject, setting, pose, and technique in a subtly effective, almost effortless manner. Like Millet, whose works these photographs are highly reminiscent of, Carrick celebrates the simple yet mystical union of people and the land.

Col. Archibald Henry Plantagenet Stuart-Wortley (1832–1890).
A Witch and a Prophetess. Tahiti. 1880. Published in Stuart-Wortley, *Tahiti*.
Photomezzotint. 14.1 × 13.8 cm.

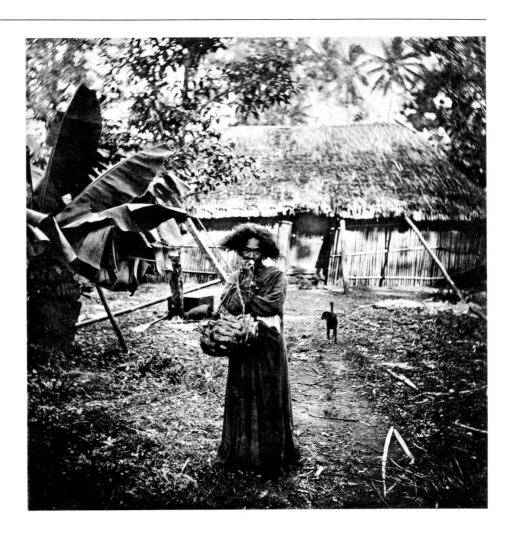

Sometimes the line between the amateur traveling with camera and the serious documentarian can become quite indistinct.

When Colonel Stuart-Wortley came to Tahiti in 1880, he was just another tourist bearing a camera. He soon became enamored of the tropical island and spent his too few weeks there exploring with eye, ear, and camera all the facets of the place and its people. By the time of his departure he knew he had found his favorite land; he took what he could back with him in the form of stories, observations, and photographs.

The works he published in 1882 reveal much of this transition and inward growth. The book contains, on the one hand, his version of such traditional views as palm trees silhouetted against the sky or rich tropical scenes—views which would become the mainstay of commercial postcard companies by the turn of the century. However, other photographs in the volume are much more complex and penetrating. As his portrait of the witch demonstrates, Stuart-Wortley sought to explore the conditions of life and the spirit of the people of the island. With his innovative framing and direct, confrontational approach, he has also presented us with a strikingly modernistic looking interpretation of an individual and her environment. Such publications as Stuart-Wortley's may seem small in scale and bibliographic history, but they continue to provide us with deeper understandings of the nuances of photographic growth even in the most prosaic British amateurs.

M.
Cast of *The Rivals.* 1878.
Albumen print; hand-colored. 9.5 × 14.2 cm.

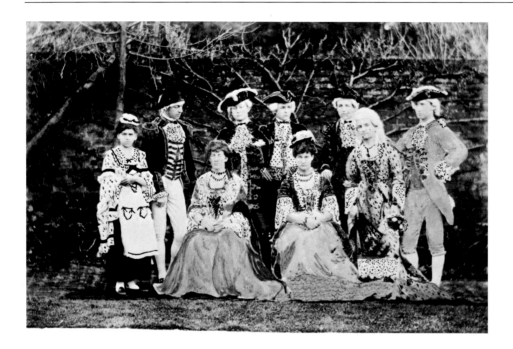

As an example of professional group portraiture this photograph of a group of Cambridge men comprising the cast of Sheridan's *The Rivals* is markedly undistinguished. The unaltered photograph appears to have been nothing more than a rather simple document of the classmen in their costumes, recorded with little sense of liveliness or imagination.

However, due to the work of an amateur hand-colorist, the function, appearance, and effect of the original print have been dramatically altered. The rather garish colors, perhaps intended merely to duplicate the rich colors of the original costumes, project the figures outward from the now monochromatic field of the albumen print's surface. Reality is thereby transformed in a manner that no natural color process could have ever duplicated. The amateur colorist, while attempting to enhance the documentation of the play, has provided us instead with a complementary visual extension to the elements of fantasy and wonder found in the theatrical production itself.

Unidentified photographer.
Muttra. ca. 1873.
Albumen print. 17.9 × 15.3 cm.

There is little within the image of Muttra which shows a marked technical proficiency on the part of the photographer. The wet plate negative from which this print was made was poorly focused and exposed at the time it was produced. Certainly most arrestingly, the plate was broken at some point before the print was produced. Finally, the print itself displays a lack of any fine care during its existence.

Taken out of any historical or physical context, the image offers the viewer little in significance or edification. Yet, as all photographs should, it begs our interpretation and analysis, even if for no other reason than this lack of context.

The print is unattributed as to artist or precise location. However, it has existed to this day because of its retention within a family album belonging to an English gentleman, Sir Henry Crichton, who served with the British army in the Hussars in In-

dia during the 1870s. The album contains numerous photographs from this tour. Some of these are commercial prints undoubtedly purchased at the time either in India or while en route to the post, but the album also contains a large percentage of obviously amateur photographs undoubtedly taken by Crichton himself or by members of the British military forces serving with him.

To clarify the subject of this image, Crichton wrote the name of the location in the lower portion of the print. Muttra—or, more correctly, Muthra—was a provincial town in northern India, an outpost and operating base for this mounted force. From other photographs in the album we are able to discern that the particular building which forms the subject of this damaged print was the home of Crichton and his family during his tour of duty.

Crichton's image of Muttra thus becomes

a major factor in the mnemonic process of photography, enabling the viewer who experienced the moment or the place to relive the experience. It is an affirmation not of the qualities of the photograph as a fine print or as a record of physical information, but rather of the powers of immediacy and emotion which cause the production of all photographic images no matter what their final optical and physical properties. We may be unable, at our present distance of time and place, to observe the details of Crichton's environment, but we can begin to experience some of the significance and interest which this portion of his life held for him and his family. Perhaps it is this intuitive, emotional quality—generated with immediacy and the full experience of the moment—which made the photograph the most intense and dominant visual medium of this era.

Unidentified photographer.
Rocks and Undergrowth. 1863.
Albumen print. 23.6 × 18.6 cm.

The camera has always had an affinity for natural forms, and the attraction of being able to duplicate through human agency the precision and beauty found in Nature was a strong motivational force among nearly all British photographers of this period.

The photographer of this work, an unidentified member of the Amateur Photographic Association, undoubtedly shared this intrinsic fascination. Yet, in the spirit of a true artist, he has provided us with more than a mere "objective" document of a site. Through those factors inherent in the creation of any photograph—framing, point of view, exposure control, processing, and print quality—he also reinterprets this particular view of the world. His foliage and undergrowth take on the richness and complexity of a fine tapestry, requiring us to examine and all but touch the elaborate textures. His rock formation glows with a majesty and presence previously reserved for selected images of cathedrals or palaces. He has presented us with an ideal of both delicacy and splendor which make us realize that perhaps there are some undefined but universal truths to be found in Nature.

George Washington Wilson (1823–1893).
Island on the Dochart, Killin. ca. 1865.
Albumen print. 18.9 × 29.1 cm.

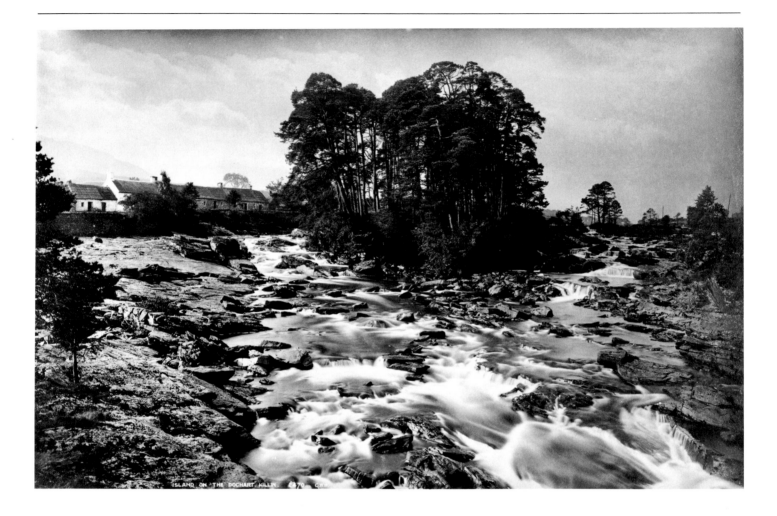

Of the legion of photographers who directed their cameras to the contours and lineaments of British landscape and architecture, perhaps none possessed so intuitive a feel for the subjects as did G. W. Wilson. No mere topographer, he founded his business in the 1850s upon the principle of providing fine-quality, affordable images of the scenes and sites of the British Isles which his customers would want if they themselves could take the photographs. The clarity of his vision and the power of his imagery were further supported by a company which maintained his extremely high standards for printing and distributing photographs. His initials accompanied each of the nearly half-million prints his firm produced annually, a standard he maintained for nearly four decades. Thus, Wilson is one of the major individuals to provide for the diffusion of photography throughout British society in the nineteenth and early twentieth century.

As in this photograph of the confluence of waters at Killin in the Scottish Highlands, Wilson found a wholeness to each of his subjects. His prints possess a richness of tone and contrast which add drama and depth to even the most pastoral settings. In addition, however, Wilson sought out the subtle components—the dramatic angle of the island with its trees, the lustrous texture of the water casting a veneer upon the rocks—which add life and depth to the overall view. What his photographs lack in monumentality they more than make up for with their eloquent purity.

George Washington Wilson (1823–1893).
Bank of Ferns. ca. 1867.
Albumen print. 29.5 × 19.3 cm.

BANK OF FERNS. 10.233. G.W.W.

The plant forms which first arose in the contact printing works of Atkins, Talbot, and Hunt would continue to fascinate graphic artists of the nineteenth century. They would reach their apex in the floral and foliate designs of William Morris, who attempted to incorporate them into many levels of human existence, from lettering and bindings to wallpapers and carpeting. Morris sought a purity of line and form which would enhance not just vision but the human experience itself.

G. W. Wilson's eloquent photograph of a bank of ferns continues to give us pause. It is not just because of its radical subject matter—although it is certainly distant from the landscapes and cityscapes which made up the bulk of his imagery. Nor is its significance solely due to the quality of the print itself—Wilson's printing technique having always been superb. Ultimately, the power of the photograph rests in the expressive quality of its image, in the sheer beauty and presence of light which seems to radiate off every frond and stem. The photograph generates a purity of feeling which eluded other photographers of the natural form until the mid-twentieth century.

George Christopher Davies (1849–1924).
The Kingfisher's Pool—Salhouse. ca. 1880.
Photoengraving. 10.9 × 14.9 cm.

G. Christopher Davies' landscapes of the Norfolk Broads are among the most exciting in this particular genre of British photography. They are also the most unpredictable. The plates he produced from his travels across the tracks and rivers of these lowlands reveal a land of great variety and change. One image may be monumental in its use of light and perspective while the next is intimate and subdued.

The complexity of "The Kingfisher's Pool" is no exception. It is a small, subtle image, printed to a much smaller scale than a number of Davies' other photoengravings. The human trace—in this case the boat—is evident in nearly all his works, but usually as only a small compositional element within the whole frame—as if humans still had a deal of work ahead before they could overcome nature. The screen of trees and brush contains the principal elements within the overall tapestry of the imagery—a tapestry binding all the ele-

ments of water, land, sky, and boat into an intricate, sentient picture.

Perhaps it was this final blending of the physical elements which made the Broadlands so attractive to photographers like Emerson and Davies, as well as to artists of other media and disciplines. Perhaps here more than at other sites in the British Isles one had the best opportunity to experience firsthand one's relationship with the totality of nature: not merely in the arts but throughout most phases of human endeavor. When H. Rider Haggard returned from a year working a Norfolk farm and wrote his commonplace book, *A Farmer's Year*, he concluded: "There is no education like that which we win from the fellowship of Nature; nothing else teaches us such true lessons, or, if we choose to open our minds to its sweet influence, exercises so deep an effect upon our inner selves—an effect that is good to its last grain."

Henry Peach Robinson (1830–1901).
At Sunset Leaps the Lusty Trout. ca. 1860.
Platinum print. 50.9 × 40.3 cm.

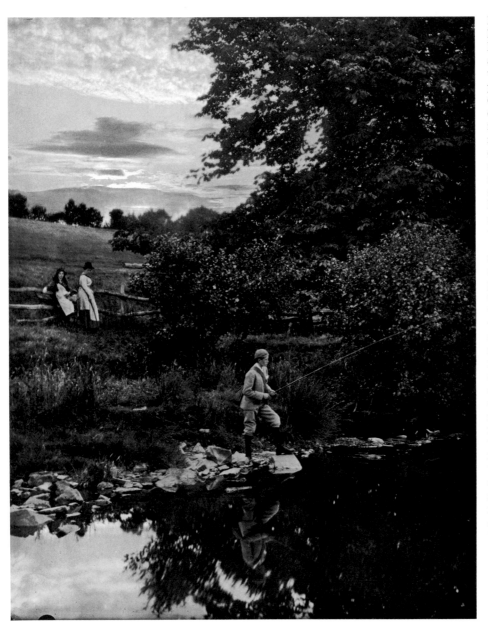

Like other Romantic artists of the time, H. P. Robinson glorified the ideal of rural life. Through his composite photographs and his firm conviction that the final print was the true, ultimate statement of the photographer, he came closer than any other photographer to creating the strong compositions and the dynamic effects of atmosphere and light which were the trademarks of the English landscape painters of the day. Whereas other photographers sought to present an image of implied instantaneity, Robinson advocated a doctrine of prescribed planning and design. Thus, his outdoor photography reflects the same sensibilities to balance as those he sought to incorporate into his studio efforts.

"At Sunset Leaps the Lusty Trout" is a composition of deliberate intent rather than happenstance. Every element of the piece—the dramatic sky, the solitary figures, the darkened patches of land and water—occupies a predetermined place within the frame. To Robinson, Nature was often incapable of perfect composition. He felt, therefore, that it was the photographer's obligation to impose that harmony onto the natural scene. To achieve this end all practical techniques—posing, exposure control, retouching, and composite printing, among others—were not only permissible but often recommended. The values, details, and balance of this final print may never have existed as a unified whole within the real world; that was of little consequence in the end. For Robinson reality became a major subjective element of immense importance to the final work but always subordinate to the ultimate truth of the photographer's vision.

Peter Henry Emerson (1856–1936).
The Haysel. ca. 1886.
Published in Emerson, *Idyls of the Norfolk Broads*
Photogravure. 14.3 × 25.0 cm.

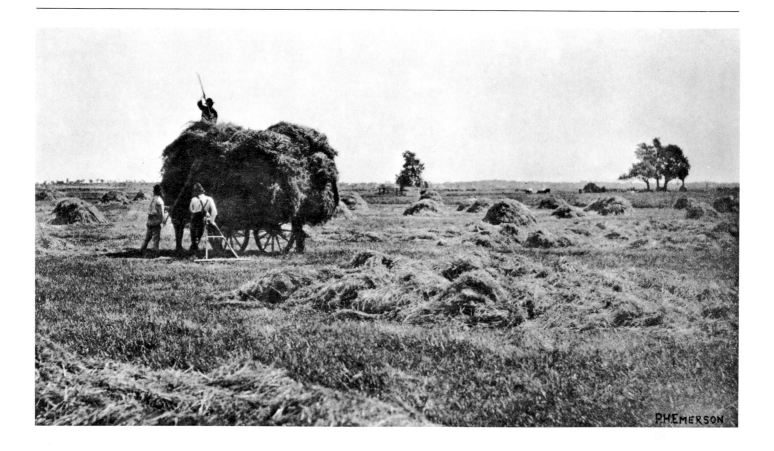

As the poets felt that the cloudless days of early spring could revive human spirits, so P. H. Emerson's precision of thought and clarity of vision can be seen as signs of resurgence within the history of photography. Exponent of Naturalism, grandfather of Modernism, to some extent a champion of the human eye over the painterly ideal, Emerson exercised an influence that is felt even today.

The landscapes and people of the Norfolk Broadlands were, like his camera and plates, the implements of his grand design. He used them all to transcribe his vision with a cleanness and economy that previously had not been experienced so intensely or in such a well-formed manner. The elements of his theory are shared with the visual elements of such works as "The Haysel": a sense for light and the feel of its atmosphere, a focus which is neither sparing of nor overwhelmed by details, and an almost documentary-like honesty capable of enriching both vision and knowledge for the viewer. Emerson's writings and his photographs share the same simple yet emotive honesty.

George Davison (1856–1930).
A Breezy Day in Spring. 1887.
Published in London Stereoscopic and Photographic Company, Ltd., *A Selection of Prize Pictures*.
Platinum print. 23.5 × 18.5 cm.

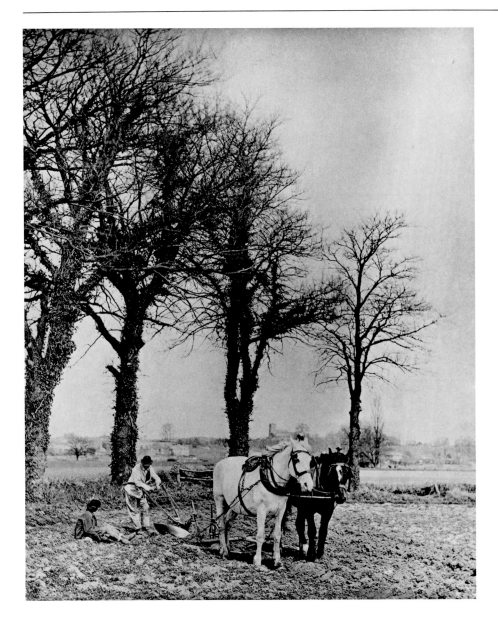

Unlike P. H. Emerson's platinum prints and photogravures, the works of George Davison's camera are more painterly. His compositions are generally more complex and his subjects more studied than experienced. His pastorales are as tightly constructed as if outlined in a sketchbook. Like most other Pictorialists, he was concerned with the mood of his final work rather than with seeking out any naturalistic truths about the land or its inhabitants.

Davison championed the "effect" of his imagery rather than the mere instantaneous qualities of the shutter and lens. His works were designed to please the senses and sensibilities of the Victorian and Edwardian viewer, ennobling the qualities of life rather than recording all of its details. He did so with a sense of style equaled by few of his fellow Pictorialists.

H. Bell.
Blea Tarn, Langdale. ca. 1895.
Platinum print. 19.0 × 29.2 cm.

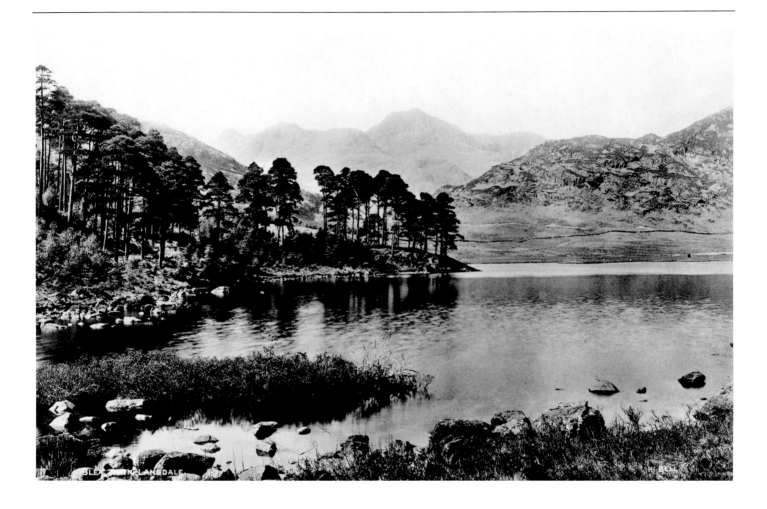

By the century's end, commercial landscape photographers such as H. Bell had fallen under the influence of many disciplines and practitioners. The simplicity of the early amateurs and the direct but complex constructions of photographers like Francis Bedford and Francis Frith had been supplanted. By the 1880s, Naturalists and Pictorialists were drawing new lines and blurring others in an attempt to redefine the parameters of their art.

Images such as "Blea Tarn, Langdale" are direct products of this confused period.

The view of the lake is a direct recording of the natural elements within this Cumbrian landscape. Yet it is also a complex interweaving of shoreline, hills, and trees, each with separate textures and patterns. The effect may be pastoral and serene, but it contains a complexity of visual elements beautifully printed to take the viewer beyond a single mood. It was only in such later landscapes that the camera was able to impose and transpose with equal vividness and power.

Horatio Nelson King (1830–1895).
Hampton Court: East Front. ca. 1880.
Gelatin silver print. 21.2 × 27.8 cm.

Obtaining a royal commission in the 1880s to photograph the Queen's palaces, H. N. King left his commercial portrait business to fulfill his plans. He spent a number of years attempting to document the buildings and grounds of the royal residences. However, as in his portraiture, the work is generally routine and recorded in a formal, picturesque fashion which only serves to emphasize the attractiveness of his subjects.

His view of the east front of Hampton Court is, therefore, the exception rather than the rule. The photograph eschews the formalized, ritualistic aesthetic of its day and attempts to be dramatically different. The building's façade is well off center to the film plane, thus providing greater depth within the frame. Also, the edifice is partially obscured by foreground foliage and further diminished by the receding walkway connecting the observer to the palace. Finally, a severe fence with trailing thorn bush is imposed into the foreground, conflicting dramatically with the rather pastoral tone of the rest of the image.

King's photograph blends the modernistic with the picturesque in a strikingly handsome manner. Yet, because of this contrast and complexity, it is one of the few pictures in his existing oeuvre which maintain a unique freshness after nearly one hundred years. We can only wonder what King's own feelings were about this radical work's place in his portfolio.

Gibson and Sons, Penzance (John Gibson, 1826–1920).
Piper's Hole. Tresco, Scilly. ca. 1885.
Albumen print. 15.4 × 20.5 cm.

For decades the Gibsons clambered over the rocks and outcroppings of Scilly and Penzance. Their views of shipwrecks and rugged coastlines provided them with a national reputation, and by century's end there existed no photographers more eloquently capable of showing the depth of the relationship which the English had with the sea.

That relationship could be dramatic or serene; in the case of "Piper's Hole" it could also reflect a much different spirit. The massive incongruity of the white ladder balanced so symmetrically within such heavy, organic forms is at once witty and unsettling. It begs for explanations (of which none exists) or practical theories (of which a number can be postulated). We may be fortunate and find the answer one day; on the other hand, we may be even more fortunate and never really know.

Chapman and Hall.
The Ceramic Gallery. ca. 1885.
Woodburytype. 12.5 × 7.8 cm.

Photographers continued to be drawn back to the still life, in part because of its technical and aesthetic challenge but perhaps even more because they recognized that it was among the purest statements of light which the camera could approach and the final print could render. No subject matter offered the photographer greater control coupled with greater challenges. Technical process and personal vision were required to work in unity if the still life was to truly possess life.

Chapman and Hall employed the Woodburytype process in their final rendering of "The Ceramic Gallery." It was a wise choice, for the original image might have tended to be a rather clinical and straightforward record of this formal arrangement of pieces. Instead, the Woodburytype provides the image with a pervasive incandescence which molds and adds substance to the various objects. Designs flourish, surfaces reflect their degree of luster, and shapes claim an almost three-dimensional presence. It is a technical tour de force which owes its complete allegiance to the nature of the light.

In comparison, the flower piece by Henry Stevens takes its values from the more subdued tonality of its carbon print process. The subject matter—more prosaic in content, yet more complex in shapes and forms—achieves an intricate rhythm all its own. The photograph retains a subdued contrast with largely darker values, but the final effect is more one of an amplification of the light that remains. Perhaps the petals and leaves never looked quite that iridescent or delicate in the common light; it is of little consequence when we may experience the image as the original photographer must have.

Henry Stevens (1843–1925).
Flower Study. ca. 1890.
Carbon print. 43.7 × 36.8 cm.

The environmental portrait was pioneered with J. P. Mayall's "At Home" series of great British artists in their studios. Rallying against the continuing style of portraiture bound in sterile or limited studio settings, Mayall sought to expand our sense of the famous and what they did. He felt, as E. O. Hoppé did two decades later, that the atmosphere of the subject's home or studio was more effective in reducing the anxiety or inconvenience brought on by sitting for a camera portrait. Also, it was felt that a look into the home life of the subjects might provide a greater insight into both their professional abilities and their humanity.

Val Prinsep was one of Mayall's more successful sitters, affecting at least a degree of comfort and ease within his work space. Unfortunately, many more of Mayall's "At Home" subjects still retained a degree of unease before the unblinking camera eye.

While environment could still help, the greatest ingredient in effective photographic portraiture remained the photographer. The camera remained the key to this manipulative medium, but its ability to create an imposition would remain a significant concern to the portrait artist.

Alice Hughes.
Queen Alexandra. ca. 1889.
Platinotype. 28.5 × 20.7 cm.

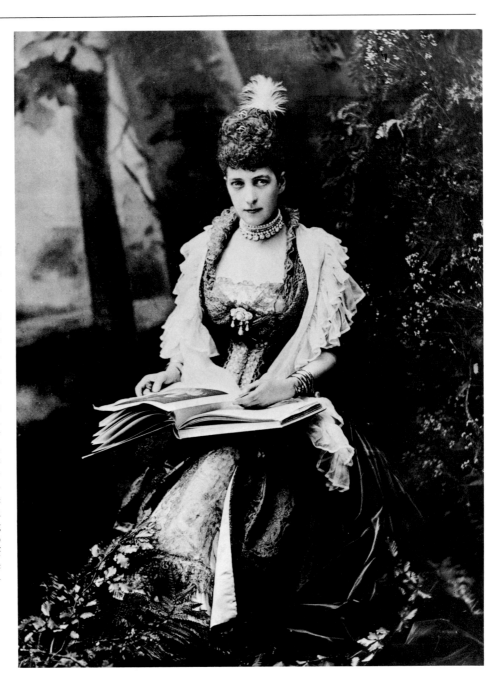

Throughout this period the popular portraiture of royalty and court figures continues to impose a certain conservative dignity upon the camera artist and the resultant works. Decorum, established by necessity and tradition, remained the mainstay in the portrait process, and few glimpses into the personal lives of the court came from the portrait studios.

It is interesting, therefore, to speculate upon the body of work produced by Alice Hughes, one of Queen Alexandra's ladies of the court. Mrs. Hughes possessed no radical vision, no driving personality such as that which Julia Margaret Cameron used in overwhelming her subjects. Her sitters bear the same formality of dress, pose, and bearing as that which they retained for the commercial portraitists. Yet throughout her portraits of the ladies of the court there seems to be the faintest leitmotiv of a personal style. Perhaps it is seen in the more relaxed positions of her sitters. Or perhaps it is merely an effect of the polished luster of her platinotype prints, which contain a richer look than the thousands of albumen prints which were turned out by her commercial predecessors.

For Mrs. Hughes did have the potential to add a higher level of intimacy to her formal portraiture. Her work was produced chiefly for herself and her subjects and friends, founded upon a mutual trust which she would not have betrayed. One might expect, therefore, a greater openness and honesty to her portraits, but that may be the hardest quality to determine. Did such a personal intimacy lead to more penetrating work or, instead, might such a relationship have served rather to increase the level of idealization of this particular artist? The question lies at the root of each photographer's personal image-making.

Herbert Barraud.
John Morley, M.P. ca. 1888.
Carbon print. 24.6 × 17.6 cm.

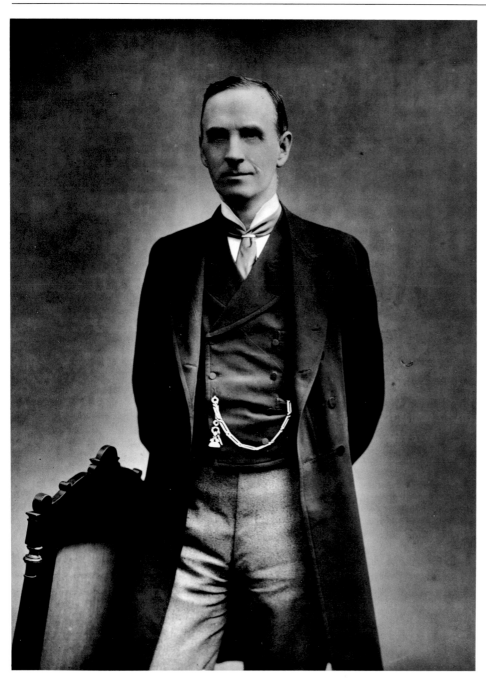

Herbert Barraud was the favored photographer of the upper classes in the final years of the Victorian age. His subjects are all but flawless, presented in their finery as they themselves wished to be viewed and remembered for the ages to come. It is perhaps no accident that Barraud chose to preserve them in carbon prints, the most permanent of all the available processes.

His portraits reflect a natural economy of style and pose which is not out of keeping with the conservative status of most of his subjects. In the case of his rather severe portrait of John Morley, there is hardly any depth or texture to the final print. Rather it becomes an exercise in tones and subdued contrasts, a superbly printed composition on an almost two-dimensional field which can only be enlivened by the complexities of the centrally placed face.

Barraud issued series of portraits which he called *Men and Women of the Day*. Nearly all the subjects possess the same quiet elegance—an elegance in tune with the wealth, but not the vitality, of the times. In pursuit of the famous images of the day he somehow missed part of the active spirit of his age while concentrating on its grace and style.

Gee's American Studio, Jersey.
A Lady in Hat. ca. 1885.
Ferrotype: gem in card. 10.3 × 6.7 cm.

As is to be expected in the history of any commercial enterprise, novelty has continued to play a role in the development of photography. Fads have been engendered by each new process or format, and the careers of a number of photographers have been built upon their adoption of a certain novelty or, conversely, destroyed by their lack of flexibility in the face of a popular new style of photographic presentation.

The "gem" cards of the latter part of the nineteenth century were derived from two popular preceding fads: photographic jewelry and the carte-de-visite. The inclusion of the small tintype portrait within the window of a decorated or embossed card was most popular in the 1870s and 1880s, despite its tendency to miniaturize the human face into an almost unrecognizable spot. In the end it formed part of a continuum, for the fascination of the public with the miniaturized photograph evolved by the century's turn into the production of photo buttons and the revival of different forms of photographic jewelry employing newer technical processes. Even the halftones and other photomechanical processes of the twentieth century have adapted to this continual fascination with miniaturized photography.

Unidentified photographer.
Holiday Group. ca. 1885.
Ferrotype. 8.9 × 6.3 cm.

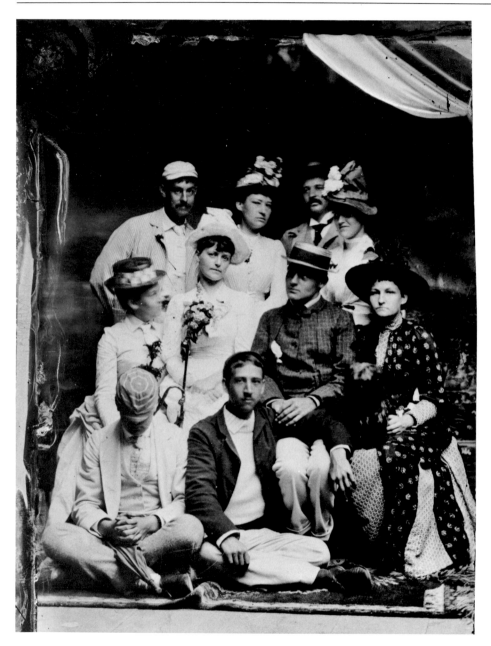

Of all the unique photographic processes which evolved during the earliest decades, only the ferrotype was able to endure through all the technical and cultural changes wrought by the photochemical and photoindustrial revolutions of the latter half of the century. Although such case art gradually came to be considered a novelty, nonetheless it did continue to be applied to commercial portrait work through a variety of new and renovated formats. These were marketed in many ways: from standardized case work available from itinerants through the incorporation of personalized imagery into a great variety of photographic jewelry.

The passage of time, together with the changes which took place both in the commercial photographic market and in popular tastes, inevitably led to modifications in the attitudes of ferrotype operators and their customers. With other more accurate or beautiful processes available, the ferrotype no longer was employed in first-rate portrait work. Also, its lack of reproducibility limited its applications to those circumstances which would not in all likelihood require multiple reproductions. With the final flourishing of hand cameras and amateur snapshooting, the process began to be restricted to a smaller, almost casual range of applications.

The ferrotype remained a relatively fast process, usually taking only five to ten minutes from initial exposure to finished plate. It was relatively instantaneous and inexpensive and most easily found its way into circumstances which required such considerations. Thus, itinerant ferrotypists continued to generate imagery in the small villages and rural fairs or at seaside and vacation spots, wherever there might be need of an immediate, permanent image of people.

As this holiday group can attest, the resultant photograph, despite its studio-like setting, was often relatively casual in terms of both its style and the attitudes of its subjects. In a sense a stylistic synthesis had begun. The spirit and substance of this early portrait process had begun to acquire the fashion and attitude of the amateur photograph. More than any other photographic process of the nineteenth century, the ferrotype was transformed not only by competitive technologies but even more so by the generative changes of British culture itself.

Queen Consort Alexandra (1844–1925).
Princess Victoria with Prince Waldemar of Denmark on the Royal Yacht. ca. 1889.
Albumen print. 6.9 × 6.9 cm.

The introduction of the Kodak No. 1 in 1888 revolutionized more than camera design. This first successful rollfilm camera, which featured compactness and a roll of stripping film capable of recording one hundred exposures, also served to change all aspects of the photographic industry, from marketing to customer services. And, while it affected the photographic habits of the consumer in the marketplace, it finally—due to its fixed-focus rectilinear lens, its singular shutter speed and fixed aperture, and its circular framing—also affected the manner in which the amateur photographer came to view the world.

Uniformity of exposure and optics and standardization of processing led to an alteration of the visual criteria usually attributed to most work of this time. The circular format and modified lens distortion produced a keyhole or eyeball effect that contrasted sharply with the precisionist dry-plate-to-albumen prints of the more serious, technically proficient amateurs. The qualities of affordability, accessibility, and trouble-free processing ("You push the button; we do the rest") led most people to forego certain aesthetic or technical standards for the sake of having a relatively effortless and more immediate image-making system.

It is indicative of the first Kodak's democratizing effect that within a year a model was being used by England's future Queen Consort, Alexandra, to document moments from her daily life. Her snapshots depict the people, places, or events of royal life in an almost proletarian manner. It is interesting to see royalty and members of the upper classes relating to the camera in much the same intimate and collaborative manner as subjects on other levels of the social ladder. The rollfilm camera, besides reshaping the iconographic qualities of the photograph, also helped to reinforce a more homogeneous relationship between photographers and their human subjects. As Gilbert and Sullivan admonished so comically:

Then all the crowd take down our looks
In pocket memorandum books.
 To diagnose
 Our modest pose
 The Kodaks do their best:

If evidence you would possess
Of what is maiden bashfulness,
You only need a button press—
 And *we* do all the rest.
 (*Utopia, Limited*, 1893)

From this date forward the rollfilm camera would change forever the photographer's subjective relationship with most people on the other side of the lens.

Frederick Hollyer (1837–1933).
Portrait of a Young Lady. ca. 1888.
Platinum print. 17.1 × 4.9 cm.

A major connoisseur and central figure in the British fine art scene, Frederick Hollyer was immersed in many of the aesthetic and literary movements of the late nineteenth century. His studios at Pembroke Square were the center for a number of the primary figures of the Pre-Raphaelite school as well as other critics and supporters of other significant trends. Not surprisingly, his own work evolved around fine reproductions of paintings or portraits of his professional associates and learned acquaintances.

Hollyer's hauntingly delicate portrait owes much of its sensitivity and subdued beauty to the influences brought to British art by James McNeill Whistler. Rather than a straightforward depiction, it is a fine study of mood and subtle harmonies. We do not know the subject's name, but perhaps it is of little consequence. It is Hollyer's own idealization of beauty that provides this image with its special presence.

Mrs. Brian Hodgson.
Woman at Window. 1889.
Carbon print. 20.7 × 15.6 cm.

The muted tones, exotic hues, and variant printing media ascribe a certain visual style to our feeling of how the work of the Pictorialists is supposed to look. It is important, however, to remember that the "pure" or straight photograph was also considered an acceptable method of artistic expression during this time. Many members of the movement recognized that rhythm and harmonious sensibility could be derived from a straightforward approach to the subject without massive manipulation of any particular printing process. Such work may have seemed effortless in both its directness and its intimacy, but it was, in fact, this apparent simplicity which enriched the beauty and impact of the final print.

Henry Herschel Hay Cameron (1856–1911).
Sir Henry Irving as "Becket." 1893.
Carbon print. 42.6 × 34.6 cm.

The continuing evolution of photographic processes and technology naturally affected the look and feel of portrait photography at the end of the century. While portraitists shaped the appeal of such work to public audiences as well as private buyers, it is important to remember that their styles were also derivative of the influences of past artists or fashions of portraiture.

Some patterns are patently obvious, as in the case of H. H. H. Cameron. The artist derived much from the portrait style of his mother, Julia Margaret Cameron—the most notable stylistic qualities being his adaptation of the chiaroscuro effects which she found so popular and the production of mammoth prints of heroic heads obviously engendered by her own series of portraits of notable men and women of her time. In the process, however, he seems to have lost some of her passion. Whereas Mrs. Cameron continually imposed her assertive, intuitive nature upon her subjects, her son's work seems to adopt a dispassionate, coolly calculated tone. His image of Irving as Becket, whether produced for private sale or public display, seems akin to the literal interpretation of its title: a record of an actor in a theatrical role. No matter what degree of success she achieved in the final prints, Julia Margaret Cameron always permitted the presence of her will and her fancy to shape the reality before her lens; H. H. H. Cameron, while attempting to go through the same motions, appears to be allowing his sense of depiction to replace that spirit of interpretation.

A. G. Dew Smith.
Margaret Darwin. 1894.
Platinotype. 37.2 × 29.2 cm.

In contrast, there exist a few remarkable portraits by an amateur contemporary, A. G. Dew Smith, a lens grinder at Cambridge University Observatory. Whereas Mr. Cameron moved in the social and professional circle of the Isle of Wight's literary and artistic elite, Smith produced his highly personal work within the confines of the university and its learned class of academicians. The accuracy and patience which were hallmarks of his profession were also undoubtedly brought to bear in his precise and luminous photography. Allusions to past masters' works abound—the Rembrandt lighting practiced by Hill and Adamson, the monumental scale of Mrs. Cameron, the delicate intimacy of Lewis Carroll—but Smith's work remains uniquely his own. His portraits evolved from relationships of mutual respect between photographer and subject; they evoke a serene yet ardent familiarity which few professional camera artists were ever able to secure.

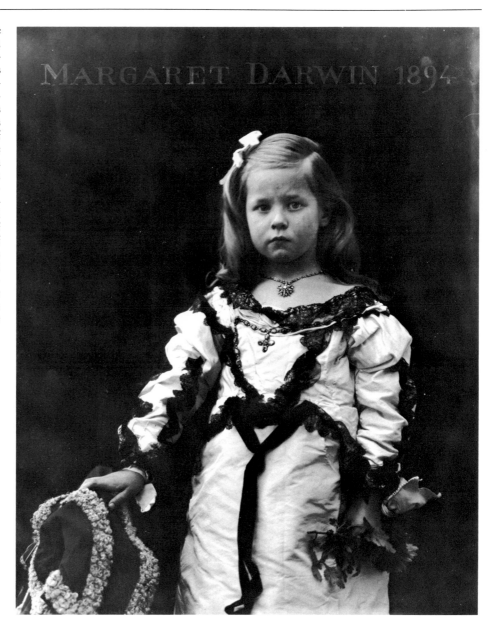

Sir Emery Walker (1851–1933).
Portrait of William Morris. 1889. Published 1897.
Photogravure. 26.5 × 21.0 cm.

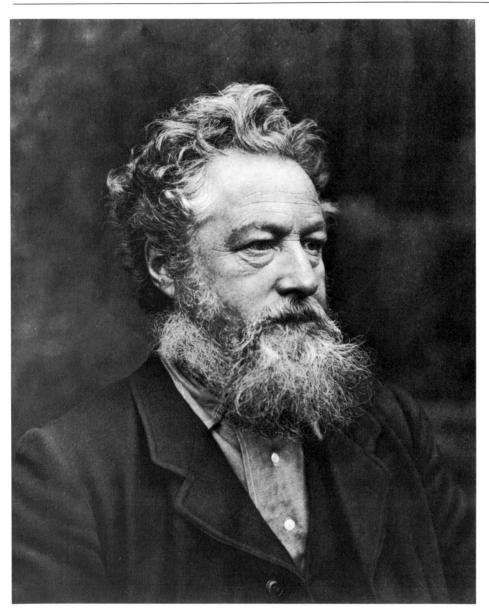

This portrait of the English artist and publisher William Morris was made in 1889, although it bears the copyright date of 1897. Since Morris had died in 1896, Walker in all likelihood published the portrait as a posthumous tribute to his former friend and associate.

At first glance there is little to remark about Walker's snapshot of Morris. There is nothing elaborate in either the pose or the expression of the sitter and, save for the generally diffuse light that pervades the overall scene, there is nothing to suggest that Walker was a talented photographer.

But it is important to remember that Emery Walker was not by profession a photographer; rather he was a master printer and process engraver who had worked with Morris and other publishers in producing some of the finest printed works in English literature. It is through his proficiency with ink on paper that we must ultimately view the work.

By adapting the image of Morris to the photogravure process, Walker was able to refine his visual depiction of his friend. The final print is pervaded throughout with a golden tone that warms all the surfaces in the image. Highlights in Morris' beard, hair, and skin surface glow with an added warmth, while details of his dress and background are further muted in the darker shades. As a result the overall portrait is provided with a tangible luminescence that beautifies the subject with a nearly halo-like radiance. Walker's subtle skill with plate and ink make Morris' head assume god-like proportions. It seems fitting that the publisher who used ink and paper to ennoble the works of so many authors and artists should himself be so ennobled.

Royal Studio, Colchester.
The Staff, Assington. 1912.
Gelatin silver print. 18.0 × 23.5 cm.

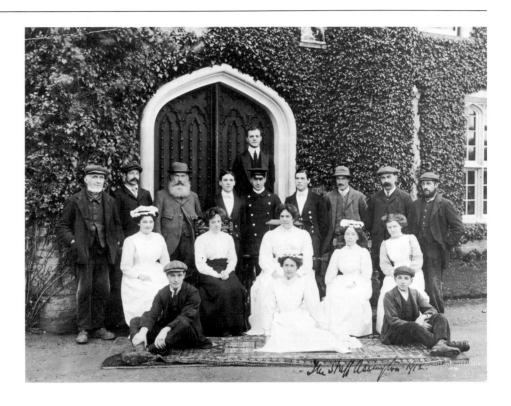

The group portrait of the staff at Assington, if not skirting the edge of anachronism, is at the very least more akin to the imagery of the earlier century. Certainly the forthcoming World War and the economic crises of the following decades would alter the social fabric of these times, affecting the number and nature of hired servants capable of being supported on private estates.

The image is, of course, wrapped up in socioeconomic metaphor. The owner of Assington Hall estate, Sir William Brampton Gurdon, M.P., undoubtedly arranged for the photograph, perhaps as part of a series documenting his property. Certainly, he provided ahead of time for photographers to be brought in from nearby Colchester and for all members of his staff to be present at an appointed time. They are arranged in tidy rows, formally posed on an outstretched carpet, in their accustomed livery. In one sense they are the Gurdon family property, placed in regimented pattern in much the same manner as the photographers might have photographed the family silver pieces.

Still, the photograph also retains its documentary intent and its romantic attitude. It is a statement of present conditions and an idealization of times which the elder Gurdon may have felt, even then, were too rapidly changing. The implications we see in a photograph today can never completely match the attitudes and expectations which attend its creation. This does not mean that we must not try to understand it, only that we must be aware of the multiple nuances found in even this seemingly simple photograph of people posing before the manor house that formed so much a part of their lives.

Hughes and Mullins, Ryde.
Idylls of the King. 1888.
Carbon print. 16.0 × 22.6 cm.

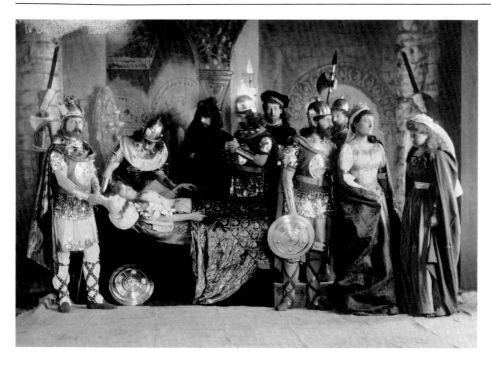

The tableau vivant was a highly popular form of entertainment and moral edification among the higher classes in Victorian and Edwardian society. The presentations of living scenes from literature, history, or moralistic sources proved to be significant barometers of British culture during these ages. And, needless to add, with their costumed figures frozen in moments of great drama or beauty, they proved to be instantly attractive to the potentials of still photography.

Although none were capable of succeeding Julia Margaret Cameron in this field, it is interesting to note the variety of work that existed within this seemingly static and limited subject matter. On the one hand there is the firm of Hughes and Mullins, which served as official photographers for the court of Queen Victoria. The tableaus being among the favorite entertainments of the queen, the firm—in much the same manner as its predecessors, such as Roger Fenton and G. W. Wilson—was sometimes called in to record the scenes from the previous evening's presentations. Their resulting photographs are subject to little personal interpretation or style; they exist as documents of the entire scene and of the costumed princesses and courtiers engaged in this royal diversion.

In sharpest contrast, T. A. Rust's image seems devoid of any pretentions toward literature or beauty. With its prosaic lighting, amateurish costuming, and exaggerated histrionics, it seems to have been staged in studio directly for the eye of the camera. Its uncomplicated metaphorical content and naïve attitude make it appear to be an image intended for the consumption of the general viewer in all classes. It bears a close affinity to the early cinematographic films of the day which displayed many of the same qualities in their production.

T. A. Rust.
The Game of Life . . . (Tableau). ca. 1900.
Albumen print. 21.5 × 27.6 cm.

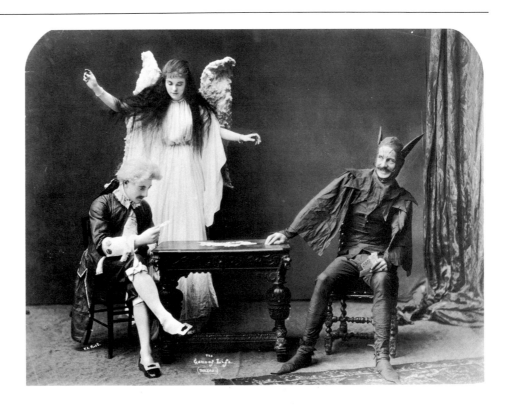

George Bernard Shaw (1858–1950).
Irish Fisherman. ca. 1908.
Gelatin silver print. 12.7 × 10.1 cm.

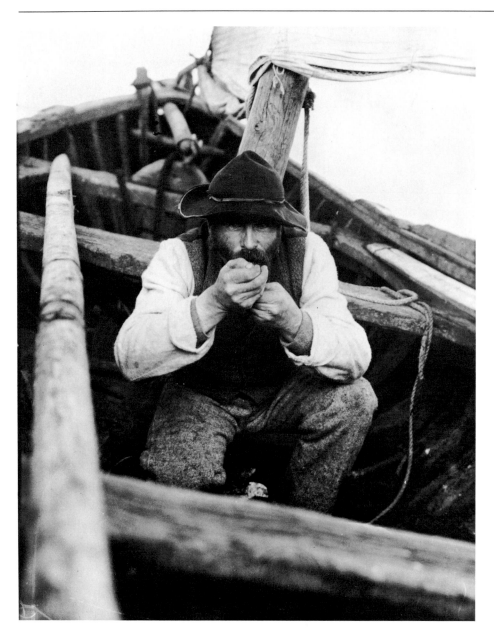

Shaw's portrait of an Irish fisherman—undoubtedly the product of a hand-held camera and a relatively fast film emulsion—derives much of its character from the evolving snapshot aesthetic of the previous decades. A non-objective directness, combined with an almost familiar sense of mood and happenstance, creates a nearly informal relationship between photographer and subject.

Still, the relationship is there, and it is well established. Most photographers would have had their subject affect a general pose, both to make their image-taking easier and to aggrandize their final figural study. Shaw's fisherman, however, is in his milieu, and the photographer has placed himself there as well. Crouched in the boat they face each other, the fisherman going about the natural action of lighting his pipe while staring back with steady eyes at the equally uncompromising lens. Except for the lines and details of the boat, there is little in the environment to help us learn more about the subject, or, indeed, the photographer's relationship to him. We are presented in the end with a highly contradictory image, one which seeks to acquaint us intimately and naturally with a figure whose expression and bodily position do not invite that degree of relationship. Shaw's commitment is personal rather than professional, and the final result of his efforts can, like most of his work, be weighed in terms of its latent humanity rather than abstract humane ideals.

Salmon's Series.
Winchester Cathedral. ca. 1895.
Platinum print. 18.9 × 28.4 cm.

The innovative, experimental attitudes of Robert MacPherson and Charles Clifford were adopted by commercial topographical artists at century's end. While the subject retained its prominent, and often dominant, position within the frame, photographers began to incorporate other elements of the environment into the photograph, thereby enlivening the print through such basic visual techniques as contrast, distortion, linear perspective, or tonal separations.

The Salmon view of Winchester Cathedral focuses, of course, upon the exterior façades of the building. The approach is non-traditional, with the edifice depicted from an angle in which entire segments are blocked by the rows of trees lining the lanes around it. Moreover, although the entire cathedral is included within the general frame, a number of the key trees used in the pattern of the image have their tops excluded from that frame. It seems obvious that the photographer elected to have the truncated trees echo the obvious heavenward ascent of the cathedral spire. The screen of foliage, therefore, serves as both a structural and a symbolic counterpoint to the basic subject of the photograph. The use of landscape to enhance architectural photography may have limited some of the medium's rich documentary qualities, but it also served to enrich the subject visually and provide a greater, more vibrant challenge to artist and audience alike.

Richard Kearton (1862–1928) **and Cherry Kearton** (1873–1940).
Hedgehog. ca. 1900.
Published in Richard and Cherry Kearton, *Pictures from Nature.*
Photogravure. 20.0 × 26.5 cm.

Until the later innovations of camera design and optics and the increase in film sensitivity during the mid-twentieth century, the challenge of wildlife photography had been difficult indeed. It required equal parts of inventiveness, determination, and patience to obtain accurate, well-produced images of undomesticated animals and birds. At first this was done with stuffed or dead animals, which were posed and then photographed in situ. Zoos also proved to be popular attractions, since photographers knew that the animals were at least within a confined space, and, with proper care to avoid the bars, images could be secured which gave the appearance of wildlife in a natural environment.

It remained for the Kearton brothers, however, to revolutionize nature photography. Through a large number of publications from the turn of the century they secured details of animals in their native habitats in imagery which was a revelation to most who had neither seen nor experienced fauna in such striking precision or intimacy. Utilizing fast emulsions, specialized lenses, specially constructed blinds, and rarely matched patience and persistence, they offered a new dimension of wonder to the natural environment. Their publications featured chiefly photogravure reproductions, which not only permitted the altering or masking of technical flaws but also, and more importantly, made it possible for the image of each animal to be provided with its own selectively enhanced tones and textures.

Thus, the hedgehog depicted here is striking not only because of the size of the print but also because of the exaggerated texture and tonality given by the process. The animal's spines and shape are selectively lightened or darkened to give it a presence which seems to extend above the subdued camouflage of the ground, affording the hedgehog a substance perhaps not entirely in keeping with nature but certainly in accord with the photographer's interpretation of it.

Paul Augustus Martin (1864–1944).
The Great Frost: Scene along the Embankment. 1895.
Gelatin silver print. 16.4 × 21.5 cm.

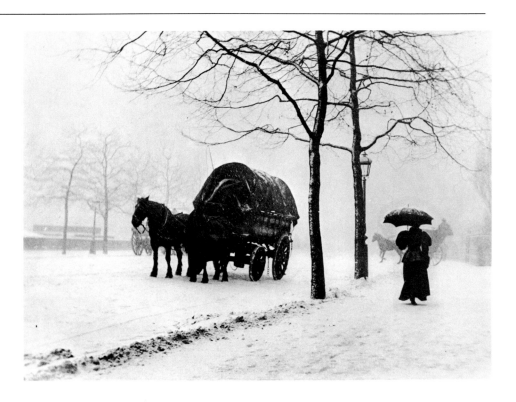

Paul Martin maintains a pivotal position in the history of British photography, not through his direct influence at the time of his greatest work but rather when we view his career in retrospect. A professional wood engraver and amateur photographer, he was able to foresee the decline of his profession as it was replaced by his avocation. An individual of limited professional photographic training, he possessed a decisive, intuitive eye which resulted in memorable compositions of light and moment. A straight photographer in the most direct, uncomplicated sense, he had no aversion to manipulating or altering the basic components of an image in order to achieve a notable effect. A shy and retiring individual, he produced some of the most effective photodocumentary images while in the pursuit of artistic awards and notices from fellow members of his photographic society. When he finally turned full-time professional in 1900 he forsook most of his personal image-making for the trials and challenges of running a photographic business which catered in the main to portraiture, commercial processing, and photographic novelties. The remarkable output of distinctive and influential photographs which he produced during the late 1880s and the 1890s became, in historical hindsight, one of the most important bodies of individual photographic work to come out of a photographer's all too brief "amateur" career.

Paul Augustus Martin (1864–1944).
Living Statues: Newspaper Vendors. ca. 1894.
Lantern slide: gelatin on glass. 8.2 ×8.2 cm.

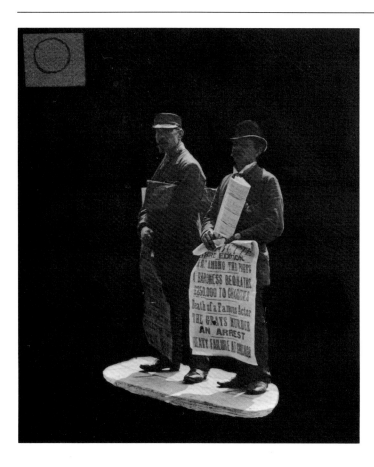

The projection of images by magic lantern goes back to pre-photographic centuries. The method had long been used as a medium of communication, entertainment, and education. Therefore, the application of the transparent photographic image was a common and, indeed, even economically profitable enterprise by the 1890s. Lantern slides were popular throughout the decade, and evenings of lantern entertainment were held in photographic societies, learned lectures, and educational classes in many academic disciplines.

Paul Martin's candid photographs of London street types are among the most sig-nificant photographic documents to come out of nineteenth-century Britain. He employed them in lantern slide formats for presentation at many of the photographic societies' evening meetings. However, he chose to remove the figures from their natural context, by blocking out all environmental imagery and drawing a base on them to produce a series which he titled "living statues." The resulting presentation won Martin the immediate acclaim he sought from his peers. Decades later, the original images, placed back in their everyday scenes, would win him additional fame in his final years.

Paul Augustus Martin (1864–1944).
Night Scene in London. 1896.
Carbon print. 23.6 × 29.6 cm.

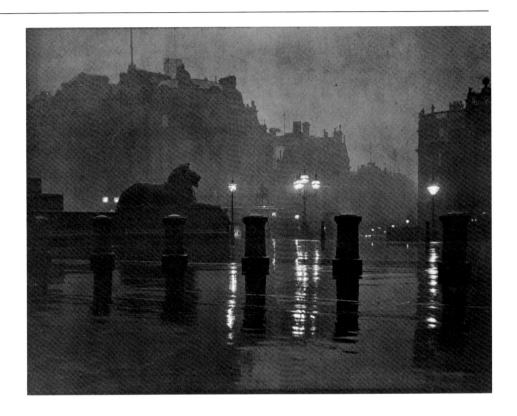

Although he may not have been the first,
Paul Martin is the acknowledged pioneer in
the field of night photography. A practical
and inventive individual, he overcame the
technical and logistical problems inherent
in the process of the day in order to produce
some evocative and innovative work. The
resulting photographs presented audiences
with city views unlike any others they had
ever seen, and the compositions of complex
tones and light formations influenced pho-
tographers throughout the world, including
no less a figure than Alfred Stieglitz.

Inadvertently, this night view also raised
a political controversy when the press no-
ticed the figure of a helmeted policeman
standing in the scene. Since the exposure of
the plate may have lasted for upward of half
an hour, the newspaper wondered at the
efficiency of the London police who stood
around for such long periods when they
were supposed to be on continuous evening
patrol.

Lyddell Sawyer (1856–1895).
The Boatbuilders. ca. 1889.
Published in W. Arthur Boord, ed., *Sun Artists*.
Photogravure. 18.9 × 14.3 cm.

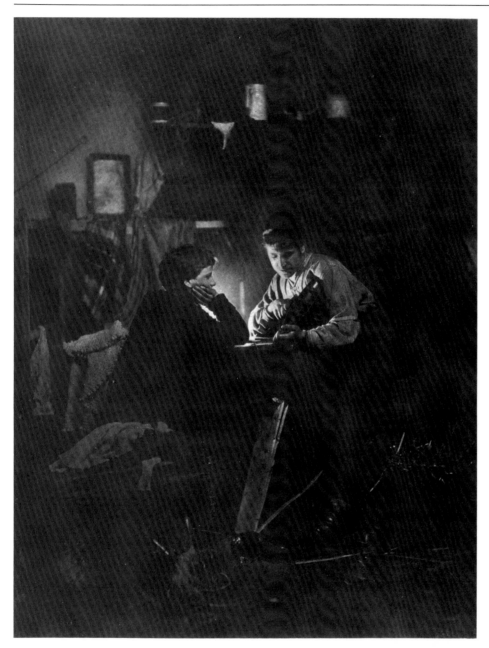

Lyddell Sawyer remains a fascinating puzzle to those who have attempted to force all the high art photographers from the end of the century into either the naturalistic or the pictorial mode. His devotion to a broad range of subjects and styles and his mastery of multiple techniques make it difficult to place him in a single camp.

Although not in agreement with the basic principles of the Naturalists, Sawyer acknowledged openly their profound effect in forcing photographers to think about the images they were creating and, thereby, reducing their narrow preoccupation with process. While working in subject matter and themes related to those of the contemporaneous Pictorialists, he nonetheless sought in his work not an abstract concept of "Beauty" but rather a work of art in which "Humanity telling of Humanity is its highest goal" (F. C. Lambert, "Mr. Lyddell Sawyer," in *Sun Artists*, ed. W. Arthur Boord, p. 28).

Thus, however posed or theatrical the composition of "The Boatbuilders" may seem to us today, it must not be approached as merely a mood piece. The print's careful construction of all the visual elements of the work and its highly effective lighting and chiaroscuro are all derivative of a Victorian style of art which had its roots among the Dutch followers of Caravaggio. Employing these elements effectively, Sawyer adds a tangible depth to both sitters and setting, a three-dimensionality of not only style and form but content as well. His image exists on a symbolic rather than reportorial plane, telling not of two boys but rather of the intensity and sincerity of boyhood as he perceived it.

Charles Job (1853–1930).
A Quai. ca. 1895.
Photogravure. 16.2 × 11.9 cm.

Heirs to the "high art" photography of the 1850s and 1860s, the writings and dialogue generated by Robinson and Emerson, and the dominant literary and painting styles of the late nineteenth century, the Pictorialists dominated the photographic art scene in Britain and the world throughout the 1890s. This position was challenged and eventually supplanted by the American Photo-Secessionists, the precursors of Modern Art on both sides of the Atlantic, and the massive shift of cultural and artistic tastes that accompanied the social and political changes wrought by World War I. However, in this final era of the formative decades, the Pictorialists succeeded in establishing an eminent position for the photograph among the fine arts and a basis in the public eye for significant artistic contributions from future schools and movements.

The contribution of the British to Pictorialism was both basic and seminal. Not only were the precursors, such as Hill and Adamson, Cameron and Rejlander, mostly Britons and heirs to the country's picturesque traditions, but so were those who provided the initial impetus to the movement, George Davison and Alfred Maskell. While the movement's standard processes—photogravure, gum bichromate, bromoil, platinum, and carbon—and its aesthetic traditions—classicism, religion, symbolism, abstraction, "pure" photography—were international in origin and application, the spirit of free creativity which provided the theoretical basis for this flourishing attitude was first derived from the British teachings and debates of the 1880s.

The Pictorialists also inherited the continuing tradition of rendering the picturesque within the English landscape—a tradition with roots in the earliest amateur landscape work of the 1840s and 1850s. The drive to observe and reinterpret Nature led photographers once again into meadows, woodlands, and seashores around the nation. Champions of a "new school" of landscape photographic art included such pioneers of Pictorialism as H. Snowden Ward, Alfred Horsley Hinton, Charles Job, and J. Dudley Johnston. The conscious attempt to treat the medium as a fine art led, finally, to a renewed appreciation of the dimensions which photography itself was capable of attaining.

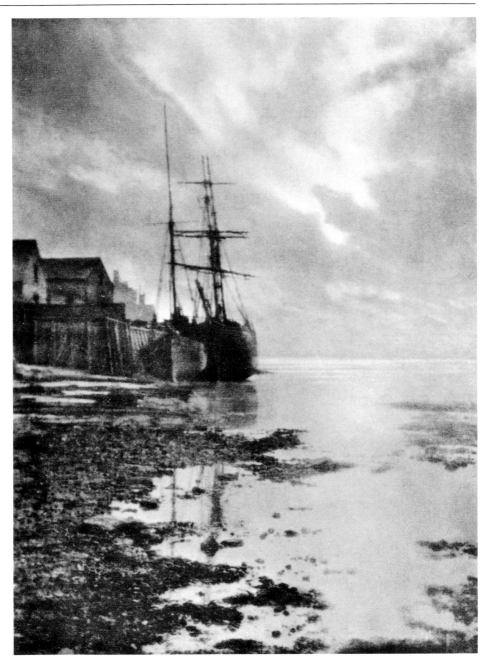

Charles A. Wilson (1865–1958).
South African Weeds—Arum Lilies. ca. 1898.
Photochrome. 19.1 × 25.4 cm.

By the 1890s, photomechanical processes began to overtake original photographic processes, not only in fine art circles but also in many areas of commercial enterprise. Photogravures, halftones, and photochromes—among other ink-on-paper techniques—extended both the range and the affordability of the imagery, and forward-thinking firms such as those founded by G. W. Wilson and Francis Frith and their sons quickly embraced their application in their businesses.

In the end, however, photomechanical processes did more than revolutionize the photographic industry. Their popularly received and distributed images did far more than extend the acceptance of the photographic representation of reality. In a sense they became "originals" of a sort themselves, reinterpreting the implied, direct reality of the photographic processes and often becoming more vivid in the viewers' minds than the originals from which they were derived.

Bowden Brothers, London.
Polo Tournament. ca. 1900.
Collodio-chloride print. 10.6 × 14.8 cm.

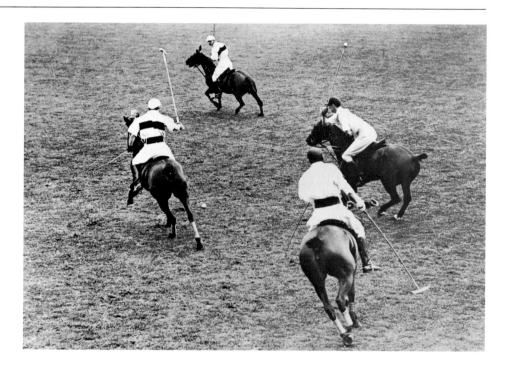

The challenge to shorten the exposure time of the photograph continued throughout the history of the medium. With each new enhancement—a faster lens, a better shutter mechanism, a more sensitive emulsion—came more experimentation in evolving photographic styles and extensions of personal vision.

The flourishing of hand-held cameras led to even greater experimentation among all classes of photographers throughout the nation. Once the obvious opportunities—leaping figures, jumping horses, etc.—had had their day before the lenses, the practitioners began to direct their cameras toward the more immediate, unposed world. The resultant explorations of time and arrested motion would eventually revise not only the manner in which the world might be seen but also the expectations and attitudes of those who sought to document it.

Unidentified photographer.
Family Butcher Shop. ca. 1910.
Post card: silver print. 8.8 × 13.7 cm.

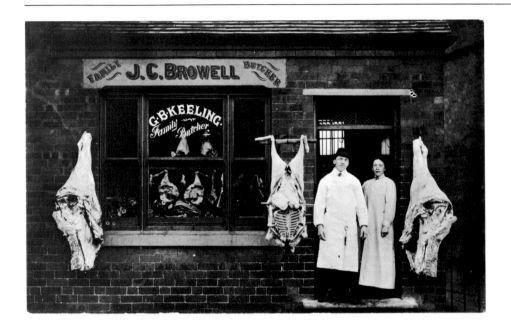

Francis Frith & Co. Ltd.
Bideford, Old Ship Tavern. ca. 1912.
Post card: photogravure, colored. 8.8 × 13.7 cm.

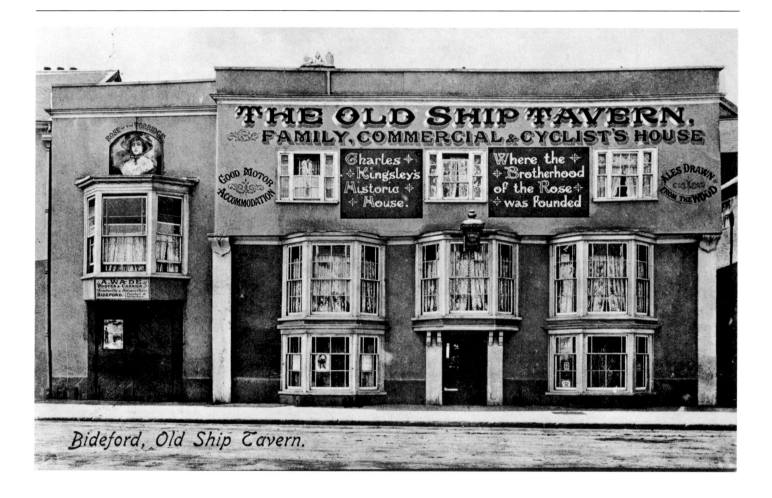

Bideford, Old Ship Tavern.

In the early decades of the twentieth century the post card emerged as the most popular and commercially successful card format in the photographic market. A natural synthesis of two staples of nineteenth-century photographic commerce—the mass-produced albumen print and the intensely popular carte with its succeeding variants—the post card also owed its remarkable popularity to its relatively inexpensive cost as well as its dual nature as both a collectible and a means of communication.

The subject matter ranged from the top-ically unique to the popularly mundane. Social types and street characters still retained a principal fascination, as in the butcher shop card, and if the card photographers did not possess the style of a John Thomson, they nonetheless provided a direct, uncomplicated attitude which revealed a healthy approach to the acceptance of the implied truth of the photographic image. Likewise, an enthusiastic audience also existed for mass-produced cards such as the Frith view of the Old Ship Tavern—truly a straightforward document of an architectural façade. With the rapid developments in mass communications and travel, a growing need for imagery related to popular and historical sites was filled by such post cards.

Along with the rather astronomical increase in amateur snapshot photography, the picture post cards combined to make photography the most prevalent type of visual imagery in the early twentieth century. Together with the photomechanical revolution within the picture press they had an immeasurable effect upon the visual literacy of pre–World War I Britons.

J. Birtles.
Letting in the Water at Ellesmere Port. ca. 1890.
Published in *Manchester Ship Canal: Making the Waterway*.
Gelatino-chloride print. 26.5 × 36.0 cm.

Commissioned to document the building of the Manchester Ship Canal in the 1890s, J. Birtles produced a wide variety of mammoth prints covering many aspects of the progress of the construction project. His work does not display the variety of approaches and styles of earlier projects—for example, Delamotte's survey of the rebuilding of the Crystal Palace or the Dixons' interpretations of passing London. We do not know if these restrictions were imposed by those who provided the commission or whether they reflected the limitation of Birtles' own vision. Suffice it to say that Birtles' photographs contain none of the experimental approaches or varieties of subject matter of the other works.

Rather, Birtles elected to find his diversity in the details of his images. Although nearly all the views show work sites and the posed figures of the individuals em-

ployed there, they vary dramatically in their use of form, texture, and detail. The shapes created by excavated earth, construction materials, and machines are carefully balanced within the frame. The contrasts between the relatively small human figures and the massive evidence of their earthworks become even more dramatic in the size and quality of the mammoth prints. Finally, foregrounds and backgrounds are given major emphasis in the component strata of the photograph. Thus, through the disorienting point of view which places rushing water in the foreground, this Birtles view of the Ellesmere Port demands the involvement of the viewer.

With photographers like Birtles the documentary statement became one of subtleties rather than merely one of solely dramatic moments or contrasts.

Russell and Sons.

Queen Victoria's Funeral: Cortege en Route from St. George's Chapel to Frogmore, Windsor Castle. 1901.
Albumen print. 27.8 × 21.1 cm.

Like a number of earlier firms and photographers, Russell and Sons bore the official designation "By Special Appointment of H.M. Queen Victoria" in their advertisements and on their trade mounts. The stamp of royal patronage brought economic prosperity to the firm, and by the turn of the century Russell and Sons had three elaborate studios in London, Southsea, and Windsor. The Russells aimed their trade at the upper classes and marked their success with some of the finest studio portraiture of this period.

Still, the support of the Queen and her court brought with it the dual obligations of visual documentation and interpretation of the experience of life among this highest class of the British Empire. It was a task to which the firm applied itself industriously and thoroughly, producing not just superb studio portraits but also staged scenes of the ruler, her children and grandchildren, and events of daily life in her court. Russell and Sons were entrusted with presenting the public face of the court at Windsor to the world in general and British society in particular. Through commercial prints sold in their studios plus engravings in the popular press based upon their images, they had a profound influence upon how the Queen's official and personal life was presented to an image-hungry Empire.

A close association with the royal family and mutual respect are evident in the photographs made by the firm during Victoria's funeral services in 1901. Although many private and amateur photographers took pictures throughout the elaborate public mourning ceremonies, only Russell and Sons were able to go behind the scenes to capture the final journey of the beloved monarch. Their eye for composition and detail, though largely developed in the confines of the studio, did not fail them in their last commission for the Queen.

Underwood & Underwood.
The Dying Bugler's Last Call—A Battlefield Incident, Gras Pan, South Africa, 1900.
Stereograph: gelatin silver prints. 8.8 × 17.7 cm.

Underwood & Underwood.
Explosion of an Ammunition Wagon during the Battle of Paardeberg, Boer War. World's Fair, St. Louis, U.S.A. 1904.
Stereograph: gelatin silver prints. 8.8 × 17.7 cm.

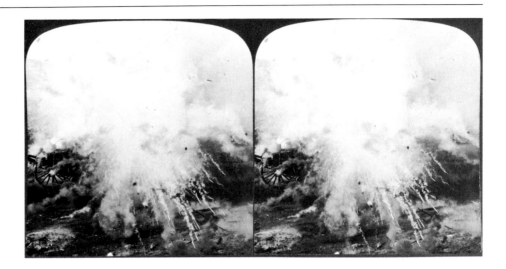

By the turn of the century the stereograph was again enjoying a period of popularity and growth. Now, however, with more refined apparatus and more sensitive emulsions, the technology behind the format expanded its potentials. The stereoviews of the 1900s and 1910s possessed an entirely different look and feel from their counterparts of forty years earlier. Also, with such expanded popularity and technology at their disposal, a number of firms—notably Keystone and Underwood & Underwood—were able to expand their financial bases and become major international suppliers of stereoviews. By the first decade of the twentieth century there seemed to be no place on the globe that was not recorded in the twin lenses of the stereo camera.

The Boer War in South Africa became the first modern war to be thoroughly covered by the stereo photographer. Both individual views and boxed sets became instantly popular with British audiences, even to the point of competing with the massive page spreads in the popular picture press of the day.

The resulting stereographs, largely the work of unidentified, uncredited staff photographers, ran the gamut of style and content, while also reviving the question of historical truth and its relationship to photojournalism. Thus, the view of the dramatic moment of an ammunition wagon's explosion appears to have been made in the midst of the Battle of Paardeberg in February 1900. Only by reading the fine print in the stereo's caption do we learn that the image was actually made during a full-scale reenactment of the battle four years later at the St. Louis World's Fair.

In addition, many views were explicitly designed to please the romantic sensibilities of a vast majority of purchasers. Thus, "battlefield incidents" involving heroic actions or tragic deaths, such as the dying bugler's last call, were staged before the camera using various troops of soldiers to provide not only the chief models but also the backgrounds of fighting men or "dead" compatriots. These theatrical, sentimental pieces represent a not insignificant number of stereos produced during the war and sold throughout Great Britain. Perhaps they also represent the last vestiges of the romanticism of war in photography, for the stereographs of World War I would be almost totally devoid of such themes.

Reinhold Thiele.
A Picket (9th Lancers) before Magersfontein. ca. 1900.
Silver print. 21.2 × 18.6 cm.

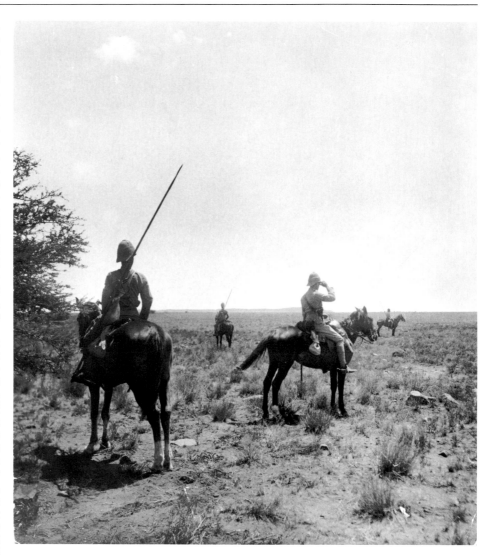

Perhaps more than any other war in British history, the Boer War reflected the changes of photographic technology and applications. Beyond the prevalence of stereophotographers, the battlefield witnessed a range of technical equipment and photochemical processes which represented both the traditional and the innovative in photodocumentary practices. The resulting imagery reflected attitudes shaped by a wide variety of circumstances: styles of camera construction, the sensitivity of negative emulsions, the experience and approaches of the photographers, and the nature of the sponsoring journalistic or publishing institution which engaged them or at least offered a potential market for their prints. Among the works of professional photographers we find view camera studies of battle sites and posed portraits of significant military figures or events; but also within this number we find products of the hand-held camera, subject to the difficult but more immediate conditions of battle and its aftermath.

Reinhold Thiele's work—designed for consumption by an image-hungry British public—is among the best of the photojournalistic productions to evolve from the war. He combined a sense of style and composition with a journalist's innate sense of drama and the search for truth. His camera ranged over the entire war zone, and the resulting photographs reflected attitudes both traditional and modern in their design and production. His photographs show men and machines in the midst of battle, but they also document those moments and events both before and after the most dramatic confrontations. He was not averse to using the "photo opportunities" of staged battle moments or controlled and posed subjects, but he also took his camera into the encampments and hospitals to tell their side of the war's full story. Above all, he retained a style of drama and an emotional presence which added impact to his final prints. Like his contemporary Jimmy Hare, he typifies those photojournalists who redefined the discipline in its evolution from Roger Fenton to the pioneers of modern twentieth-century war photography.

Unidentified photographer.

Umslopogaas, the Day before His Death. 1897.
Silver print. 28.2 × 22.5 cm.

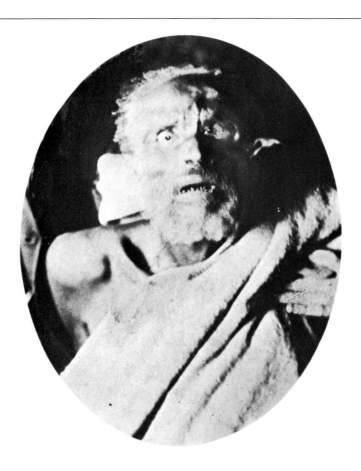

The relationship between photography and literature has long been devoid of any significant inspection and analysis. We continue to compile our bibliographies of photographically illustrated books and albums and discuss particular works as they relate to photographic themes and biographies. Somehow, however, that special relationship between the word and the photograph has had only limited historical study.

We know that photography has shaped and altered the written word since its earliest decades. From Baudelaire through Scott and Joyce to such modern writers as Beckett and Brautigan, we have witnessed structural and emotive changes in our use of language that have been inspired in large part by our changing visual experience. Likewise, we have also seen publishers employ different photographic styles, techniques,

modes of presentation, and types of subject matter for purposes ranging from direct illustration to primary creative composition. The association is as varied as the categories of literature and photography which developed during these decades.

Umslopogaas was a Zulu prince who served with H. Rider Haggard on the British commissioner's staff in the Transvaal during the 1870s and 1880s. He crossed the line between real life and popular fiction when Haggard used him as the model for many native heroes in his "Zulu romances," especially under his real name in one of Haggard's most famous novels, *Allan Quartermain.*

Though Haggard and his publishers employed only line drawings and washes in illustrating the author's works, he wrote with an almost photographic clarity espe-

cially of the Zulus, "whose true inwardness I understand by the light of Nature" (*The Days of My Life*, vol. 2, p. 207). Thus, it is not surprising that Haggard retained the stunning portrait of his old friend taken the day before his death or that he chose to reproduce it in his own autobiography. Despite its technical flaws, the portrait, with its sheer directness and its almost naked revelation of human evanescence, can continue to hold us today. Haggard's words were a bit more florid and metaphorical, the products of his own style and times: "The face might have served some Greek sculptor for the model of that of a dying god" (*The Days of My Life*, vol. 1, p. 76). In neither age, however, can we deny the power of this image, no matter what words we use.

Frederick Henry Evans (1853–1943).
George Bernard Shaw. 1901.
Platinum print. 23.3 × 17.3 cm.

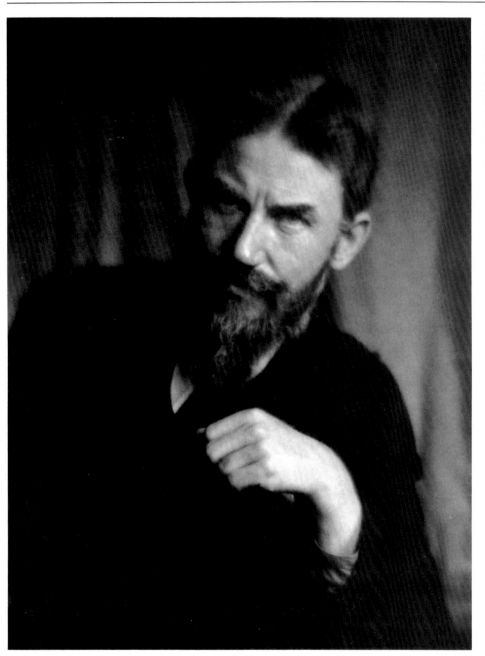

An aggressive and knowledgeable book-seller—"this ideal bookman" as George Bernard Shaw called him—Frederick H. Evans eventually forsook literary commerce to enter the final pitched battle for photography as a fine art. During the last years of these formative decades, he led the fight for a pure photography, produced without artifice or manipulation, as a means of creative expression on a par with (or often exceeding) many of the other fine arts.

Although he is best remembered for his architectural studies—exquisite prints which utilized light and tone to lend emotive substance to space and atmosphere—the essence of his total vision is best found in his portraiture. Here, first and perhaps best, he transposed figures from life into realms of light that were ultimately larger than life. His portrait of Shaw is just such an image, conforming to no style of portraiture that had ever been experienced before. His subjects do not pose: they stand or sit restlessly, unwillingly snatched for a moment from the continuum of life, forced into a mere frame, and always ready at any moment to break forth and get on with the act of living.

Evans sought an ultimate evocation of his sitters, a representation not simply of their outward appearance but of their inner spirit and mettle as well. It was a true test of his skills and vision, and it must have pleased him to know that a critic as stern as Shaw found him to be as successful as an artist as he had been as a bookman.

H. Walter Barnett (1862–1934).
The Old Lock-Smith, Dieppe. ca. 1920.
Gelatin silver print. 25.1 × 20.0 cm.

For years H. Walker Barnett was one of the most successful portrait photographers on the London scene. A master of dramatic lighting and the fine print, he created strong, albeit conventional, portraits of a number of the notable cultural and society figures of his day.

However, there exists within his oeuvre a series of portraits of common workers—a series which tends to break most of the conventions found in his studio portraits. His locksmith, removed from the traditional neutrality of the studio, stands within a clearly definable room, bathed in the direct, curtained sunlight. It is a light that defies standard practices, blocking features of face and dress and casting patterns of shape and shadow which might distract from the objective depiction of the subject. The final effect, however, is one of enhancement rather than distortion. For Barnett's use of light adds texture, form, and shape—the elements of substance itself—to this figural study, in a manner which is innovative, theatrical, and original. It is significant that even some of photography's most traditional and successful practitioners could find the medium flexible enough to challenge and expand upon their own predilections.

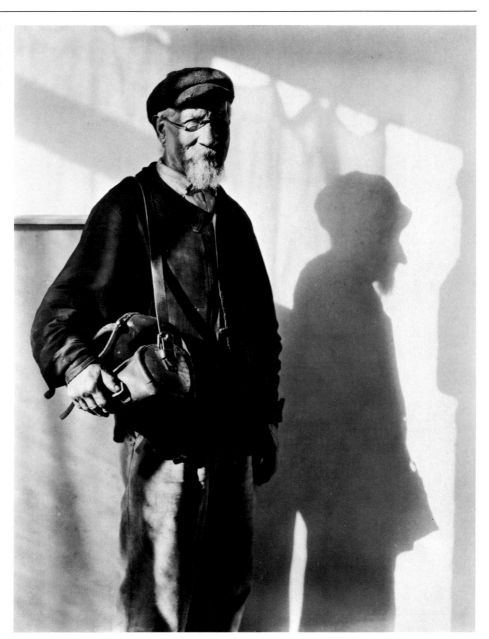

Sherril Schell (1877–1964).
Portrait of Alice Meynell. ca. 1910.
Platinotype. 23.2 × 18.4 cm.

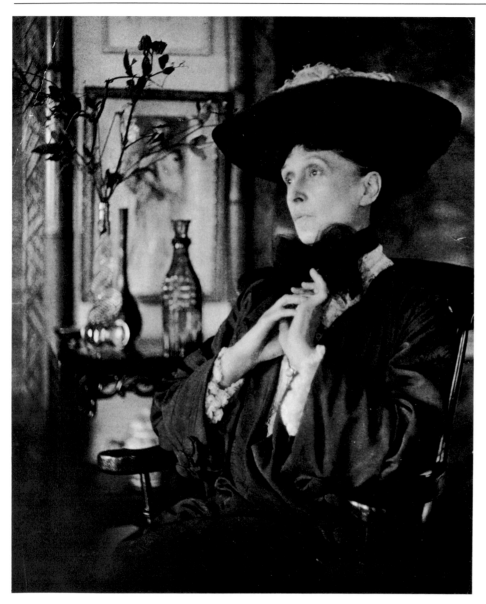

The two portraits of Alice Meynell are indicative of the Janus-like condition of photography in its final formative decade. Both photographs tell us much about the subject and her portraitists, as well as revealing the aesthetic extremes of the time.

The Sherril Schell portrait has its roots in the Aesthetic Movement and Art Nouveau traditions of the late nineteenth century. It attempts to create a mood or an effect as much as it tries to delineate the face of the subject. An organic piece with muted tones and soft, fluid lines, it is a fine Pictorialist work, generated less from photographic properties than from the painterly school of such contemporaneous artists as John Singer Sargent.

Within three or four years Alice Meynell sat for another portrait, this by the young E. O. Hoppé. The resulting image is a marked departure from Schell's work. It acknowledges the camera's innate ability to control and record light, a light that etches features with a delicacy and precision on a par with some of Thomas Eakins' best works. The pensive face and quiet hands, joined by the cascade of reflective buttons, all depict an individual of calm presence capable of facing the past or the modern day.

In 1904 Alice Meynell wrote of Julia Margaret Cameron, "She was a great admirer, whether of beauty, of genius, or of distinction, and found these gifts in so many places where they were not so perceptible to the passer-by . . ." (*Exhibition of Photography by Julia Margaret Cameron with a Note by Mrs. Meynell*, p. 4). The description is well suited to its author for—as poet, essayist, journalist, biographer of Ruskin, and anthologist—Meynell was an important figure in English letters during this time. With such diversity in her professional pursuits, it is not surprising to find her depicted so differently in relatively contemporaneous portraits. It is a testimony to the richness of her character and to the insight of both Schell and Hoppé that both photographs can say so much, so differently about this remarkable individual.

Emil Otto Hoppé (1878–1972).
Alice Meynell. ca. 1913.
Silver print. 19.8 × 14.2 cm.

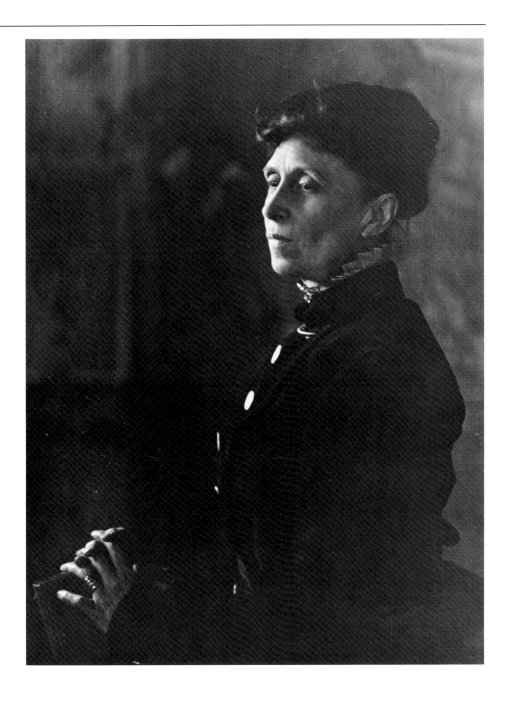

Herbert George Ponting (1870–1935).
An Iceberg Grotto. ca. 1912.
Gelatin silver print. 38.4 × 30.3 cm.

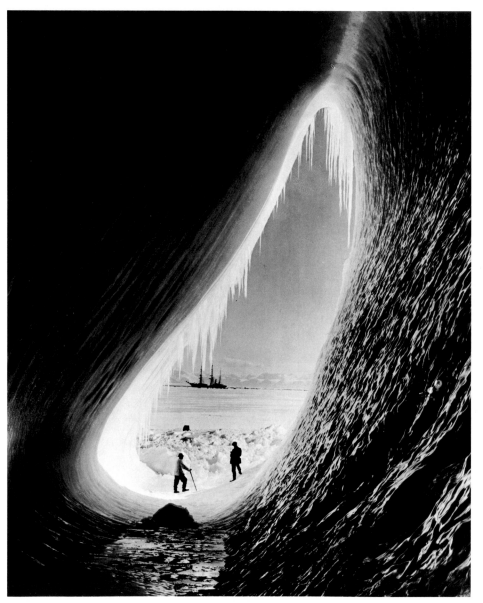

There exists a strong correlation between the flourishing of photography in distant lands and the increase of photographic imagery in such rapidly growing media as the picture press or the stereograph and post card industries around the turn of the century. It is as if the revolution within photo-communication processes spurred a rapid increase in the very natural human curiosity about the past and present of the entire world. The traditional impetus behind the grand tour of the previous centuries remained, but the methodology for practical experience engendered a fundamental change: now the images of foreign lands and peoples could be reproduced with far better clarity and detail and transmitted to a far greater number of potential viewers. Additional significant developments in advertising and distribution practices and the rise of the popular press further enhanced the spread of such images.

Among the photographers who traveled the world at this time, H. G. Ponting seems to typify this class, both in terms of the nature and distribution of his works and the variety of territory and lands he covered with his camera. He began his career in the United States working for stereocard manufacturers. From there he went on to travel the world on a variety of assignments and commissions from publishers and journals, documenting and interpreting everything from magnificent landscapes to the grim tragedy of the Russo-Japanese War. In addition to the appearance of his photographs throughout the picture press of the day, he also published a notably beautiful and exquisitely delicate volume on Japan and its people. Finally, he joined Captain Robert Scott and his ill-fated British Antarctic Expedition, for which he produced both still photographs and motion pictures. The Antarctic photographs are among the most dramatic and sensitive documentary imagery ever produced in expeditionary work; Ponting proved himself capable of capturing both the beauty and the harshness of this last remaining unexplored continent. After Scott's tragic death, Ponting continued to apply his skill with both still and motion picture cameras to preserving the records and telling the story of the expedition and the savage land that had claimed it. Thus, even toward the end of his career, Ponting, like so many fellow photographers, continued to recognize the power of the photograph to edify, educate, and persuade its viewers.

Christina Broom (Mrs. Albert Broom) (1863–1939).
Off to War. 1914.
Gelatin silver print. 11.4 × 14.4 cm.

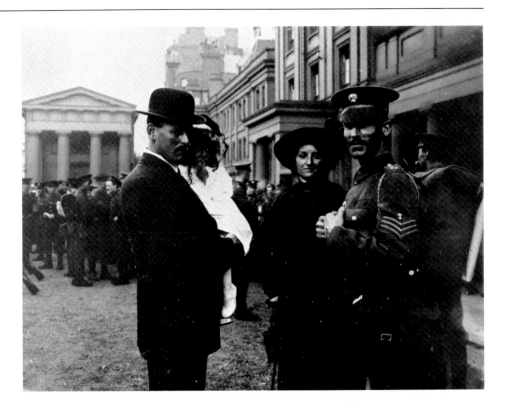

With the rise of the photographically illustrated press came the creation of a new profession—photojournalism. Now the immediacy of the medium could be applied to the process of news gathering, with the result that words and photographs could enhance one another to the mutual benefit of both as well as provide information for their audience in the communications process.

One of England's most energetic and talented early photojournalists was Christina Broom. Although the discipline required more hustle and offered less security than most, Broom was capable of surviving with some of the best talents Fleet Street had to offer. She covered many news events of national and international importance—among them, the investitures and deaths of British monarchs, the effects of World War I on the home front, political incidents, and the women's suffrage movement.

In the final analysis, the quality which makes Broom's work stand out above most of her contemporaries was her deep interest in people and the manner in which she transmitted this humanity through her camera's lens. It was a talent which would mark the works of most of the important photojournalists of future generations.

Mrs. Deane.
Ectoplasm & Spirit Head Issuing from the Sitter. ca. 1920.
Gelatin silver print. 8.8 × 6.8 cm.

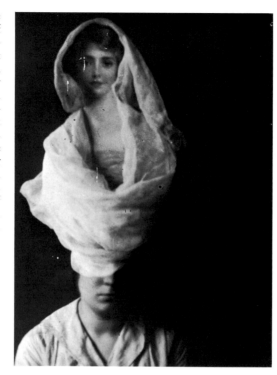

Spirit photography had, throughout these decades, remained a curiosity, a side road of interest traveled by only the most avid believers. The Victorian era was a daylight world, impressed with clear thought and human energy and having little place for metaphysics in its future plans. Only with the early years of the twentieth century— with its shifting world economy, its First World War, its writings of Freud and Ellis and others, such as Burckhardt's "Terrible Simplifiers"—only then would the deeper contents of the human psyche arise and seek to thrive in the British light. As Lewis Mumford would note, "The optimists of the machine had forgotten that there was a night and madness and mystery to contend with, coexisting with daylight and science and universal literacy" ("Mirror of a Violent Half-Century," in 7 *Arts #2*, ed. Fernando Puma, p. 111).

By the end of World War II and on into the 1920s, spiritualism reached a renewed level of scientific interest and emotional fervor. And the camera, often in untrained or even intentionally deceptive hands, began once more to contradict its assumed objective status as an instrument of accurate documentation.

Mrs. Deane's photograph of ectoplasm and a spirit head is one of hundreds of pieces of "evidence" collected by Sir Arthur Conan Doyle to aid in his defense of spiritualism. It is a contemporaneous copy print taken of a halftone image which was, of course, based upon an original manipulated photograph. Even in Doyle's time, therefore, it belied any scientific accuracy as a piece of verifiable, objective data. Both the photographer and the potential audience were able to shape the "truth" of a photographic image to a certain point of view.

Elsie Wright (b. 1901).
Frances and the Leaping Fairy. 26 August 1920.
Gelatin silver print. 10.5 × 8.0 cm.

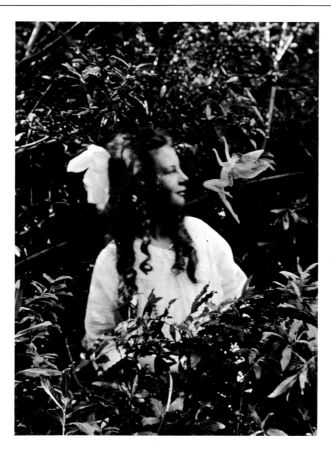

Two young girls took the family box camera into the woods one summer day in 1920 and returned with two photographs of themselves and some fairyfolk they supposedly found there. The resulting photos touched off an incident which would be debated for many decades, for the "Affair of the Cottingsley Fairies," as it came to be called, opened a debate which had far-reaching theological, metaphysical, and philosophical connotations, not to mention also engendering a deep-seated debate about photographic truth.

Although eventually proven to be a fraud (and a rather obvious one at that), the photographs attracted support from a wide number of believers, including no less a figure than Sir Arthur Conan Doyle himself. As with the spiritualist photographs of the same period, many were willing to grant the images a willing suspension of disbelief that was essentially contrary to the very nature of their optical or scientific properties.

In the end the photographs said less about the nature of any "unseen" world than they did about the social tenor of the times. Had the prevalence of photography within everyday life and individual human experience created an attitude of unquestioning belief in this seemingly objective medium?

Alvin Langdon Coburn (1882–1966).
St. Paul's Cathedral. 1908.
Photogravure. 40.9 × 30.4 cm.

The professional career of Alvin Langdon Coburn encompasses the final twenty years of the formative decades. In a very real sense, the change, conflict, and growth of those final years are also reflected in the progress of his own artistic development.

Throughout this period Coburn moved between his native America and his adopted country of England. As a member of both Alfred Stieglitz's Photo-Secession and the British Linked Ring, and because of the richness of his vision and the total dedication he brought to both the technical and aesthetic concerns of the day, Coburn dominated the photographic world on both sides of the Atlantic. His work, generative of both the Pictorialists in Britain and the spirited innovators in the United States, presented its own unique vigor and discipline. For example, his photogravure of St. Paul's evokes a mood of contemporary London, but does so not with a picturesque intent but rather with an attempt to create an atmosphere charged with a progressive dynamism.

Coburn continued to move in literary and artistic circles on both continents, stretching the limits of his photography while absorbing the prevalent reflections and ideas of the major writers, artists, and cultural giants of the day. In 1913 he traveled to Paris to meet Gertrude Stein and to be introduced to such members of her circle as Picasso. Later, under the aegis of Wyndham Lewis and Ezra Pound, he began to be influenced by the Vorticists and their attempts to establish an avant-garde movement in Britain. His resultant light abstractions, called Vortographs, although they alienated many of his former professional associates, reflected the spirit of challenge and change that ended the formative decades.

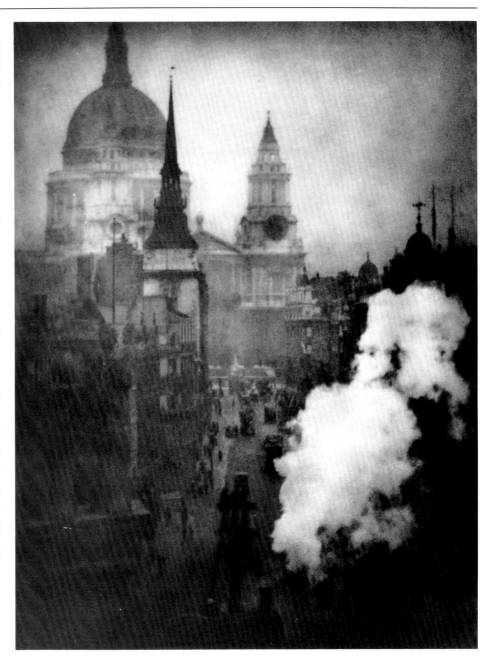

Alvin Langdon Coburn (1882–1966).
Vortograph. 1917.
Gelatin silver print. 21.3 × 16.3 cm.

Nahum Ellan Luboshez (1869–1925).
Famine in Russia: Starving Girl. 1910.
Silver print. 47.3 × 33.7 cm.

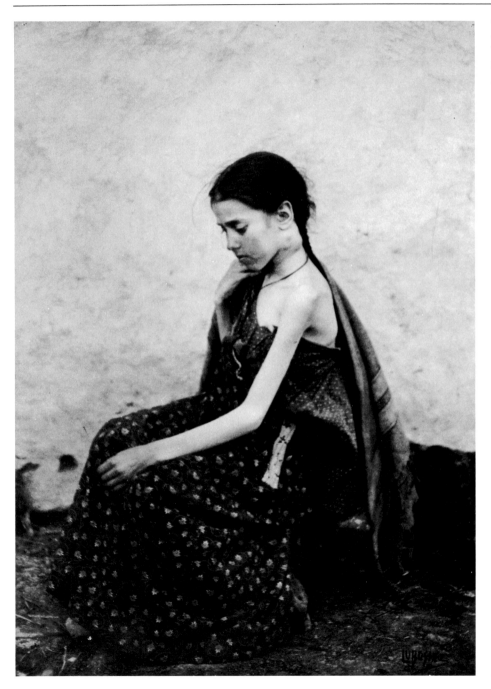

With his retirement from the presidency of the Royal Photographic Society in November 1919, Dr. C. Atkin Swan sounded a call for individuality in defense of the photographic art:

> Because an effect does not meet with universal approval we are inclined to think that it must be wrong artistically. But if a picture pleases one, I do not think it matters whether it follows the ordinary stereotyped rules at all. . . . Every man has a right to maintain his own individuality. . . . We are all too much afraid to break away from the ordinary lines and rules. . . . Surely a photograph is a photograph and need not be labelled as like something else.

If such a true independence was possible in the work of a selected few original artists like Alvin Langdon Coburn or Paul Martin, it also was evident in the highly derivative creations of less-known photographers like Nahum Luboshez. For Luboshez's works are largely contradictory in terms of their content and presentation. Thus, his documentary photographs of the effects of famine in his homeland, Russia, although moving and effective images, were printed in moody pictorial tones on texturized gallery papers typical of the fine art trends of the day. Likewise, the results of his X-ray experiments, though largely technical extensions of the intense fascination which this "new photography" created at the turn of the century, were arranged in a modified triptych for presentation in the annual Royal Photographic Society exhibition.

Perhaps this contradictory nature is reflective of Luboshez's ambivalent life spent between his native Russia and his adopted England. Or, perhaps, it has to do with the contrast between his professional career with the research laboratories of Eastman Kodak Company and his personal involvement in a number of photographic salons and societies. For whatever fundamental reasons, the spirit of change which permeated the medium by the 1910s was not confined only to movements, organizations, or specific aesthetic or cultural traditions. In the end it evolved throughout personal careers as well.

Nahum Ellan Luboshez (1869–1925).
X-ray: Set of Eggs in Process of Incubation. ca. 1919.
Silver prints. 35.0 × 27.4 cm.

Sir Frederick Pascoe William Rutter (1859–1949).
On the Road Home from Scotland. September 1910.
Collodio-chloride print. 10.0 × 12.2 cm.

Sir Frederick Rutter typifies the closure brought to the final formative decades. A self-made man arising out of the growing middle class, he became famous and wealthy through his leadership in one of the newer "white-collar" industries, insurance. Through his astute management of the London and Lancashire Insurance Company he became the dean of British insurance leaders. In many ways Rutter was a quintessential product of the Victorian and Edwardian eras, a person capable of effecting change and adapting to the changes around him.

It is no surprise, therefore, to find that his photographs are primary examples of the degree of visual experience of most camera owners of the 1900s and 1910s. They are products of the mass-produced, commercial rollfilm cameras which evolved from the Kodaks of the late 1880s. As such they are subject to the limitations of most handheld cameras of this period—including standardized formats, viewfinder optics, circumscribed ranges of film sensitivity and exposure controls, and commercial processing techniques. Most amateur "snapshot" photography at the end of the era suffers from the same visual restrictiveness in terms of such properties as presentational format or print quality. Likewise, since the photographs tend to evolve from personal experience, they tend to nurture a documentary affinity for events and individuals of importance to the individual photographer, becoming less records of fact than records of the memory of those realities.

Like stills from a motion picture, the snapshots produced by Rutter in the course of his life can give us select clues as to the overall experience of his life. Within the limitations of the medium, certain stylistic elements—his experimentation with motion as well as fixed poses, his sense of space within the frame, his tendency to ennoble as well as record the faces of family and friends—can tell many things about his tastes, personality, and convictions. Together with his writings and the public facts of his life and career, his photographs expand our understanding of the individual and the times. The expressive, intuitive, and emotional levels within his photographs finally make this era live again.

Bibliography

Annan, Thomas. *Photographs of Old Closes, Streets, &c., Taken 1868–1877.* Glasgow: City Improvement Trust, 1878(?).

Arnold, H. J. P. *William Henry Fox Talbot, Pioneer of Photography and Man of Science.* London: Hutchinson Benham, 1977.

Barraud, Herbert. *Men and Women of the Day.* 3 vols. London: Richard Bentley; Eglington, 1888–1890.

Barrow, Thomas F., Shelley Armitage, and William E. Tydeman, eds. *Reading into Photography: Selected Essays, 1959–1980.* Albuquerque: University of New Mexico Press, 1982.

Bayley, R. Child. "'The A.P.' and Other Memories," *The Amateur Photographer & Cinemaphotographer* 78 (June 20, 1934): 551.

Beales, Derek. *From Castlereagh to Gladstone, 1815–1885.* New York: W. W. Norton, 1969.

Boord, W. Arthur, ed. *Sun Artists.* London: Kegan Paul, Trench, Truber, 1891.

Braive, Michel F. *The Photograph: A Social History.* Translated by David Britt. London: Thames and Hudson, 1966.

Braudel, Fernand. *On History.* Chicago: University of Chicago Press, 1980.

Brettell, Richard R., et. al. *Paper and Light: The Calotype in France and Great Britain, 1839–1870.* Boston: David R. Godine, 1984.

Briggs, Asa. *Iron Bridge to Crystal Palace: Impact and Images of the Industrial Revolution.* London: Thames and Hudson in collaboration with the Ironbridge Gorge Museum Trust, 1979.

Buckland, Gail. *Fox Talbot and the Invention of Photography.* Boston: David R. Godine, 1980.

Buckley, Jerome Hamilton. *The Victorian Temper: A Study in Literary Culture.* New York: Vintage Books, 1951.

Buerger, Janet E. *The Era of the French Calotype.* Rochester, N.Y.: International Museum of Photography at George Eastman House, 1982.

———. *The Last Decade: The Emergence of Art Photography in the 1890s.* Rochester, N.Y.: International Museum of Photography at George Eastman House, 1984.

Bunnell, Peter C., ed. *A Photographic Vision: Pictorial Photography, 1889–1923.* Salt Lake City: Peregrine Smith, Inc., 1980.

Burke, James. *Connections.* Boston and Toronto: Little, Brown and Co., 1978.

Burns, Archibald. *Picturesque "Bits" of Old Edinburgh.* Edinburgh: Edmonston and Douglas, 1868.

Caffin, Charles H. *Photography as a Fine Art: The Achievements and Possibilities of Photographic Art in America.* New York: Doubleday, Page and Co., 1901.

Canaday, John. *Mainstreams of Modern Art.* New York: Simon and Schuster, 1959.

Cantor, Norman F., and Michael S. Werthman, eds. *The Making of the Modern World, 1815–1914.* New York: Thomas Y. Crowell, 1967.

Carroll, Lewis. *Rhyme? and Reason?* London: Macmillan, 1883.

Clark, G. Kitson. *The Making of Victorian England; Being the Ford Lectures Delivered before the University of Oxford.* New York: Atheneum, 1982.

Clark, Kenneth. *Landscape into Art.* London: John Murray, 1949.

Claudet, J. F. A. "On the Classification of the International Exhibition of 1862 as Regards Photography." *The Photographic Journal* 7, no. 112 (August 15, 1861): 241–244.

Coe, Brian. *The Birth of Photography: The Story of the Formative Years 1800–1900.* London: Ash and Grant, 1976.

Coe, Brian, and Paul Gates. *The Snapshot Photograph: The Rise of Popular Photography, 1888–1939.* London: Ash & Grant, 1977.

Coe, Brian, and Mark Haworth-Booth. *A Guide to Early Photographic Processes.* London: Victoria and Albert Museum, 1983.

Crawford, William. *The Keepers of Light: A History and Working Guide to Early Photographic Processes.* Dobbs Ferry, N.Y.: Morgan and Morgan, 1979.

Dallas, Eneas Sweetland. *The Gay Science.* London: Chapman and Hall, 1866.

Darrah, William C. *Cartes de Visite in Nineteenth Century Photography.* Gettysburg, Pa.: W. C. Darrah, 1981.

———. *The World of Stereographs.* Gettysburg, Pa.: W. C. Darrah, 1977.

Delamotte, Philip Henry. *Photographic Views of the Progress of the Crystal Palace, Sydenham, Taken during the Progress of the Works, by Desire of the Directors*. London: Directors of the Crystal Palace Company, 1855.

de Vaucouleurs, Gerard. *Astronomical Photography: From the Daguerreotype to the Electron Camera*. New York: Macmillan, 1961.

Dickens, Charles. *Hard Times*. London: Bradbury and Evans, 1854.

Eder, Josef Maria. *History of Photography*. 4th ed., 1932. Translated by Edward Epstean, 1945. New York: Dover, 1978.

Emerson, Peter Henry. *Idyls of the Norfolk Broads*. London: Autotype Co., 1886.

————. "Naturalistic Photography." *The Photographic Journal*, n.s. 17, no. 6 (March 28, 1893): 156–167.

Exhibition of Photography by Julia Margaret Cameron with a Note by Alice Meynell. London: Serendipity Gallery, 1904.

"Fifth Ordinary Meeting, Wednesday, December 22nd, 1852." *Journal of the Society of Arts* 1, no. 5 (December 24, 1852): 50–53.

Flukinger, Roy, Larry Schaaf, and Standish Meacham. *Paul Martin: Victorian Photographer*. Austin and London: University of Texas Press, 1977.

Fontanella, Lee. *Photography in Spain in the Nineteenth Century*. Dallas and San Francisco: Delahunty Gallery; Fraenkel Gallery, 1983.

Ford, Colin, ed. *An Early Victorian Album: The Photographic Masterpieces (1843–1847) of David Octavius Hill and Robert Adamson*. New York: Alfred A. Knopf, 1976.

French Primitive Photography. Commentaries by Andre Jammes and Robert Sobieszek. *Aperture* 15, no. 1 (Spring 1970).

Frith, Francis. *Egypt, Sinai, and Jerusalem: A Series of Twenty Photographic Views*. London: W. MacKenzie, 1860(?).

Frith, William Powell. *My Autobiography and Reminiscences*. 3 vols. London: R. Bentley, 1887–1888.

Fry, Roger. *Vision and Design*. New York: Meridian, 1956.

Galassi, Peter. *Before Photography: Painting and the Invention of Photography*. New York: Museum of Modern Art, 1981.

Gaunt, William. *A Concise History of English Painting*. London: Thames and Hudson, 1964.

Gernsheim, Helmut. *The Origins of Photography*. London: Thames and Hudson, 1982.

Gernsheim, Helmut and Alison. *Creative Photography: 1826 to the Present. An Exhibition from the Gernsheim Collection*. Detroit: Wayne State University Press, 1963.

————. *The History of Photography from the Camera Obscura to the Beginning of the Modern Era*. New York: McGraw-Hill, 1969.

————. *L. J. M. Daguerre: The History of the Diorama and the Daguerreotype*. 2d ed., rev. New York: Dover, 1968.

Gettings, Fred. *Ghosts in Photographs: The Extraordinary Story of Spirit Photography*. New York: Harmony Books, 1978.

Gilbert, Sir William S., and Sir Arthur Sullivan. *The Complete Plays of Gilbert and Sullivan*. Garden City, N.Y.: Garden City Publishing Co., 1938.

Godfrey, Richard T. *Printmaking in Britain: A General History from Its Beginnings to the Present Day*. Oxford: Phaidon, 1978.

Goldberg, Vicki, ed. *Photography in Print: Writings from 1816 to the Present*. New York: Simon and Schuster, 1981.

Gould, Lewis L., and Richard Greffe. *Photojournalist: The Career of Jimmy Hare*. Austin and London: University of Texas Press, 1977.

Gray, Thomas. *Letters of Thomas Gray*. Edited by Henry Milner Rideout. Boston: Sherman, French and Co., 1907.

Green, Jonathan, ed. *Camera Work: A Critical Anthology*. Millerton, N.Y.: Aperture, 1973.

Haggard, Henry Rider. *The Days of My Life*. 2 vols. London and New York: Longmans, Green, 1926.

————. *A Farmer's Year; Being His Commonplace Book for 1898*. London and New York: Longmans, Green, 1899.

Hannavy, John. *Roger Fenton of Crimble Hall*. Boston: David R. Godine, 1976.

Harker, Margaret. *The Linked Ring: The Secession Movement in Photography in Britain, 1892–1910*. London: William Heinemann, 1979.

Harrison, William Jerome. *A History of Photography; Written as a Practical Guide and an Introduction to Its Latest Developments*. Bradford: P. Lund; London: Trubner, 1888.

Haworth-Booth, Mark, ed. *The Golden Age of British Photography, 1839–1900*. Millerton, N.Y.: Aperture, 1984.

Henley, William Ernest. *Book of Verses*. London: David Nutt, 1888.

Hershkowitz, Robert. *The British Photographer Abroad: The First Thirty Years*. London: Robert Hershkowitz, 1980.

History of Photography: An International Quarterly. 8 vols. 1977–1984.

Hobsbawn, E. J. *Industry and Empire*. London: Pelican, 1969.

Holt, Elizabeth Gilmore, ed. *The Art of All Nations, 1850–73: The Emerging Role of Exhibitions and Critics*. Garden City, N.Y.: Anchor Press/Doubleday, 1981.

————. *The Triumph of Art for the Public: The Emerging Role of Exhibitions and Critics*. Garden City, N.Y.: Anchor Press/Doubleday, 1979.

Hunt, Robert. *A Manual of Photography*. 3d ed. London: J. J. Griffin, 1853.

————. *Photography: A Treatise on the Chemical Changes Produced by Solar Radiation, and the Production of Pictures from Nature by the Daguerreotype, Calotype, and Other Photographic Processes*. London: J. J. Griffin, 1851.

————. *A Popular Treatise on the Art of Photography*. London, 1841. Reprint, with introduction and notes by James Yingpeh Tong; Athens, Ohio: Ohio University Press, 1973.

————. *A Popular Treatise on the Art of Photography, Including Daguerreotype, and All the New Methods of Producing Pictures by the Chemical Agency of Light*. Glasgow: R. Griffin, 1841.

————. *Researches on Light: An Examination of All the Phenomena Connected with the Chemical and Molecular Changes Produced by the Influence of Solar Rays; Embracing All the Known Photographic Processes and New Discoveries in the Art*. London: Longman, Brown, Green and Longmans, 1844.

Jay, Bill. *Victorian Cameraman: Francis Frith's Views of Rural England, 1850–1898*. Newton Abbot: David and Charles, 1973.

Jeffrey, Ian. *Photography: A Concise History*. New York and Toronto: Oxford University Press, 1981.

———. *The Real Thing: An Anthology of British Photographs, 1840–1950*. London: The Arts Council of Great Britain, 1974.

Jenkins, Reese V. *Images and Enterprise: Technology and the American Photographic Industry, 1839 to 1925*. Baltimore and London: Johns Hopkins University Press, 1975.

Jones, Bernard E. *Encyclopaedia of Photography*. London: Cassell, 1911.

Jussim, Estelle. *Slave to Beauty. The Eccentric Life and Controversial Career of F. Holland Day: Photographer, Publisher, Aesthete*. Boston: David R. Godine, 1981.

———. *Visual Communication and the Graphic Arts: Photographic Technologies in the Nineteenth Century*. New York and London: R. R. Bowker, 1974.

Kearton, Richard and Cherry. *Pictures from Nature*. London and New York: Cassell, 1905.

Kouwenhoven, John A. *Half a Truth Is Better than None: Some Unsystematic Conjectures about Art, Disorder, and American Experience*. Chicago and London: University of Chicago Press, 1982.

(Lloyd, Valerie). "Notes on the Processes." In *Photodiscovery: Masterworks of Photography, 1840–1940*, by Bruce Bernard. New York: Abrams, 1980.

London Stereoscopic and Photographic Company, Ltd. *A Selection of Prize Pictures from the London Stereoscopic and Photographic Company's Amateur Photographic Exhibition, November, 1887*. London, 1887.

Macdonald, Gus. *Camera: Victorian Eyewitness. A History of Photography, 1826–1913*. New York: Viking Press, 1979.

Manchester Ship Canal: Making the Waterway. Manchester: Birtles and Warrington, 1890(?).

Margolis, Marianne Fulton, ed. *Camera Work: A Pictorial Guide*. New York: Dover, 1978.

Mayor, A. Hyatt. *Prints and People: A Social History of Printed Pictures*. New York: Metropolitan Museum of Art, 1971.

Morley, John, Viscount. *On Compromise*. London: Macmillan, 1923.

Mumford, Lewis. "Mirror of a Violent Half Century." In *7 Arts #2*, edited by Fernando Puma, pp. 107–114. New York: Doubleday, Permabooks, 1954.

———. *Technics and Civilization*. New York: Harcourt, Brace and Company, 1934.

Naef, Weston J. *The Collection of Alfred Stieglitz: Fifty Pioneers of Modern Photography*. New York: Metropolitan Museum of Art, 1978.

Nevins, Allan. *The Gateway to History*. Rev. ed. Garden City, N.Y.: Doubleday, 1962.

Newhall, Beaumont. *The History of Photography: From 1839 to the Present*. Rev. and enl. ed. New York: Museum of Modern Art, 1982.

———. *Latent Image: The Discovery of Photography*. Garden City, N.Y.: Doubleday and Co., 1967.

———, ed. *Photography: Essays and Images. Illustrated Readings in the History of Photography*. New York: Museum of Modern Art, 1980.

Nye, Russel B. *The Unembarrassed Muse: The Popular Arts in America*. New York: Dial Press, 1970.

Ollman, Arthur. *Samuel Bourne: Images of India. Untitled*, no. 33. Carmel, Calif.: Friends of Photography, 1983.

Panofsky, Erwin. *Meaning in the Visual Arts: Papers in and on Art History*. Garden City, N.Y.: Doubleday and Co., 1955.

Pare, Richard. *Photography and Architecture, 1839–1939*. Montreal: Canadian Centre for Architecture, 1982.

Pevsner, Nikolaus. *The Englishness of English Art*. Harmondsworth: Penguin Books, 1964.

Photographic Art Treasures. London: Patent Photo-Galvano-Graphic Co., 1856–1857.

"The Photographic Society and the International Exhibition of 1862." *The Photographic News* 5, no. 147 (June 14, 1861): 281–282.

Photography: The First Eighty Years. Text by Valerie Lloyd. London: P. and D. Colnaghi, 1976.

Pictorial Photography in Britain, 1900–1920. Text by John Taylor. London: Arts Council of Great Britain in association with the Royal Photographic Society, 1978.

Porter, Bernard. *The Lion's Share: A Short History of British Imperialism, 1850–1970*. London and New York: Longman, 1975.

Price, William Lake. *A Manual of Photographic Manipulation*. London: J. Churchill, 1858.

Pumphrey, William. "Rambles in North Wales in the Summer of 1862: By James Wilson & William & Alfred Pumphrey." (London: Unpublished original manuscript w/mounted photos, 1862).

Reilly, James M. *The Albumen and Salted Paper Book: The History and Practice of Photographic Printing, 1840–1895*. Rochester: Light Impressions Corporation, 1980.

Rempel, Siegfried. *The Care of Black and White Photographic Collections: Identification of Processes*. Technical Bulletin, no. 6. Ottawa: Canadian Conservation Institute, November 1979.

Robinson, Henry Peach. *Letters on Landscape Photography*. New York: Scovill Manufacturing Co., 1888.

———. *Pictorial Effect in Photography: Being Hints on Composition and Chiaroscuro for Photographers*. London: Piper and Carter, 1869.

Robinson, Sir John Charles. *The Art Wealth of England*. London: P. and D. Colnaghi, Scott, 1862.

Rudisill, Richard. *Mirror Image: The Influence of the Daguerreotype on American Society*. Albuquerque: University of New Mexico Press, 1971.

———. "On Reading Photographs." *Journal of American Culture* 5, no. 3 (Fall 1982): 1–14.

Sedgfield, Russell. *Photographic Delineations of the Scenery, Architecture, and Antiquities of Great Britain and Ireland, Part I*. London: Samuel Highley, 1854.

Shaw, George Bernard. *The Quintessence of G. B. S.* Selected by Stephen Winsten. New York: Creative Age Press, 1949.

"The Societies and the International Exhibition." *The Photographic News* 5, no. 147 (June 28, 1861): 304–305.

Society for Photographic Relics of Old London. London: Private publication, 1875–1886.

Solomon, Robert C. *History and Human Nature: A Philosophical Review of European Philosophy and Culture, 1750–1850.* New York and London: Harcourt Brace Jovanovich, 1979.

Steegman, John. *Victorian Taste: A Study of the Arts and Architecture from 1830 to 1870.* Cambridge, Mass.: MIT Press, 1971.

Stevenson, Sarah. *David Octavius Hill and Robert Adamson: Catalogue of Their Calotypes in the Collection of the Scottish National Portrait Gallery.* Edinburgh: Trustees of the National Galleries of Scotland, 1981.

Stuart-Wortley, Henry. *Tahiti; A Series of Photographs . . . , with Letterpress by Lady Brassey.* London: S. Low, Marston, Searle and Rivington, 1882.

Swan, C. Atkin. "Ordinary Meeting. Held at 35, Russell Square, W.C., on Tuesday, November 11th, 1919, Presidential Address." *The Photographic Journal*, December 1919, pp. 244–248.

Szarkowski, John. *Looking at Photographs: 100 Pictures from the Collection of the Museum of Modern Art.* New York: Museum of Modern Art, 1973.

Talbot, William Henry Fox. *The Pencil of Nature.* London: Longman, Brown, Green and Longmans, 1844(–1846).

———. *Sun Pictures in Scotland.* London, 1845.

The Thames from London to Oxford in Forty Photographs. London: Virtue and Co., n.d.

Thompson, William Irwin. *At the Edge of History.* New York: Harper and Row, 1971.

Thomson, David. *England in the Nineteenth Century, 1815–1914.* London: Penguin, 1950.

Thomson, John, and Adolphe Smith. *Street Life in London.* London: Woodbury Permanent Printing Co., 1877.

Tissandier, Gaston. *A History and Handbook of Photography.* 2d ed., rev. Edited by J. Thomson. Appendix by William Henry Fox Talbot. London: Sampson Low, Marston, Searle and Rivington, 1878.

Victoria and Albert Museum, London. *'From Today Painting Is Dead': The Beginnings of Photography.* London: Arts Council of Great Britain, 1972.

Watson, John Forbes, and John William Kaye, eds. *The People of India.* 8 vols. London: India Museum, 1868–1875.

Weismann, Donald L. *The Visual Arts as Human Experience.* Englewood Cliffs, N.J.: Prentice-Hall, 1974.

West, Sir Algernon. *Recollections, 1832–1886.* London: Smith, Elder, 1899.

White, Terence Hanbury. *Farewell Victoria.* New York: H. Smith and R. Haas, 1934.

Williams, Jonathan. "The Camera Non-Obscura." In *The Magpie's Bagpipe: Selected Essays of Jonathan Williams.* San Francisco: North Point Press, 1982.

Wood, Rupert Derek. *The Calotype Patent Lawsuit of Talbot vs. Laroche, 1854.* Bromley: R. D. Wood, 1975.

Glossary

Albumen print: The most prevalent form of photographic printing medium in the last half of the nineteenth century. A thin, plain paper was coated with a layer of egg white and salt and then sensitized with a silver nitrate solution. The original negative was contact printed in daylight against the paper before being processed and fixed.

Ambrotype: Also called the collodion positive, the ambrotype was a unique image on glass usually prepared in a case with decorative matte and cover glass. At its simplest the ambrotype was a collodion negative on glass with a black enamel or cloth backing applied on the opposite side of the glass in order to achieve the positive appearance of the final image. Several variants were tried in the forty-year history of this process.

Calotype: The earliest practical negative process, discovered by Talbot in 1840. A fine paper was sensitized with potassium iodide and silver nitrate solutions, before being exposed in a camera. The negative was developed in a solution of silver nitrate in gallic acid and then fixed. The resulting paper negative was often waxed to increase its translucent quality. The final negative was generally contact printed in sunlight onto a piece of salted paper in order to produce a positive print.

Carbon print: An early pigment process which proved to be among the medium's most permanent and popular. A sheet of paper, coated with gelatin containing potassium bichromate and a suitable pigment (usually carbon black, hence the name), was exposed to daylight through the desired negative. The gelatin hardened relative to the amount of light which struck each section of the paper. Then hot water was applied to the paper to wash off all the soluble gelatin and thereby "develop" the image. As the original paper support became insoluble, the image was normally transferred onto another support base, which could range from another sheet of paper to such esoteric supports as metal, wood, or leather.

Collodio-chloride print: A printing out paper which employed collodion rather than gelatin as the binder of the light-sensitive emulsion. These papers were popular during the decades around the turn of the century, not only because of their efficiency but also because they often had toners within the print's emulsion.

Collotype: One of the most practical of the photomechanical processes. It first employed a plate coated with bichromated gelatin which was exposed under the negative and then allowed to dry. The structure of the print's reticulated surface was first inked and then transferred to the selected paper surface by means of a press. The final image, although somewhat grainy in texture, was marked by sharpness of line and excellent tonal reproductions.

Cyanotype: A simple, early paper process invented by Sir John Herschel in 1842. Paper was impregnated with iron salts and then used in contact printing with daylight. The final image, simply fixed by washing in water, was a deep Prussian Blue.

Daguerreotype: The first publicly announced photographic process, the daguerreotype rapidly became the first commercially viable portrait medium. In this process a copper plate was coated with silver, finely polished, and sensitized with the fumes of iodine. After its exposure in camera the plate was removed and developed over the vapors of boiling mercury. The resulting image, unique and highly delicate to the touch, was usually enclosed in a matte and cover glass and mounted in a protective case.

Dry plate negative: Collodion, used as the suspension agent for the light-sensitive salts, was coated onto uniform glass plates and provided with a protection layer of albumen or (later) gelatin. The resulting dry plates were sold commercially and revolutionized the picture-making process since they freed pho-

tographers from all the effort and inconvenience of the wet collodion process. Dry plates were a viable picture-making medium from the 1870s through the first half of the twentieth century.

Ferrotype: Also known as the tintype and melainotype, this early portrait medium was derived from the collodion positive process. In this case, the unique image was secured on a black enameled metal plate. Although the resultant image appeared flatter and darker than its predecessors, the daguerreotype and the ambrotype, its cheaper cost and rapid production time soon enabled the process to rapidly outdistance these two rivals in commercial photographic portraiture.

Gelatin silver print: The use of gelatin as a flexible medium for the support of light-sensitive emulsions marked a final revolution in the making of photographs. Generally, silver bromide was suspended in the emulsion layer upon which the print was made. The bromide paper was a favorite, especially since it afforded greater speed and flexibility in both enlarging and toning subsequent prints. It has existed from the 1880s through many modifications on to the present day.

Palladiotype: A developing out process closely related to the platinum print. Processing procedures between the two were often identical, with palladium often substituted in the formula for the more expensive platinum. Both metallic solutions were also capable of being combined in the same print.

Photochrome: A color printing process noted for its accuracy and the quality of its multiple reproductions. From the original negative any number of copy negatives, each colored to a particular hue, were produced. Lithographic plates were then made from each negative and printed in succession to make the final image.

Photoengraving: The general term for any of a number of photographically assisted relief process prints from either line or halftone originals. The metal plate is etched away, leaving a raised relief for those areas which are to be recorded as black in the final print. The entire plate is inked and impressed upon the paper surface.

Photogravure: The photomechanical process capable of producing the richest coloring and tonality. The plate was dusted with asphaltum powder and then coated with bichromated gelatin. The exposed and selectively hardened layer controlled the penetration of etching solution, producing a plate etched to different selective depths. Finally, the plate was inked and contact printed to suitable paper.

Photomezzotint: A mechanized form of carbon printing closely related to the Woodburytype as well. The carbon print was electrotyped, forming a copper mould in which the gelatin relief was then cast. Multiple prints were then pulled from the hardened relief.

Platinum print or platinotype: Among the most delicate and refined printing processes, platinum prints flourished between the 1870s and the 1920s. Papers containing light-sensitive iron salts and a platinum compound were exposed and then developed in a solution of potassium oxalate. The resulting photographic image was formed by the remaining fine platinum metals being deposited in the paper after the processing.

Salted paper print: Talbot's early positive image process, often derived from printing with his calotype negatives. The photographer treated plain writing paper with salt and sensitized it with silver nitrate, before contact printing the image in broad daylight and subsequently fixing the finished print.

Wet collodion negative: The prevalent means of negative-making throughout most of the latter half of the nineteenth century. Collodion—guncotton dissolved in ether—and potassium iodide were used to coat a single piece of glass. The plate, sensitized at the site with a silver nitrate bath, required exposure and immediate development while the negative was still wet. The resulting negative was among the brightest and finest-detailed of all available processes of the day.

Woodburytype: Perhaps the most delicate and "permanent" of the photomechanical duplication processes. It required that a relief image be made in bichromated gelatin, which was in turn placed in a hydraulic press in contact with a block of lead. The resulting pressure created a shallow mould following the various delicate contours of the original image. In the final stage the block was coated with gelatinous ink before being transferred to paper in another press. A grainless, texturally pure print, the Woodburytype was often mistaken for an original photographic print.

Index

(Page numbers of photographs by each photographer are listed in boldface type.)

Adamson, Robert, **30, 33,** 35, 121, 133
Aesthetic Movement, 13–14, 146
Aesthetic Society, 12
Alexander, Lady Jane, **32**
Alexandra, Queen Consort, **117**
Amateur Photographic Association, 100
Anderson, James (pseud.), **54**
Annan, Thomas, **73**
Arago, François, 24
Atkins, Anna, **20,** 102
Atkinson, Isaac, **54**

Barnett, H. Walter, **145**
Barraud, Herbert, **114**
Beard, Richard, 8–9, **26, 27,** 96
Bedford, Francis, **38, 39,** 107
Bell, H., **107**
Birtles, J., **138**
Boer War, 140–142
Bourne, Samuel, **52**
Bowden Brothers, London, **135**
Broom, Christina (Mrs. Albert), **149**
Burns, Archibald, **72,** 73
Burrows, Robert, **63**

Caledon, Countess of, **32**
Cameron, Henry Herschel Hay, **120**
Cameron, Julia Margaret, **87, 88,** 113, 120,
 124, 133, 146
Carrick, William, **96**
Carroll, Lewis (pseud.), 26, **78, 85,** 121
Chapman and Hall, **110,**
Claudet, Jean François Antoine, 22, 26, **27**
Clifford, Charles, **55, 127**
Coburn, Alvin Langdon, **152, 153,** 154
Coke, E., **77**
Crimean War, 47–49
Crookes, Sir William, **23**
Cundell, George S., **34**
Currey, Francis, **62,** 63
Currey, W., **86**

Dallas, Eneas Sweetland, 12–13
Davies, George Christopher, **103**
Davis, Sebastian, 10
Davison, George, **106,** 133
Deane, Mrs., **150**
Decadent Movement, 14
Delamotte, Philip Henry, 28, **56,** 138
de la Rue, Warren, **24**
Dixon, Henry and T. J., **74,** 138
Dodgson, Charles Lutwidge. *See* Carroll,
 Lewis

Emerson, Peter Henry, 5, 14–15, 103, **105,**
 106, 133
England, William, **40**
Evans, Frederick Henry, **144**

Fear, George, **82,** 84
Fenton, Roger, 9, 28, **36, 47, 48,** 55, **64,**
 70, 124, 142
Frith, Francis, 15, **44,** 55, **71, 75,** 107, 134,
 137
Fry, Peter Wickens, **28**

Gee's American Studio, Jersey, **115**
Gibson and Sons, Penzance, **109**
Good, Frank Mason, 44, **45**
Great Exhibition of 1851, 6, 9, 10, 40,
 56, 57

Hare, Jimmy, 142
Hay, David Ramsay, 12
Herschel, Sir John, 24
Hill, D. W., **58**
Hill, David Octavius, **30,** 33, 35, 121, 133
Hill and Adamson, **30,** 33, 35, 121, 133
Hinton, Alfred Horsley, **133**
Hodgson, Mrs. Brian, **119**
Hollyer, Frederick, **118**
Hoppé, Emil Otto, 112, 146, **147**
Hughes, Alice, **113**
Hughes and Mullins, **124**
Hunt, Robert, 7–8, 9, **19,** 102

International Exhibition of 1862, 9–11, 40

Job, Charles, **133**
Johnston, J. Dudley, 133

Kearton, Richard and Cherry, **128**
Keith, Thomas, **35**
Keystone firm, 141
King, Horatio Nelson, **108**

Lawton, J., **53**
Linked Ring, 152
London Stereoscopic and Photographic
 Co., Ltd., **76**
Luboshez, Nahum Ellan, **154, 155**

M., **98**
MacPherson, Robert, **43,** 54, 55, 127
Maddox, Richard Leach, **67**
Marks, Arthur, 74
Martin, Paul Augustus, **129, 130, 131,** 154
Maskell, Alfred, 133
Maull and Polyblank, **31**
Mayall, J. P., **112**

Mayall, John Jabez Edwin, **80**
Meynell, Alice, 146–147
Milles, Lady Charlotte, **91**
Morris, William, 102, 122
Mudd, James, **70**

Naturalists, 14–15, 105, 132
Negretti and Zambra, **57**

Pain, Robert Tucker, **93**
Photographic Club, 7
Photographic Society of London, 7
Photojournalism, 153
Photo-Secessionists, 133, 152
Pictorialists, 12, 15, 106, 119, 132, 133
146, 152
Playfair, Lyon, 10
Ponting, Herbert George, **148**
Pre-Raphaelite school, 118
Price, William Lake, **46**
Prout, Victor Albert, **68**
Pumphrey, Alfred, **94**

Realism, 82, 83
Rejlander, Oscar Gustave, 12, **61**, **89**, 133
Robertson, James, **49**
Robinson, Henry Peach, 5, 12, 14, 15, 88,
89, **90**, **104**, 133
Romanticism, 13, 82, 84, 104
Ross and Thompson, **41**(?)
Royal Photographic Society, 154
Royal Studio, Colchester, **123**
Ruskin, John, 13
Russell and Sons, **139**
Rust, T. A., 124, **125**
Rutter, Sir Frederick Pascoe William, **156**

Salmon's Series, **127**
Sawyer, Lyddell, 88, **132**
Schell, Sherril, **146**

Second Afghan War, 51
Sedgfield, William Russell, **38**
Shaw, George Bernard, **126**, 144
Silvester, Alfred, **59**
Silvy, Camille, **81**
Smith, A. G. Dew, **121**
Smith, John Shaw, **42**
Society for Photographic Relics of Old
London, 74
South London Photographic Society, 10
Spiller, John, **23**
Spiritualism, 150, 151
Stevens, Henry, 110, **111**
Stieglitz, Alfred, 131, 152
Stuart-Wortley, Col. Archibald Henry
Plantagenet, **97**
Swan, C. Atkin, 154
Swan, Joseph Wilson, **95**

Talbot, William Henry Fox, 19, **21, 22,** 27,
42, 64, 78, 102
Thiele, Reinhold, **142**
Thompson, Charles Thurston, 64, **65**
Thomson, John, **83**, 96, 137
Turner, Benjamin Bracknell, 36, **37**

Underwood and Underwood, **140, 141**

Valentine, James, 72, 76, **84**
Venables, Gilbert, **92**
Vorticists, 152

Walker, Sir Emery, **122**
Wall, Alfred H., 10
Ward, H. Snowden, 133
Watkins, Carleton, 43, 54
Wilson, Charles A., **134**
Wilson, George Washington, 15, 72, 76,
101, 102, 124, 134
Wright, Elsie, **151**